SIGMAR POLKE

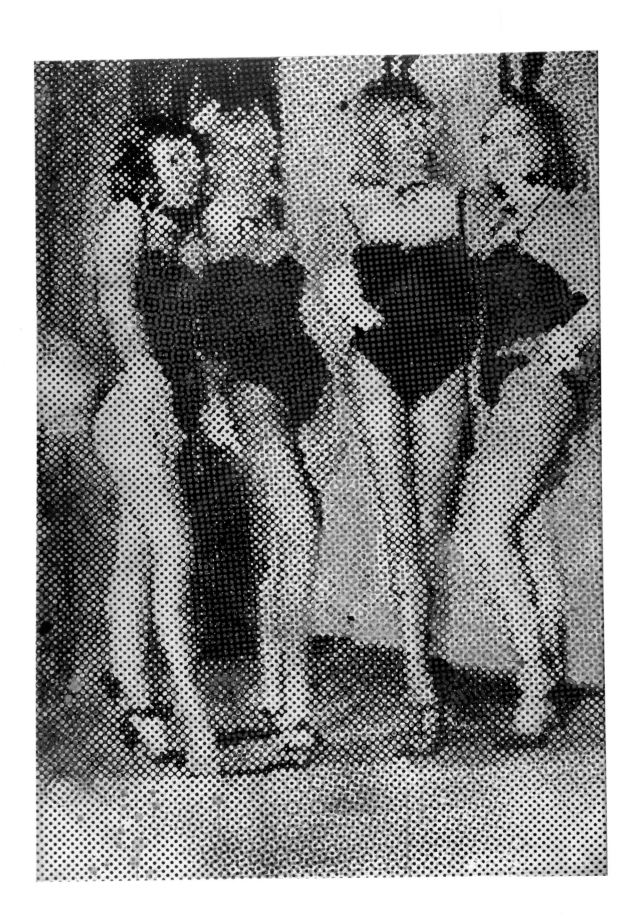

SIGMAR POLKE

SAN FRANCISCO MUSEUM OF MODERN ART

Published on the occasion of the exhibition *Sigmar Polke*, organized by the San Francisco Museum of Modern Art.

San Francisco Museum of Modern Art
15 November 1990–13 January 1991

Hirshhorn Museum and Sculpture Garden, Smithsonian Institution, Washington, D.C.
12 February–7 May 1991

Museum of Contemporary Art, Chicago
20 July–8 September 1991

The Brooklyn Museum, New York
11 October 1991–6 January 1992

The exhibition and catalogue are generously supported by the Andy Warhol Foundation for the Visual Arts, Inc., and the National Endowment for the Arts, a Federal agency.

Library of Congress Cataloging-in-Publication Data

Polke, Sigmar.
 Sigmar Polke.
 p. cm.
 "Published on the occasion of the exhibition Sigmar Polke, organized by the San Francisco Museum of Modern Art"—T.p. verso.
 Exhibition held at the San Francisco Museum of Modern Art and at other galleries, Nov. 15, 1990–Jan. 13, 1991.
 Includes bibliographical references (p. 144).
 ISBN 0-918471-18-4 (hardcover)
 ISBN 0-918471-16-8 (paperback)
 1. Polke, Sigmar—Exhibitions. I. San Francisco Museum of Modern Art. II. Title.
N6888.P56A4 1990
759.3—dc20 90-8943

FRONTISPIECE: *Bunnies*, 1966. Acrylic on canvas, 35⁷⁄₁₆ × 23⁵⁄₈ in. (90 × 60 cm). Private collection, New York.

CONTENTS

LENDERS TO THE EXHIBITION

Thomas Ammann, *Zurich*
ARC, Musée d'Art Moderne de la Ville
 de Paris
The Art Institute of Chicago
Walter Bareiss, *Munich*
Anna and Otto Block, *Berlin*
John and Frances Bowes, *San Francisco*
Udo and Anette Brandhorst, *Cologne*
The Carnegie Museum of Art, *Pittsburgh*
Galerie Crousel-Robelin/Bama, *Paris*
Gerald S. Elliott, *Chicago*
Charlene Engelhard, *Cambridge*
The Froehlich Collection, *Stuttgart*
Gagosian Gallery, *New York*
The Garnatz Collection, *Cologne*
Mimi and Peter Haas, *San Francisco*
Karl Stroeher Foundation, Hessisches
 Landesmuseum, *Darmstadt*
Hirshhorn Museum and Sculpture Garden,
 Smithsonian Institution, *Washington, D.C.*
Prof. Dr. A. Huhn, *Bonn*
Prof. Dr. Rainer Jacobs, *Cologne*

Museum of Fine Arts, *Bern*
Kunstmuseum, *Bonn*
Raymond Learsy, *New York*
The Dr. H. G. Lergon Collection,
 Rheinbach, Germany
Linda and Harry Macklowe, *New York*
Joseph E. and Arlene McHugh, *Chicago*
Susan and Lewis Manilow, *Chicago*
Helen van der Meij, *London*
Museé National d'Art Moderne,
 Centre Georges Pompidou, *Paris*
Maria Osthoff, *Herrischried, Germany*
Raschdorf Collection, *Düsseldorf*
The Rivendell Collection, *New York*
F. Roos Collection, *Zug, Switzerland*
San Francisco Museum of Modern Art
The Dr. Speck Collection, *Cologne*
Jerry and Emily Spiegel Family Collection,
 New York
Staatsgalerie Stuttgart
The Stober Collection, *Berlin*
Hans Vetter, *Bonn*
Anonymous

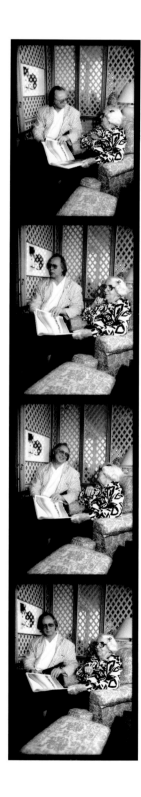

Sigmar Polke and Phyllis
Wattis, San Francisco, 1990.
Photo: Jo Fielder

Sigmar Polke's artistic production, made over the
past thirty years, surely represents one of the late
twentieth century's most penetrating and sustained
critical commentaries on the condition of Western
culture at the same time as it is a remarkably inven-
tive and vitalizing contribution to the art of painting.
The broad scope of Polke's explorations, enthusi-
asms, and engagements—ranging from the keenest
of insights on the work of Andy Warhol and Joseph
Beuys (two figures so extraordinarily crucial for
understanding the current state of the visual arts),
to sharp observations on the political, economic,
and ideological contradictions of postwar Europe, to
the wittiest meldings of popular culture and high
art, to highly skeptical considerations of every
manner of official system, to experimentation with
altered states of mind and material through chemis-
try and alchemy—makes the task of precisely
defining his achievements an elusive enterprise. Yet
this ambiguity is ultimately emblematic of the West's
current plight, a culture seemingly absent of fixed
philosophical or spiritual points of reference. The
centrality of Polke's role in revealing these conditions
is evidenced by the remarkable number of astute
younger artists on both sides of the Atlantic who see
in his work their own apprehensions and skepti-
cisms, and yet, amid this state of doubt, also find in
his endeavors the model for an urgent willingness to
go on observing, experimenting, and searching for
meaning in the contemporary world.

The proposal to Sigmar Polke that a large-scale
review of his work be arranged grew out of John
Caldwell and John Lane's involvement with the
artist on the part of the *Carnegie International* exhibi-
tions of 1985 and 1988. Since 1989, as curator of
painting and sculpture at the San Francisco Museum
of Modern Art, Caldwell has been the principal
figure in the organization of this exhibition and its

8

accompanying publication. Helen van der Meij, representing the artist, has played a crucial role in every aspect of this undertaking. Polke, himself, has been deeply involved with shaping the project and aiding in its realization. We deeply appreciate the commitment of each of them to this complex venture between artist and museums.

At the San Francisco Museum of Modern Art, express thanks for their contributions to the overall development and organization of the exhibition are due to Inge-Lise Eckmann, Tina Garfinkel, Virginia Glasmacher, Mindy Holdsworth, Barbara Levine, Pamela Pack, Sandra Poindexter-Gary, and Peter Samis. Preparation and publication of this catalogue were achieved through the particular energies of Kara Kirk, Catherine Mills, and Fronia Simpson. For their special efforts in presenting the exhibition at its Washington, Chicago, and New York venues, we thank, respectively, Ned Rifkin, Bruce Guenther, and Charlotta Kotik.

We are grateful to the authors who prepared texts for the publication: artist and teacher John Baldessari; ethnologist and filmmaker Michael Oppitz; poet and critic Peter Schjeldahl; Dr. Katharina Schmidt, director of the Kunstmuseum Bonn; physician and collector Dr. Reiner Speck; John Caldwell; and Eugenie Candau, SFMOMA librarian and compiler of this publication's exhibition history and bibliography.

We are especially obliged to the lenders to the exhibition, who are acknowledged on a special page in this catalogue, for sharing their works of art with our four museums.

Dr. Schmidt provided invaluable assistance in locating drawings for the exhibition, as did Dr. Joachim Blüher at Galerie Michael Werner, Cologne. Special thanks are also due to Elizabeth Kujawski and Peggy Ross, curators of private collections lending works to the exhibition.

Organization of the national tour of this first major North American exhibition of the work of Sigmar Polke has been made possible by grants from the National Endowment for the Arts and the Andy Warhol Foundation for the Visual Arts. We very much appreciate the generosity and perspicacity of all the project's sponsors and friends.

JOHN R. LANE
Director, San Francisco Museum of Modern Art

JAMES J. DEMETRION
Director, Hirshhorn Museum and Sculpture Garden, Smithsonian Institution, Washington, D.C.

KEVIN E. CONSEY
Director, Museum of Contemporary Art, Chicago

ROBERT T. BUCK
Director, The Brooklyn Museum, New York

JOHN CALDWELL

SIGMAR POLKE

Born in 1941 in Oels, in Silesia, in what was then the eastern part of Germany, Sigmar Polke crossed into West Berlin by subway, feigning sleep so as to pass unnoticed, in 1953, at the age of twelve. Six years later he was in Düsseldorf, studying the craft of glass painting, but in 1961 he enrolled in the Art Academy there, where he continued to study until 1967. It was while he was still a student in 1963, that Polke, together with Gerhard Richter and Konrad Fischer-Lueg, founded a style of art they called Capitalist Realism.

Although Polke was clearly aware of the work of American pop artists (his early painting *Table*, 1963, pl. no. 3, evidences his knowledge of Roy Lichtenstein's benday dot paintings of a few years before), even at the beginning, his work showed a marked distinction from the paintings being made in America. *Table*, for example, lacks the allover graphic punch of the illustrator that Lichtenstein's work typically had, and coming to it today, we are reminded far more of the look of the conceptual art that followed a few years later than of paintings by Lichtenstein, Andy Warhol, or James Rosenquist.

Although Polke's paintings occasionally indicate his familiarity with the conventions of graphic design (see *Chocolate Painting*, 1964, pl. no. 5), he was not particularly interested in developing his own graphic style based on advertising and translating it into the medium of paint. Instead, his work of the early 1960s for the most part is less involved with appropriating or referring to the pictorial style of advertising than in depicting a consumer society's—and his own—objects of desire. (In this connection it is worth pointing out that the candies and cakes, butter and sausages that Polke painted and drew at this time had in fact been highly prized and were not easily available in the Germany of the 1950s and early 1960s.)

What was new, however, was that Polke reproduced these consumer items exactly as they might appear in the contemporary consciousness, as images taken from the pictorial shorthand of the illustrated press and not as they would actually appear in the real world. The images are flat and unseductive, and they have none of the flash either of advertising or of the American pop artists. Instead, they are straightforward renditions of the mental-visual images that run constantly through our heads. One is reminded of Leopold Bloom's persistently distracted mind as he strolled through Dublin and encountered a sign for Plumtree's Potted Meat. Polke's concern, like James Joyce's, is to report truthfully on the real state of our consciousnesses. This is a concern that has continued throughout his work, suggesting that we regard him in some sense as a great realist painter.

Yet what of the actual impact of the paintings themselves? Among their most unusual characteristics are the speed with which they are grasped and their absolute lack of the aura that is usually associated with works of art. In comparison with Lichtenstein's paintings of this period, with their comic-book texts and implied narratives, Polke's are far more quickly comprehended and reacted to. Warhol's paintings, too, carry a great deal more information, especially when the images are repeated, and even the simplest of them—Marilyn Monroe, Marlon Brando, the electric chair— elicit complex responses that prompt the viewer to linger a while before them. Part of Warhol's method, in fact, in his multi-image paintings, was to suggest a kind of progression through time, as the silkscreen image became increasingly blurred, and then to pull the viewer up short with the realization that the image itself remained unchanged and that its repetition implied the absence, rather than the presence, of meaning. Even Richter's work of these

years—hard-to-read black-and-white paintings of pictures from the popular press—is mysterious and reticent by comparison to Polke's.

Resolutely ordinary in their subjects, Polke's paintings from the mid-1960s are instantaneously legible, completely immediate, and uninvolved with the rituals and conventions of the world of art. They hit our consciousness directly, like a small bullet from a silenced gun. In this respect Polke's work— more than the American pop artists of these years— marks the most complete break with the abstract expressionism that had preceded it, and it reflects most clearly his direct relationship to life as we actually experience it. His *Plastic Tubs* (1964, pl. no. 4) and *Doughnuts* (1965, pl. no. 7) are the instantly grasped and sometimes retained images from a newspaper's pages as they are turned or from a single glance at a television screen.

Having made, in effect, a visual revolution, Polke very quickly went on to other things. Already, in his work of the second half of the 1960s, he was abandoning the radically simple methods of picturemaking he had just developed. If *Lovers II* (1965, pl. no. 11) is a throwaway image, perhaps an ad for travel or engagement rings, then *Bunnies* (frontispiece), four Playboy Club hostesses painted the next year, is from an entirely different world. Although obviously derived from the popular press, *Bunnies* reproduces actual people as they were photographed and not the instant shorthand of advertising graphics. One can, for example, easily distinguish between the four women, and it is possible to decide which is the more attractive—which is surely part of the point, since their costumes are reproduced in three different systems of dots. The painting itself is flawlessly executed, and it is perhaps the first of Polke's works that in its actual visual substance might prompt the word beautiful. The women seem to shift in and out of focus, obscured, then revealed, by evidently off-register color that defines them and their background. The inability of the viewer to see clearly, of course, precisely mimics the way we look at such erotically tinged material in newspapers, with the instantly quickened impulse of desire frustrated

by the impossibility of actually seeing anything through the blurry grid of newsprint.

By the next year, Polke's subject had changed to art. For example, he made satirical "stripe paintings," absurd lines of paint that suggested his entire lack of sympathy with the color field work being done at that time in America. The painting entitled *Higher Powers Command: Paint the Upper Right Corner Black!* (1969, pl. no. 19) bears the words of the title, as if badly typed, across its lower margin. Its painted portion follows the command, producing a bluntly satirical version of a painting by Ellsworth Kelly. In other work, however, Polke began the exploration of multiple levels of consciousness that he would pursue for an extended period. *Lilac Form* (1967, pl. no. 14) is in part a reference to Picasso with its clearly discernible eye and mouth. Significantly, the absurd Picassoid form appears against a background of cheap printed material, in a sentimental, bluish purple pattern of flowers. Although not the first time Polke utilized preprinted fabric as a ground for his paintings, it is perhaps the beginning of his use of such a backdrop to suggest the partly hallucinatory quality of what is painted on it. The lilac head is an unreal convention of art exaggerated by the banality of the fabric above which it seems to hover.

Clearly, Polke was beginning to wonder what to paint, and in the process he reported on the inappropriateness of the many styles he found around him. *Modern Art* (1968, pl. no. 22) is a brilliant parody of the conventions of geometric abstraction developed by Wassily Kandinsky and the constructivists; here they are reduced to ridiculous, vaguely Rube Goldbergish squiggles. In a series of paintings called *Solutions* (pl. no. 18) first made in 1967, Polke wickedly satirized the pretensions of conceptual art by painting a series of numbers added to and subtracted from or multiplied and divided by other numbers, invariably with the wrong answers. Even his own work became a subject for doubt, and in 1969 he selected twelve small paintings from the last six years and incorporated them into an installation entitled *The Fifties* (pl. no. 12), which he installed over trelliswork in a variety of decorator colors. The

implication was that he himself made paintings that were entirely banal, a matter of a period style.

Polke's own solution, in terms of a direction for his work, is suggested by some of the most casual and informal of his works of the late 1960s. In 1968 he made a pair of paintings inscribed with the lines of each of his palms (pl. nos. 20 and 21). One is on pink, the other on blue fabric, but the ground in each case is an aggressively metallic fabric of the sort once used to upholster cars. That the artist's tongue is in his cheek is obvious; yet these *are* the lines of his palms and are thus real and to some degree authentic, despite the absurd character of their support.

In other works of these years, Polke adopted the most stylized of decorative conventions to more complex and serious uses. In the *City Paintings* he made in 1969, one is aware at first of the hackneyed, hyperactive image of a city at night, illuminated both by strips of electric lights along the contours of the buildings and by fireworks. After a moment, however, one realizes that an alternative reading of the paintings is possible: they are also a strikingly accurate rendering of the way a streetscape actually appears after one has consumed hallucinogenic drugs. Similarly, *Heron Painting IV* (1969, pl. no. 17) is both a witty evocation of banal decorative motifs and a depiction of the distortions of reality that might be induced by ingesting psychedelic substances.

In *Alice in Wonderland* (1971, pl. no. 25) the theme of drug-altered consciousness is explicit. To the left and right sides are pieces of a hyperactive, commercially printed fabric of an athletic event, and in the center is an extremely insistent pattern of white dots on a black ground. Polke has painted the scene from Lewis Carroll's novel (and Disney's film) in which Alice has a nonsensical conversation with a hookah-smoking caterpillar, the quintessential literary drug reference of the 1960s. At the right, painted over the fabric print, is a ghostly white figure of a jumping basketball player. What is remarkable about the painting is not the clear reference to activity that was then—and still is—illegal

and even then somewhat marginal, but rather that the artist has succeeded in creating a precise visual analogue of drugged consciousness, just as he did for the consumer goods that fixated much of the 1950s and early 1960s. The painting depicts the experience of watching sports on television after consuming a drug, and shows the split in consciousness between a rather irritable, partial awareness of the game and a stronger focus on the experience of the drug itself.

Polke's discovery of a way to depict several layers of consciousness at the same time by means of superimposing one or more figural motifs over a ground of printed fabric was one that he would return to repeatedly during the years to come.[1] Yet such work has never predominated in his artistic production, and the widespread assumption in this country that it constitutes something of a signature style reflects not his own practice but the powerful influence that Polke's occasional work of this type has had in America, where it was paradigmatic for neo-expressionist paintings made here in the 1980s by David Salle and Julian Schnabel.

For Polke himself, this way of painting offered possibilities of expression that went far beyond the experience of taking drugs. Not surprisingly, a method that made it possible to depict hallucinatory experience against a background of banality had other applications. In 1982 he painted *Camp* (pl. no. 46), the first of a number of works to deal with the concentration camps that were for Germany— and the rest of the world—the central nightmare of twentieth-century history. Measuring more than fourteen feet high by eight wide, presumably the largest painting Polke has made, *Camp* is enormous, overwhelming us as viewers by its size as well as its subject. Two inwardly curving fences of barbed wire, one bearing electric lights, loom against an unnatural, dark yellow sky that partially covers an ordinary purple fabric, which functions here visually as if it were clouds in a sky at sunset. At the base of the painting is a poisonous black mist that seems to be actually consuming the fabric of the painting itself, which is penetrated in that area by a number

of holes. As viewers, we are clearly placed inside the concentration camp among its inmates, dwarfed by its mechanisms of repression and unable to see anything but the barbed wire and lights that ensure our incarceration and ultimate death. The purple fabric is ordinary material of the sort bedspreads are made of, and it refers at once to the everyday comforts of life that for us as inmates of the camp are irretrievably lost and to the fabric of ordinary civilization, which obviously has failed. In its very ordinariness the fabric may stand as well for our jailers and the absurd normality, the banal evil, of those in charge of the camp.

After he painted *Camp*, Polke produced a number of other works associated with the same theme.[2] In a series of paintings entitled *Watchtower*, he repeatedly used an ordinary image to suggest the horrifying reality of the concentration camps in his and the German consciousnesses—and in our own. In *Watchtower II* (1984–85, pl. no. 49), the tower looms over us in the same way the barbed wire did in *Camp*. The tower itself, a small guardhouse on tall, stilt-like supports, is delineated by the absence of the silver oxide that forms a multicolored sheen, like oil on water, over the rest of the canvas, and it comes in and out of visibility as the viewer moves slightly in front of the painting—an overpowering and disturbing, yet evanescent and barely visible presence.[3] The image itself has multiple referents. Identical watchtowers are frequently found today in the German countryside where they serve as look-outs for hunters in search of game. Similar towers stood until very recently along the border between West and East Germany, where they held armed soldiers who often shot at and sometimes killed defectors from the East. Inevitably, as viewers of the painting we feel ourselves not only to be under surveillance but also the human prey of unseen guards. We are at the same time hunted animals, East Germans in great peril as we attempt to cross the border, and concentration camp inmates. The image itself, hovering at the edges of visibility, becomes both an emblem and a concrete actuality of the nightmare of history and recent experience.

The hallucinatory presence of the watchtower is the result of many experiments Polke made in the making of paintings by unconventional methods in the early 1980s. *Scissors* (1982, pl. no. 27) is based on a photograph, published in a 1920 volume entitled *Physical Phenomena of Mediumism*, that shows a Polish medium, Stanislawa Tomczyk, in the process of levitating a pair of scissors. The medium herself is a ghostly image, painted in part with mica on a support of painted fabric. At the right, the canvas has been split vertically by a slit two feet or more in length, as if with the medium's scissors. An often reproduced picture of the painting shows the artist spreading the cut canvas with his hands with his face protruding through the fissure. Aside from a witty reference to the cut canvases of Lucio Fontana, the work clearly refers to the magical possibilities of painting, and we are intended to see the painter himself as in some way equivalent to the medium he depicts. At the same time, however, Polke's own real presence in the photograph of the work he allowed to be published suggests another very down-to-earth view: that painting is a bearer of illusions, a species of chicanery like the practice of mediums.

Despite his skepticism about the possibility of painting as a bearer of truth, in the early 1980s Polke embarked upon a series of experiments that continue down to the present, which have often been termed alchemical and in which the paintings themselves, as real, physical objects, effectively serve as his laboratory and at the same time the objects of his experiments. Before long, it became clear that Polke's experiments had resulted in something of a change in direction and a reversal of some aspects of his previous strategies.

What is especially significant about Polke's technical, "alchemical" experiments with works like *Watchtower II* is that they have produced paintings with a physical nature that is perceived as mutable. Not only does the guard post in *Watchtower II* come in and out of visiblity as the viewer shifts his position slightly in front of the work, but the color of the painting itself actually changes as conditions of temperature and humidity around it change. Thus

its characteristic purple sheen in Pittsburgh, its usual location, became green when it was exhibited in Los Angeles in 1986. Since 1982, Polke has consistently produced work that alters its appearance: the large wall painting he made in the German pavilion at the Venice Bienale in 1986 that responded to variations in humidity; the very large mural painting he created for his Paris retrospective in 1988 that changed with the temperature; and a series of individual canvases, beginning with *The Spirits that Lend Strength Are Invisible IV* (1988, pl. no. 68), in which little or nothing was visible at the time the painting was first exhibited but in which a composition is developing slowly over the years, rather like an enormously delayed color Polaroid.

One wonders at the purpose of such novel effects, which depend on a great deal of sophisticated and demanding technical work. Polke, not surprisingly, would seem to have an important goal in mind. By making paintings that literally change their appearance as the viewer moves about them and whose color or visibility alters over time, he has animated them in a new way and rendered them unsusceptible to photography. When *Watchtower II* was to be reproduced for the first time the artist sent the museum publishing the catalogue four slides of the work, photographed in differing lighting conditions, the clear implication being that an even larger number of images would be necessary to portray the work adequately. Obviously, a painting that changes its appearance before one's eyes, as did the Paris mural, creates a profoundly disturbing and disorienting experience.

One suspects, however, that this bringing to life, as it were, of a painting by giving it the ability to respond to its environment serves a deeper purpose as well. In a justly celebrated essay first published in 1936, "The Work of Art in an Age of Mechanical Reproduction," the German critic and man of letters Walter Benjamin was perhaps the first to discern the crisis in painting and other fine arts that was to reach general proportions in the latter half of this century. Put very briefly, Benjamin propounded the thesis that works of art in his day had lost their original, magical presence because photography permitted them to be reproduced, which seriously called into question the originality and even authenticity of works of art. The concrete expression of this change in the nature and role of the work of art in our time was the loss of its aura, or presence, which had derived from its being a unique object, made by hand and existing over time.

In an extraordinary passage from his discussion of Charles Baudelaire published three years later, Benjamin defines another characteristic of this aura as returning the look of the viewer. Citing Marcel Proust's disappointment that his memories of Venice were as vapid as photographs, Benjamin continued:

Photography is decisively implicated in the phenomenon of the "decline of the aura." What was inevitably felt to be inhuman, one might even say deadly, in daguerreotypy was the (prolonged) looking into the camera, since the camera records our likeness without returning our gaze. But looking at someone carries the implicit expectation that our look will be returned by the object of our gaze. Where this expectation is met (which, in the case of thought processes, can apply equally to the look of the eye of the mind and to a glance pure and simple), there is an experience of the aura to the fullest extent. "Perceptibility," as Novalis puts it, "is a kind of attentiveness." The perceptibility he has in mind is none other than that of the aura. Experience of the aura thus rests on the transposition of a response common in human relationships to the relationship between the inanimate or natural object and man. The person we look at, or who feels he is being looked at, looks at us in turn. To perceive the aura of an object we look at means to invest it with the ability to look at us in return.[4]

What Polke has done is to produce paintings that seem to look back at us by changing as we look at them, and thus allow them to have the very aura of a work of art that Benjamin saw as inevitably vanishing in the modern world. Polke's alchemical experiments can thus be seen as an effort to return art to the ceremonial and ritualistic basis that Benjamin saw as lost and to restore it to its previous powers and functions.

Characteristically, however, Polke's experiments did not proceed in a single direction or toward a simple goal. Another result of his method of producing paintings that changed over time and in

14 various conditions was to make them into works that were not so much paintings in the traditional sense, whether figurative or abstract, but rather objects that existed independently of what they represented or communicated and on which certain processes had left their traces. *Magnetic Landscape*, the three *Negative Value* paintings, and *Hallucinogen* are in a sense the first of Polke's non-painted paintings in that their compositions suggest natural processes rather than conventional forms of expression. The title *Magnetic Landscape* (1982, pl. no. 26) refers both to its appearance and to the late nineteenth-century spiritualist doctrines grouped under the term *magnetism*. Ferrous mica has been attached to the canvas in forms that resemble mountains as well as the patterns produced by iron filings in the presence of a magnet, as if in imitation of the experiments of the "magnetists."

The titles of *Negative Value I–III* (1982, pl. nos. 34–36) refer to the ambiguous sheen of the paintings' overall color, in certain lights gold, in others the disturbing greenish purple of food past its prime. The subtitles, which are the names of stars in traditional astronomy, suggest the ambiguities and difficulties of looking at and understanding the paintings themselves. For example, *Alkor*, according to the artist, is the name of a star in the constellation Ursus Major, which in Arabic is an injunction to improve one's eyes and is thus a metaphor for recognizing things in paintings if one looks carefully and diligently. Yet what one sees here is highly ambiguous—even when looking very closely. *Negative Value I: Alkor* is a painting that is impossible to decipher by ordinary methods since it is the result of natural processes taking place on the canvas rather than a deliberately composed painting. A large canvas, eight and a half by six and a half feet, it seems to contain hints of figures and a landscape, but nothing that can actually be distinguished with certainty. Inevitably one looks closely, then, in frustration, focuses instead on the work as a whole, only to return again to the hard-to-read "structure" of the composition, then back to the whole, and so on. Finally, the viewer is left with an unresolvable

paradox and a sense of having looked into nature and its processes rather than at a painting.

In the case of *Hallucinogen* (1983, pl. no. 37), another of Polke's works that was "composed" by natural processes, a similar kind of looking takes place, but by picking an extraordinary title for the work Polke has taken his method a step further. The viewer realizes, of course, that the title suggests an equivalency between the painting and the mental experience after taking drugs, and because the painting itself is so unconventional in the way it looks, so unlike any other work of art one has ever seen, the claim advanced by the title is taken seriously. Because its effects were actually determined by more or less random reactions in the materials used by the artist, its composition is entirely unconventional: enormous swatches of ethereally beautiful purple concentrated at the right side of the canvas meet evanescent brown and black clouds of undefinable substance at the left. Again, one has never seen such a painting before, and because it stands outside the world of art history, because it is at once so strong and so unprecedented, it succeeds in suggesting the actual experience of psychedelic drugs, something no other work of art has managed to do. Indeed, the effect is so powerful that it is possible to take the painting's title in precisely the direct way it was meant and wonder if the canvas itself is not a psychedelic drug.

The most significant of Polke's work of this type, and in some ways the culmination of his work to date, is a series of five paintings he made for the 1988 Carnegie International exhibition in Pittsburgh that bear a collective title based on a Native American proverb, *The Spirits that Lend Strength Are Invisible* (pl. nos. 65–69). The whole suite is an homage to and meditation on the Americas because it utilizes for its creation only materials associated with the New World as opposed to Europe. Polke has made works that, though clearly paintings—flat, rectangular canvases altered by the presence of visible material affixed to their surfaces—cannot in any conventional sense be said to have been painted. Merely to cite the descriptions of their media

provided by the artist makes this clear: *I*, tellurium (pure) blown onto artificial resin on canvas; *II*, 1 kg of meteoric granulate of a 15-kg meteor found in 1927 at 22° 40′ south and 69° 69′ west of Tocopilla thrown onto artificial resin on canvas; *III*, various layers of nickel incorporated in artificial resin on canvas; *IV*, silver nitrate painted on invisible, hermetic structure and artificial resin on canvas; *V*, silver leaf, neolithic tools, and artificial resin on canvas.

The paintings are grand, slightly enigmatic presences. Although there is no specific reference to landscape, unless perhaps in the fourth work of the series, which is still undergoing the slow process of revealing its content, landscape associations arise, perhaps in part because of the mineral dust that is included in several of them. In these especially, we sense dust blown across a desert, and somehow, almost miraculously, in the fourth work in its original, totally blank state, the invisible presence of the wind itself. In the fifth and final work of the series, the Indian arrowheads, still labeled as they were when the artist purchased them in a natural history shop in Düsseldorf, testify to the ancient American past and its survival in contemporary place names. They are embedded in pools of brown resin that have darkened since the work was made and that suggest both weather and the earth and its geological evolution. We are in a strangely empty, yet magical landscape, in which the dust of meteors and of obscure chemical elements is moved about by silent, unfelt winds.

The problem arises of what to call these works, since blowing tellurium dust into resin is not an activity normally associated with the act of painting. Yet no other word seems to exist to describe them. Alchemy, perhaps, would be one, even though that, too, would seem hardly appropriate, since alchemy is commonly believed to have failed, most notably at turning lead into gold, and these works so evidently succeed. One tends, as well, to associate alchemy to a certain degree with trickery—with gold perhaps obtained through chicanery—and these paintings are so evidently honest and straight-

forward, specific though esoteric, and are about exactly what they claim to be—meteorite dust, for example, thrown into wet resin. The actual effect of these canvases when shown in naturally lit galleries suggests, however, that something in the nature of successful alchemy, unlikely as it might be, has in fact taken place. Although there is no tint visible in the artificial resin that covers all five works, somehow the light falling on them is picked up and reflected back and forth among them in such a manner as to lend a very apparent, though subtle, golden tinge to the light in the gallery. Again Polke has created something that, though real and unmistakable, cannot be photographed, and in the process has literally created an aura around works of art.

One would not like to claim that the success of Polke's artistic project disproved Walter Benjamin's perception of the crisis engendered by photography in the making of art. One would hesitate to do so especially because it is precisely in the areas of contradiction and difficulty described by Benjamin that Polke has so often chosen to work. Then, too, his continuation of the art of painting has frequently been accomplished by resorting to the most esoteric means, and it is quite possible to view his accomplishment as unrepeatable by others, to see him as, in effect, the last painter. It is certainly true that Polke has worked in an art form that he himself has continually doubted and that every step forward has required of him enormous inventiveness and daring, not to mention silence and cunning. Yet to have succeeded at all, as he undoubtedly has, is a remarkable achievement.

Notes

1. To emphasize Polke's originality in this method is not to ignore the work of Francis Picabia, an artist whom Polke admires and whose work he is very well aware of. In a series of paintings usually called *Transparencies* made from 1927 through 1932, Picabia painted several images one on top of the other. Probably inspired by the technique of montage in film, these works differ from Polke's in several important respects. For one thing, the images tend to be similar in size and grouped centrally as part of an overall composition. Their import and purpose differ as well. Picabia's multiple, overlaid

16 images are typically dreamy, suggesting a kind of narrative like the material that comes to mind in reverie. Polke's, on the other hand, are radically disjunct both in size and composition, and rather than narrative they suggest an edgy, distracted simultaneity. Both artists do, however, use the technique of overlapped images to depict multiple streams of consciousness as existing at the same moment.

2. In *Paganini* (pl. no. 39), for example, painted in the same year as *Camp*, the devil plays a violin at the deathbed of a nineteenth-century figure with a doorway to another world between them. At the left, death appears in the guise of a joker, juggling reels of film that change into skulls, which have attracted, like a swarm of flies, swastikas. The act of juggling has created a whirlwind that somehow controls a line of figures in ordinary clothes below the joker. The sense of disorder and disaster in the painting is overwhelming, and its grimness is immeasurably heightened by the 1950s fabric of truly remarkable ugliness and banality that underlies the entire composition. A year later, in *The Living Stink* (pl. no. 45), Polke

contrasted the smiling face of a doctor surrounded by numbered case reports reflecting the "cures" or "improvements" he had effected with a contrasting vision in the printed fabric substructure of the work. At the right are images taken from Gauguin's Tahitian paintings, and at the left the world of nature is represented by a family of elephants. Clearly good health is no goal, but rather a meaningless preserver of stinking life.

3. Polke made the painting using a process akin to photography. His photographic work, which has been crucial to his development, in many ways serving as his primary tool for understanding and ordering the world and his experience, has recently been explored in a catalogue accompanying an extraordinary exhibition curated by Jochen Poetter at the Staatliche Kunsthalle, Baden-Baden, *Sigmar Polke: Fotografien* (Stuttgart: Edition Cantz, 1990).

4. Walter Benjamin, "On Some Motifs in Baudelaire," *Illuminations*, ed. Hannah Arendt (New York: Schocken Books, 1969), pp. 187–88.

PETER SCHJELDAHL

THE DAEMON AND SIGMAR POLKE

One of the most fecund artists of the last three decades, Sigmar Polke may also be absolutely the most elusive and refractory. In the United States his mystery is largely circumstantial, since only intermittently, and usually only in New York, have we seen the work of this forty-nine-year-old German in quantity and at its best. The present retrospective is a crash-course chance to alleviate our ignorance. But anyone who thinks that simple familiarity with Polke's output will dispel its obscurity has another think coming. To learn more and more about him, it has sometimes seemed to me, is to know less and less. His art is like Lewis Carroll's Wonderland rabbit hole, entrance to a realm of spiraling perplexities, one of which is his uncanny relation to American art, first as a provincial follower and later as a seminal influence.

From East Germany, that perennial source of gifted and driven emigrants, Polke studied in Düsseldorf in the late 1950s and early 1960s. In 1963, with Gerhard Richter and Konrad Fischer (the dealer, then an artist), he cofounded the German variant of pop art, which with characteristic critical finesse they dubbed "Capitalist Realism." They thereby declared their intention to embrace, pell-mell, the American preoccupation with media-derived imagery, but with a chilly irony about the political uses of representation. These were artists who read both *Playboy* and Walter Benjamin. Polke soon developed a style that, while parodying mechanical reproduction, was far more freely drawn and painted than its design-conscious counterparts in the United States. Polke's insistent manual touch

in his paintings of halftone reproductions, Dufyesque decorative motifs, and self-mockingly "expressive" brushwork would have seemed old-fashioned at the time to any Americans who happened to see them, more akin to the earlier, proto-pop paintings of Andy Warhol and Roy Lichtenstein than to their impeccably slicked-up mature styles. But Polke's handmade mark was, of course, new-fashioned in the extreme. Evading any signature or finished look, Polke subordinated his hand promiscuously to a hallucinating plenitude of impulses, old and new and high and low, with such notably reliable inspirations as Francis Picabia and science fiction. He force-fed the practice of spontaneous picture making a diet of paradoxical consciousness, contributing directly to the delirious proliferation of imagery in art of the 1980s.

The extraordinary variety of Polke's technical and stylistic means—painting on non-canvas fabrics, overlaying images, and mixing a witches' brew of chemical mediums, to note only the most obvious—has had a highly visible and invigorating influence on younger artists. But Polke's true significance lies beyond the antic surfaces of his art, in a philosophical attitude that has haunted recent artistic theory and practice like a ghost in a machine. It is an attitude of bottomless skepticism that contemplates—"with terror and delight," as Baudelaire recommended to his fellow connoisseurs of hysteria—its own endlessly ramifying contradictions. Polke is heir to a great and secret (because practically indescribable) theme of modern art: the daemon.

For "daemon," my dictionary offers "a subordinate deity, as the genius of a place or a man's attendant spirit." That will do, though without the religious overtones. Modern daemonism is the secular revelation of impersonal energies that are experienced in the intense activity of, apparently, nothing. Given shape in the spiritual dandyism of the late nineteenth century, it is empirical and materialistic, even scientific, in its bias. What do you suppose Oscar Wilde is talking about in this passage from "The Critic as Artist":

18

[I]n the subjective sphere, where the soul is at work, it comes to us, this terrible shadow, with many gifts in its hands, gifts of strange temperaments and subtle susceptibilities, gifts of wild ardours and chill moods of indifference, complex multiform gifts of thoughts that are at variance with each other, and passions that war against themselves. And so, it is not our own life that we live, but the lives of the dead, and the soul that dwells within us is no single spiritual entity, making us personal and individual.[1]

The antecedent of Wilde's "terrible shadow" is "the scientific principle of heredity," understood (in 1890) as canceling the illusion of personal subjectivity, of an autonomous "I." That Wilde's science is dated does not matter. He had hit on a metaphor still paradigmatic as an account of the dissociation of the modern mind as it is revealed to us, in flashes of epiphany, by certain artists.

Polke is one of these artists. In his work, nothing is either quite subjective or quite objective, though everything seems ordered by some mastering comprehension. It must be said that this comprehension—the Polkean daemon—is extremely unreassuring. It is derisive, impudent, Mephistophelean. It steers awfully close to outright cynicism. It is without apparent pride, a rascally character. It has an affinity for the debased in imagery, materials, and procedures, a debasement it is at no pains to redeem—or to not redeem, for Polke on occasion will make things that are immensely fine, with the same seemingly distracted nonchalance with which he uncorks outrages. The dynamic mess of many of Polke's paintings suggests the work of a blind man with good luck. I have a fantasy of him: he enters a pristine studio full of exquisite materials all in order, and wrecks the place. The wreckage—a series of paintings—is removed. The studio is bulldozed.

The bulldozing of the studio—that is, of the conventionality of painting—is a recurrent avant-garde dream, of course. It was a dominant theme of much American and European art in the late 1960s, when Polke, besides looking regressive in the context of pop, courted an impression of complete irrelevance in relation to minimalism and its offshoot tendencies by the simple act of continuing to paint

and draw. What a difference a decade or so can make! In the 1980s, the spirit of 1960s radicalism survived in the sphere of picture making, Polke's in particular, far more robustly than in what remained of "post-studio" aesthetics, hopelessly entangled in conventions of their own. Painting's vast ironic capacity is seen in the way Polke's deeds of artistic vandalism, performed on painting, have ended up *in* and *as* painting. He has shown painting to be like the tar baby in the Southern folk tale, absorbing and trapping the force of every blow against it. And yet he has kept hitting, with an imperious irrationality that begins to feel like a force of nature.

If Polke's perversity is an enigma, his frequent whimsicality is almost an insult. Instances of crude jokiness, decorative fuss, and dubious mysticism abound in his work, sometimes making one feel vaguely humiliated for even looking at it. The humiliation is salutary. Polke's tastelessness (never bad taste, which is still taste) is an earnest of his daemonic seriousness, his sense of a permanent emergency at the core of all cultural conventions. For him, aesthetic decorum often appears to be roughly as important as table manners during an air raid, and this includes the surreptitious decorum, the tacit agreement, that made lugubriousness and frenzy the small change of much neo-expressionist painting in the 1980s. Polke's immunity to the self-fulfilling and self-justifying imperatives of any style, in an era inundated with styles, has qualified him as an artist's artist of and for our time.

In the metaphysical junkyard of Polke's art, everything is broken, then broken again. In his hands no received image seems too mean or too destroyed to be beyond further debasement and destruction. The very medium of paint (or whatever evil fluids Polke uses in lieu of paint) may be severed from its own properties, notably color (which tends to look arbitrary, even mistaken), and may be violently at odds with its support. Polke often doesn't so much cover a surface as obliterate it. Jules Olitski once declared a yearning to paint in thin air, without canvas. Polke can seem motivated to make simple messes on walls and floor, but canvases keep getting

in the way. The upshot of all this depredation is a rawness beyond *art-brut* primitivism, like the rawness of sandpapered nerve ends.

If popular culture has a form hospitable to the daemon, it is stand-up comedy, the strange ritual by which a man or woman, terrifically isolated and exposed, becomes an open spigot of personal and collective dark stuff, a convulsive mentioner of the unmentionable. Polke has not been alone in realizing, within art, a structural equivalent of this form—a common trope of younger American artists, especially. But his is easily the most profound version, for he triggers the effect of comedy while directing it to levels too deep and inchoate for laughter. Polke's is an art of cosmic pratfalls—or, rather, cosmic prat-free-falls, which never encounter the embarrassing but reassuring security of a floor. Part of my own typical response to his work is a certain ache, like an ache to laugh, that is without issue, a sensation of blockage in the mechanism of humor, a monkey wrench lodged in the autonomic cycle of tension and release. It is a brief, fitful, not terribly pleasant feeling, but it is the basis of my conviction about Polke.

It is the nature of the daemonic artist to awaken a sense of conviction, of being in the vicinity of things self-evidently true, and most particularly, to put this sense to serious tests. Oscar Wilde's aestheticism takes on a startling grandeur, in the passage of his writing I quoted, by being used to cope positively with a situation of, one would think, primordial fear, the fear of divorce from oneself that is a dire corollary of scientific imagination. Similarly, Polke's cavalier way with the means of art, his sarcastic shamanism, becomes charged with dignity in face of what it both enacts and counteracts, namely the disintegration of the self in a hypertrophic culture. Polke evokes a sort of organic heroism, a heroism without heroes, by which consciousness turns the tables on its enemies. It may not count for much in the larger scheme of things, but this Polkean defiance remains a touchstone of art's always provisional capacity to sustain a hope and an appetite for the future.

Notes

1. Oscar Wilde, "The Critic as Artist," in *The Portable Oscar Wilde*, edited by Richard Aldington and Stanley Weintraub (New York: Penguin/Viking, 1946), 105.

This is a revised version of an essay for the catalogue of a Sigmar Polke exhibition at the Mary Boone Gallery, New York, in 1985.

POLKE IS AN
ARTIST'S ARTIST

Compare a similar artist's work to Polke's and it looks stiff and labored. His work emanates the stuff of life—it's music.

His work is a font of ideas. Any one move can provide a career for a lesser artist. He is a font; a treasury.

The roller-coaster ride he takes one on with various stops for high and low culture is unpredictable, brash, and irreverent.

Giotto and Matisse have long been in my pantheon. I'm thinking of adding a third—Polke. He makes me glad that I'm an artist.

REINER SPECK

ON THE DIFFICULTY OF
APPROACHING SIGMAR POLKE

Estragon: *What exactly did we ask him for?*
Vladimir: *Were you not there?*
Estragon: *I can't have been listening.*
Vladimir: *Oh . . . nothing very definite.*
Estragon: *A kind of prayer.*
Vladimir: *Precisely.*
Estragon: *A vague supplication.*
Vladimir: *Exactly.*
Estragon: *And what did he reply?*
Vladimir: *That he'd see.*
Estragon: *That he couldn't promise anything.*
Vladimir: *That he'd have to think it over.*
Estragon: *In the quiet of his home.*
Vladimir: *Consult his family.*
Estragon: *His friends.*
Vladimir: *His agents.*
Estragon: *His correspondents.*
Vladimir: *His books.*
Estragon: *His bank account.*
Vladimir: *Before taking a decision.*
Estragon: *It's the normal thing.*
Vladimir: *Is it not?*
—Samuel Beckett, *Waiting for Godot*

In 1981 the gallery owner Erhard Klein exhibited a new work by Sigmar Polke at the Cologne Art Fair. It was an eye-catching work in more ways than one: its tremendous quality was at once apparent to many people who saw it, even though most of them found it unsettling; its price was exceptionally high, which, initially at least, discouraged a number of those who might have thought of buying it; and the curtain material that served as a background was arranged in such a way that it hung down, monolithically, over the lower edge of the frame.

My decision to buy the painting was made in a matter of seconds, but all I could do at that time was reserve the work with a little green sticker until the artist himself had assessed my eligibility and signaled his approval. Until then, the dealers would go on wrangling, the critics would trade in rumors, and other collectors would whisper among themselves. A pitying smile was one trade journal's response to the price I had had to pay. In arriving at the asking price, the artist appeared to have doubled his age and added three noughts: I needed nearly as many 1,000-mark notes as the century itself was old. Since then the painting—*Tischerücken* (Moving Tables)—has been on the move, scarcely ever coming to rest in my own collection but appearing at exhibitions in countless public and private galleries on all five continents. This in itself was enough to inspire me to start saving up once again and to look for another of Polke's paintings, for the twenty or so of his other works that I already owned were clearly in need of company: comparisons had to be drawn and a critical confrontation made. The plan was as simple as it was naive, the difficulties great and insurmountable, as the following account of my seven-year struggle will show.

After 1983 Polke's older and more recent work could be seen at a series of major exhibitions in Rotterdam, Bonn, Berlin, Zurich, Cologne, New York, Venice, Mönchengladbach, Paris, Düsseldorf, Amsterdam, and Baden-Baden. . . . On the evening before the official opening I would look at the works that were on display and generally note down some half-dozen titles still labeled "Collection of the Artist," both signaling my interest and reminding Polke that I was still on his trail. In the course of the following day I would keep going back to the exhibition, but my earlier uncertainty about the significance of the works I had earmarked was certainly not diminished. Indeed, the labels that indicated their provenance often seemed to have been replaced by some invisible hand. Knowing that, for Polke, there could be no question of good or bad paintings but only of increasing understanding or else of continuing blindness, I finally sent him a list of my

secret desires. "There is a kind of understanding that does not exclude the freedom of choice," Jean Starobinski once said when discussing the subject of skepticism.

My stratagem seemed to me all the more sensible in that all the artist's gallery exhibitions were sold out weeks in advance (the hyenas are generally already present whenever I have to visit a patient), and it is, in any case, easier to make a rational choice in the calm, contextualized setting of a museum or municipal gallery than it is at a private showing. Agonized choice is a necessary part of collecting. I wrote to Polke, drawing my bow at a venture. I suspect that the letters wound up in Pandora's Box, since the cover address was a woman's. . . .

Motivated by desperation as much as by temerity, I assumed the artist knew the reason why he refused my requests. Impertinence and adoration spurred me on in my all too predictable actions: I went to Polke's exhibitions, drew up my list, and wrote him begging letters. A suitable moment seemed to present itself when, at a vernissage, I managed to draw him aside and question him on the subject, but he answered with a sardonic smile and said he had never been fully "conscious" of what it was that I wanted. The truth about an artist reveals itself in his works, but Polke hides his untruthfulness behind that camouflage which, recurring with leitmotivic regularity, gives his works their sense of style.

This raises the question to what extent the artist's life has left its mark on his art. Is Polke's life revealed in his works? In the case of Marcel Proust, this problem has been discussed in hundreds of learned papers and doctoral dissertations that involve their authors in snuffling under the bedclothes. In the case of Polke, by contrast, it needs no more than a glance at his pictures to see that, although he confronts us in person here, it is, for the most part, to disappear behind them once again. If we know the lines on the palms of his hands, it is through his images, not through the chiromancer's art. His name may be written in the stars, but all we can see of the artist himself is the head that is poked through his *Scissors*, a thoroughly tautological work. Does

an artist have to emerge even *more* from his work before we can make head or tail of it?

The self-pitying way in which writer after writer of reviews and catalogue essays complains of Polke's invisibility seems to confirm the suspicion that the critics in question believe they have to shake the artist's hand before they can understand him. "Sigmar Polke is hard to catch." "Polke likes going away on long journeys. He likes to be off and away." "Looking for Polke is quite an adventure." "He is always running away from his follower and from his shadow."

Only rarely does the critic demand that the artist keep his appointments and act as his own interpreter. His unattainability and the game of hide-and-seek that he plays then become part of a *nouvelle critique* approach to his works. Paul Groot has spoken of the way in which Polke, fleeing from his own past, has become a father figure for a whole generation— even if that generation is now decidedly elderly. And Katharina Hegewisch is altogether ambivalent in her assessment: "For, unlike many of his colleagues, this artist is not predictable." How gratifying it is, then, to stumble upon a sentence that Werner Hofmann wrote some thirty years ago, when Polke first became a father, a sentence that defends those qualities that have always been the prerogative of the creative artist: the dignity of seclusion and the right to be unapproachable.

It was clear from what others had written on Polke that I was not alone in feeling frustrated. But it gave me little comfort to know that my reasons for trying to track him down were quite different from those of the army of hacks and reviewers that dogs his every step. Critics and collectors should, of course, be satisfied with the works themselves, but the collector needs to own them first. The true connoisseur must be able to choose, for otherwise collecting amounts to no more than hoarding things at random. On the other hand, the artist has a right to know where his works end up, for it is only outside the studio that the arbitrary nature of context becomes at all significant. Sometimes the creative act lies in bypassing exegetical apparatus

and placing the work in the peaceful setting of a private collection, a "launch" which guarantees the virginity of the work of art at least a little longer. After all, the fewer eyes to which it is exposed, the longer it remains verifiable.

Time passed, and I continued to visit Polke's major exhibitions, the unattainability of my ambitions adding to my depression but not yet inducing terminal resignation. For a while I took my cue from Franz Kafka and signed my letters with the letter *K*, but still failed to get through to the Other Side. It was both mystifying and unsettling to discover that the paintings to which I thought I had a claim were suddenly not in the artist's collection any longer. Instead, they were labeled "Raschdorf Collection"—a collection which, completely unknown till then, had overnight acquired a series of paintings by Polke, but not by anyone else. What mysterious links might there be between the lists I'd drawn up of works that I myself wanted and the greater portion of these marvelous paintings that appeared to have landed, as though by magic, in the hands of this apocryphal person who must have known my letters? The immensely high quality of these key works would often remind me of my *Tischerücken* and make me suspect that some higher being must be involved, someone whose pseudonym had already struck me on reading some early catalogue essays which, among the best of their kind, were the work of a writer who never had to complain of not having met the artist. . . . Suspicions which I thought I would have to take to the grave with me were confirmed by the sight of a dedication that issued from the darkroom: the catalogue of a photographic exhibition in Baden-Baden was dedicated to the photographer Else Raschdorf.

Still I refused to give up, though, given the artist's worldwide fame, I thought that I now stood little chance of succeeding. Rumors were rife of lengthy waiting lists, shady deals, and even outright corruption. There were said to be seven prospective buyers for every painting that Polke had not even started. Attempts to make contact by means other than letter seemed to be ruled out, not least because,

although my goal remained out of reach, I felt only sympathy for his wish, as an artist, to remain unattainable. A telephone call was out of the question for reasons of Proustian *politesse*, which demanded that calls be announced at least five days in advance by means of a *petit bleu*. After all, it might disturb him while he was eating, sleeping, writing, painting, or talking to Raschdorf.

Instead, I made a habit of going past Polke's studio every couple of weeks, after I'd called on a patient who lived near the artist's atelier. Even when my patient died, it remained a favorite pastime of mine to cycle round the rectangular inner courtyard that was bounded on its left-hand side by a two-story warehouse where (according to rumor) Polke sometimes worked and stayed. To the right were a number of rooms that were occupied by a Yugoslav family, but the rest of the building was given over to car mechanics, furniture restorers, scrap-metal dealers, and paint-spraying workshops. Since the stench of Polke's experiments with arsenic was mixed with the smell and the noise of this local light industry (the lethargy of the small community suggesting alchemical poisoning), it was never possible to say for certain whether the artist was working there. They came to tolerate me, growing used to me as an intruder who would cycle up and down only once, for no apparent reason, shouting out a friendly greeting but never knocking at any door. In the half-light some of these people looked like figures from Polke's paraphrases of Goya as they squatted on chairs or crates or old car seats. For me, they were well-known figures whom I came to like: I met shady secondhand car dealers, manual workers, my former cleaning lady, a man named Gohr who had lost his leg, a nursing sister, carpenters, patients, a man who was mentally ill, an unknown collector, and Hermann Kreuz—but never a sign of Sigmar Polke.

Walter Benjamin was not the first to realize that everyone who is a collector leads a life between chance and systemization. Only posthumous research will reveal which of these was the dominant factor when I built up my own collection. I knew that

24

Polke knew of my obsession. I knew he had not misunderstood what I meant when I let slip a saying of Beaumarchais's: "With goods of every kind, what matters is not to possess them but simply to enjoy them." And I also knew, of course, that Polke allows himself plenty of time for good paintings, just as every good butcher allows his beef to hang before putting it on sale. "Polke leaves his pictures sagging for months on end in a horizontal position, using them as containers for whole lakes of varnish," Harald Szeemann wrote at the time of Polke's Zurich retrospective.

To the freaks and monstrosities in that courtyard, my routine visits must have seemed like rounds of inspection made by someone planning to close down the building, though my aim was in fact to find a secret opening. And then, one day, in the course of one of these visits, I found the studio door ajar. I hesitated for a very long time before going up—not because I had already fallen down the steep steel steps on a previous occasion, one cold winter's evening, when they were covered in ice, sustaining extensive bruising (and nursing an injured foot for some time afterward), but because I felt inhibited, like Parsifal in the presence of the Grail. I remembered all of Gurnemanz's warnings—but even before I knew what I'd done, I was standing at the top of the stairs: *on frappe à la porte*. "Herr Polke!" Silence. "Pooolke!" Nothing. "Artist!!" All was quiet as the grave.

I was turning to leave when I noticed him at the foot of the stairs. The artist himself, with Hermann, his Cerberus. He ignored the figure standing there, though I knew that he had seen me; such was my respect for art, he knew I would not have set foot in the room; and I knew that he was the only man who sees everything from behind his glasses but who does a good impression of someone who is blind. His camouflage achieved a high point here— no doubt he was hoping to see the collector flee empty-handed.

But then—he falls upon his works in progress, climbing over them, even destroying them, showing the nervous collector unfinished paintings, others

that have been rejected, and yet others that are experimental. He destroys iconographic memorabilia in the collector's presence, his gestures and affected behavior evoking certain associations. He then proceeds to overturn them, disowning them and snubbing them, juggling with them and satirizing them, disillusioning the spectator; if he builds up one's hopes, it is only to dash them down again. (Hermann grins his approval, a knowing conspirator, helping to form and complete the little scene.) Politely but firmly Polke escorts his frustrated visitor over to the doorway, which has all the time remained open. All at once we are back at the foot of the stairs, hurrying past the other occupants, who for years have observed my bizarre behavior and who suddenly all appear in the courtyard, as though on cue, to witness the scene. After running the gauntlet of their prying eyes, we come, as though by chance, to a warehouse. Fixed to the door—I can still remember it clearly—is a notice with the single word *Ruhrkohle*. The floor is unsafe and covered in clay, patches of oil, dirt, and a few dead mice; and *four paintings*, two of which have been arranged, as though by chance, to catch the light of a watery sun that filters through the grimy window: *entrons avec lui la cathédrale!* After this purgatory, stunned silence on my part, furtive observation on theirs, no one says another word. I look more closely. A seemingly insignificant movement to the four huge paintings (all of them similar in format) has the effect of an ordered rehanging: familiar fragments from Polke's work appear as part of their composition. Has the collector just been prevented from being the victim of a game of hide-and-seek that Polke plays with all who write about his works? No one could describe or catalogue these works in such a short space of time, no one could pass a definitive judgment on them: at the very next encounter it would, I am sure, be different. Polke never dips the same brush into the same pot twice. The pictures which are "simply *found*" and of which he speaks in connection with the creative process associated with his most recent works are—as I discovered on this occasion and as I shall never

forget—the result of a brilliant act of calculation. Only now do I know when paintings are finished.

I go on secretly adding to my list of desiderata, though I know that these paintings will be packed up tomorrow and sent to San Francisco, after which they'll be seen in Washington and Chicago, and, after that, in New York. And on each occasion they'll be marked, "Collection of the artist." Did anyone ever succeed in getting hold of Picasso's Picassos?

Translated from the German by Stewart Spencer.

MICHAEL OPPITZ

OCHER describes how pictures can become invisible.
GOLD contains an old formula for turning natural substances into gold.
CINNABAR AND INK deals with the links between terms that are used to describe a kinship system and ones that are used to classify colors.
TURQUOISE tells the tale of the man who spewed gold and the man who spewed turquoises.

OCHER

A number of years ago I made a remarkable discovery. I was staying at the time in a Himalayan village which I had chosen for the purpose of an ethnographic study. As is so often the case, there was not a lot to do there. In order to while away the time, a few of the villagers who had gravitated toward me and I began to leaf through a magazine. These magazines were extremely popular with the local inhabitants, since they gave them their first brief glimpse of the outside world that was my home. The photographs that they found there—American skyscrapers, women dressed in the latest fashions, and cigarette-smoking cowboys in an American Wild West setting—aroused my hosts' curiosity, prompting all manner of questions which not infrequently encouraged me, in turn, to ask new questions about the world in which they lived. One of these magazine articles dealt with Neolithic cave paintings that had recently been discovered in France. On seeing these Stone Age figures hunting and dancing, one of the men who was standing beside me murmured in passing, "We've got the same thing here!"

The following morning my guides and I set off up a steep mountain slope until we reached a rocky ledge open toward the north. And there, protected from the sun, there were indeed a number of figurative shapes painted on the ocher-colored stone: hunters bringing down game with their bows and arrows, couples dancing, emblematic animals, and a figure beating a drum—"the shaman," they said in a single voice. The sienna outlines stood out distinctly from the ocher ground of the stone. Both stylistically and in their subject matter, these drawings resembled the ones which, at better excavated sites, have been described as *Neolithic*. It was a genuine discovery, I thought, since archaeology had not yet registered the existence of drawings such as these in the inaccessible vastnesses of the Himalayan mountains. And so, with my guides' consent (they were pleased to have shown me something new), I set to work and systematically photographed all these unknown petroglyphs in black and white as well as in color, and with and without a flash.

A few months later I had the photographs of these drawings developed in a German laboratory. Imagine my amazement on discovering that, apart from the rock face itself, nothing at all could be seen. The figurative drawings had disappeared. Assuming I must have made some technical error, I repeated the whole operation on my very next trip to the Himalayas, retaking the series of photographs with even greater care but again with exactly the same result: the Stone Age pictures remained invisible.

With a look of disquiet on my face I told my hosts of the puzzling change, but all they could do was laugh at me: "It's obvious. Those, after all, are no ordinary paintings. The marks there were left by Chita, the goddess of the rock, by her alone. They're painted in her blood. They can't be so easily removed from the place that's consecrated to her."

I did not photograph the prehistoric drawings a third time. It will be enough for me in the future to have captured the monochromatic ocher rock face that conceals the goddess's sienna-colored drawings.

Later, when an Italian friend of mine succeeded in taking a series of photographs in which the prehistoric drawings in the goddess's mountain retreat were plain for all to see, the villagers laughed at me again: "It's obvious. You're not her. If the wood is damp, the fire goes out and the wood remains. Only dry wood is burned by fire, and none of the wood remains."

GOLD

According to a two-thousand-year-old pun involving letters from the Chinese alphabet, the grandfather of gold is lead, while his younger brother—the father's youngest son—is silver. The proverb plays on the association of the characters *qian* [鉛], which stands for lead, and *yin* [銀], the sign for silver. Both contain the component *jin* [金], the character for gold. The phonetic element *gong* [公] in the sign for lead means "head of a household, grandfather," while the phonetic element in the sign for silver, *gen* [艮], is one of the eight trigrams corresponding to the "youngest son." But this play on words is more than a simple game with characters from the Chinese alphabet. It also recalls an ancient practice, the creation of gold and silver from lead.

Attempts to manufacture gold by artificial means stretch back in China to the third or even the fourth century B.C. The oldest written record to deal with the transmutation of natural substances into gold—aurification and aurifiction—is an edict issued by the Chinese emperor Jing Di dating from 144 B.C., in which public execution is prescribed as the punishment for those found guilty of counterfeiting gold or producing it by artificial means. The art of making gold, passed on above all by Taoist alchemists in the form of a secret science, was based on a long tradition of metallurgical experimentation, though its aims were less economic than macrobiotic, one might almost say transcendental. It was not to enrich themselves personally by heaping up and hoarding the precious metal that generations upon generations of protochemists immersed themselves in experimentation. Rather, it was to produce an artificial, consumable gold that would help them

prolong their lives or even obtain the *elixir vitae* itself. The ingestion of gold, or merely the eating from golden vessels, was said to produce the very qualities that were ascribed to the metal itself, namely, beauty, purity, and durability.

Thus the famous historiographer Sima Qian, writing at the court of the emperor Wu Di, describes the alchemists and magicians who were active there: "By making sacrificial offerings to the spirit of the kilns, *ci zao*, it is possible to transmute natural substances. If one can effect the transmutation of substances, one can also turn cinnabar into gold. Once one has produced gold in this way, it can be reworked as eating and drinking vessels which will prolong the user's life." There is no doubt that initially the artificial production of gold did not serve Mammon but was one of the means of achieving immortality. This is clearly stated by Go Hong (A.D. 282–343), a leading Taoist in his day and the most important writer of alchemical texts of any period. He was notorious for turning down his emperor's offers of patronage, which he declined with the words, "I am looking not for a great career but for the secrets of the elixirs." In the end his search persuaded him to accept the post of a minor magistrate in the distant province of Annam, for it was there that considerable quantities of cinnabar were found.

The following formula for manufacturing gold was written by Go Hong himself [transmitted to us by Joseph Needham]. Cinnabar plays a central role in it:

First take any desired amount, but not less than five catties, of realgar obtained from Wu-tu, vermilion in colour like a cock's-comb, lustrous and free from bits of rock. This is pounded to powder and mixed with ox bile and heated until dry. Take a red clay pot (fu) with a capacity of one peck (as the lower part of a reaction-vessel), spreading crude Kansu salt (jung yen) and blue vitriol (shih tan) in powder form all over the inside to a thickness of three-tenths of an inch. Then put in the realgar powder, (spreading it) to a thickness of five-tenths of an inch, and placing more of the salt (mixture) over it until it is completely (covered). Next spread on top of this a layer of pieces of hot charcoal, about the size of jujube-date stones, two inches thick. The pot must be smeared all over outside with a lute made from the earth (excavated by) earth-worms and crude salt. Another pot

28

is then inverted over (the lower one) (to form the reaction-vessel), and all the outside smeared with lute to a thickness of three inches so that there can be no leaks. After allowing the whole to dry in the shade for a month it is heated in a fire of burning horse-dung for three days and three nights. When cool, remove the contents (and place it in a smelting furnace), then work the bellows to liquefy the copper (ku hsia chhi thung), and it will flow like newly smelted copper or iron. This copper(-like) substance is then cast into the shape of a cylindrical container (yung), and filled with an aqueous solution of cinnabar (tan sha shui). This is again to be heated in a horse-dung fire for thirty days and then (the contents) taken out, pounded, and smelted. Two parts of this with one part of crude cinnabar added to mercury will immediately solidify it into gold. It will be bright and shining with a beautiful colour, fit for making into nails or ingots (ting).

The powdered cinnabar had first to be placed in a sealed bamboo container with saltpeter and copper sulfate, the whole thing plunged into strong vinegar, and buried in the ground for a month. The solution which was produced, red and bitter, must have contained anions [negatively charged ions] of mercury, copper, and potassium, together with cations [positively charged ions] of sulfate, nitrate, acetate, and arsenic. The vessel in which the mixture was heated would be made of an alloy of copper and arsenic, so that it would corrode during the lengthy heating process, causing more and more copper and arsenic to enter the solution. The subsequent smelting process presumably produced a copper containing sufficient arsenic to give it the color of natural gold.

CINNABAR AND INK

In Tibet painting is reckoned as a branch of science (*rig gnas*), an intellectual activity far removed from the intuitive expressions of the mind (*nang rigs*). In consequence it is on a par with grammar, rhetoric, mathematics, medicine, astrology, and cosmology. Its links with cosmology are particularly close in that almost every kind of painting expresses fixed ideas concerning the cosmos using an equally fixed iconology and color symbolism. Painting is a projection on canvas of the celestial world. "To describe gods," *lha bris*, is a Tibetan term for painting. The painted surface of the picture is a "mirror" (*me long*) of the universe. The scroll painting or *tanka* which the observer contemplates serves a transcendental purpose, raising him momentarily out of the cycle of his earthly existence and freeing him from the world of samsara [life cycles] through the act of seeing. "Liberation through seeing" (*mt'ong grol*) is therefore a term still used in discussing Tibetan painting. In this type of painting, subject as it is to liturgical and ritual principles, the artist has no freedom of choice in creating his subject. Indeed, even the choice of the colors used is dictated by theological rules.

At various stages in their history, the Tibetans have classified colors according to varying points of view. Sometimes cosmological associations came to the fore, at other times sociological ones, and, yet again, simple pragmatism. Among the oldest classifications are those that reflect a pre-Buddhist conception of the origins of the world. One of these color classifications is contained in an anthology of the Bon, the *klu 'bum*, where the origins of the different colors are closely bound up with the genesis of natural phenomena, including metals and human classes.

In the beginning was the void. From out of it came Tongpa and from him there shone forth a light of every color filling the whole of the universe. Then there arose a wind, and a circle of fire, and from them emerged a further fire and water; from these in turn there issued the ocean. On the ocean a tent of foam was formed inside which a golden turtle was born. It laid six eggs: a white one of rock crystal, a yellow one of gold, a blue one of turquoise, a red one of copper, a dark one of bronze, and a black one of iron. From each of the eggs there hatched a different race of klu beings:

from the yellow egg of gold came the family of kings or rgyal rigs;
from the black egg of iron the caste of Brahmans, bram ze rigs;
from the blue egg of turquoise the lowest caste, dman rigs;
from the dark egg of bronze the caste of Untouchables, gdol rigs;
from the red egg of copper the animals; whereas no species at all emerged from the white egg of rock crystal.

The six cosmic eggs, each of which was allotted its own color quality and, at the same time, its own independent social function, reappear in an old popular tradition of Ladakh. In this variant the people of Ladakh find themselves in possession of six different birds, each of which sits on a different limb of the world tree, which branches out six times from three intersections along its trunk:

on the first branch sits the great k'yung
or garuda bird with a golden egg;
on the second sits the rgodpo *vulture,*
the king of the birds, with a turquoise
egg;
on the third, the gopo *vulture with a*
white egg the color of a conch;
on the fourth, the eagle or glag *with a*
silver egg;
on the fifth, the divine white grouse with
a coral red egg;
on the sixth, the white falcon, k'ra skya,
with an iron egg.

The six birds on the world tree are guardians watching over the six cardinal points, East, West, North, South, Above, and Below. In this way the six original colors are additionally associated with the points of the compass: the East with the whiteness of the seashell, the West with turquoise blue, the North with the blackness of iron, the South with golden yellow, Above with silver, and Below with coral red.

Another way of classifying colors which is still very common today proceeds by analogy with kinship terminology and survives in the writings of the polymath Sum-pa mkhan-po, who was born in 1704, the year of wood and the monkey. According to this classification there are seven father colors, one mother color, fourteen son colors, two sister colors, and one maidservant color.

The list of father colors comprises: (1) azurite, *mthing*; (2) malachite, *tshon ljang*; (3) minium, *li khri*; (4) cinnabar, *mtshal*; (5) orpiment yellow, *ba bla*; (6) maroon, *skag*; (7) indigo, *rams*. The mother color is chalk, *ka rag*. It is striking that the names of these parent colors are not colors in themselves but names of minerals, pigments, and dyestuffs. In other words,

they refer not so much to finished colors as to the ways that colors are produced. These are the natural elements of Tibetan primary colors.

At the same time, azurite stands for blue, malachite for green, minium for orange, orpiment for yellow, maroon for brown, indigo for violet blue, and chalk for white. With one exception, the seven Tibetan father colors coincide with the seven prismatic colors in Newton's theory of color: in place of the Tibetans' maroon (a dyestuff), Newton has the Western primary color of violet. The non-color, or sum of all colors, white, is the mother color for the Tibetans. By mixing it with the primary or father colors, the son and daughter colors are produced, in other words, what we in the West call secondary or accidental colors.

The fourteen son colors are made up as follows:
1. *azurite blue (father color) is mixed with (+) an equal part of chalky white (mother color) to produce (=) the son color bright blue or cobalt blue,* sngo skya;
2. *azurite blue + chalky white (in a larger quantity) = mountain blue or lapis lazuli,* sngo se;
3. *malachite green + chalky white = May green or pea green,* ljang skya;
4. *malachite green + chalky white (in a larger quantity) = whitish green,* ljang se;
5. *minium + chalky white = whitish orange,* li skya;
6. *minium + orpiment = orange-yellow,* li ser;
7. *cinnabar red + chalky white = pink,* dmar skya;
8. *cinnabar red + chalky white (in a larger quantity) = flesh colors,* mi sha;
9. *orpiment + minium + chalky white = creamy saffron,* ngar ma;
10. *orpiment + indigo = greenish yellow,* ljang ser;
11. *maroon + chalky white + ? = the color of lungs,* glo kha;
12. *maroon + chalky white + cinnabar + indigo = bright mauve,* mon kha;
13. *indigo + chalky white = the color of leather,* mchin kha;
14. *indigo + chalky white (in a larger quantity) = bright indigo,* rams se.

It is clear from the combination table for the son colors that in the majority of cases the "sons" are in fact produced by an exclusive mixture of father and mother colors, with the amount of the maternal portion determining whether an older (darker) or younger (lighter) son is the outcome. In individual

cases (Nos. 9, 11, and 12), more than one father is involved in producing the son, whereas there are two instances (Nos. 6 and 10) in which no mother at all is involved: the son is the product of two fathers.

The two daughter colors, which may be regarded as sister colors or *sring mo* when seen from the perspective of the son colors, are produced by mixing together the following colors:

1. *cinnabar pink + yellow + inky black + white = sister tea color,* ja kha;
2. *reddish tea color + inky black = sister smoke color,* dud kha.

If the sister colors differ from their "brothers," the son colors, it is chiefly by virtue of the fact that the mixing process is more advanced. They are, so to speak, further removed from the family line. On the level of kinship terminology, this reflects the fact that the word for sister, *sring mo*, is used sometimes for elder sisters, sometimes for younger ones, sometimes for both, but first and foremost for all parallel cousins. Like the daughters of their mother's sisters, these latter—the daughters of their father's brothers—are indeed further removed from their own line of descent than the genuine sons. That more colors are mixed together to produce the sister colors than the son colors is offset, therefore, by a greater semantic field for the word for "sister" in comparison to that for the word for "son."

The last of the colors is described as a maidservant color, *gyog mo*, and is made up of cinnabar red and ink. Just as ink serves the writer, so (by analogy) a color that is largely made up of inky components is no more and no less than a servant.

The color classification of the Tibetans draws its various frames of reference from the terminology used in their kinship system and is therefore anything other than arbitrary in terms of its borrowing or application. The classification of colors according to certain classes using the categories of kinship— father, mother, son, sister, and maidservant colors— is the result, rather, of the discovery that similar qualities obtain in both systems: the fathers are the primary colors (Tibetan society is traditionally patrilineal and virilocal, in other words, it relates primarily to the paternal line); the mother (the woman who marries into the paternal line) is the non-color that is added, a non-color, moreover, from which secondary colors issue when mixed with primary ones; the sons are directly descended from the parent colors; the sisters, by marrying out, are like cousins in that they are already half-removed from the direct line of descent, just as the sister colors result from a wider range of mixtures; the maidservant color, finally, because it includes ink, which is not a part of the consanguine relationship between the different colors, is like the servants who are not descended from the family proper.

TURQUOISE

There was once a far-off country whose inhabitants had a strange custom. Every year, when drought threatened their harvest, the farmers would offer up a human sacrifice to a gold and a turquoise frog that lived on the banks of a lake at the very border of their country. As a rule, the heavens would open and the country's inhabitants could hope for a plentiful harvest. This particular year it was the turn of the king's own family to sacrifice one of its members. In order to spare his only son, the king resolved to offer himself as the sacrificial victim. But the prince forestalled his father's wishes by journeying to the lake in place of his royal forebear. The son, however, had a good friend whom nothing could dissuade from accompanying the prince on his journey. The two men received a royal send-off before finally setting out together.

The way was long, and when they reached the banks of the lake in question, they sank down exhausted beneath a yellow willow. Scarcely had they fallen asleep when the two frogs crawled out of the lake. "Hey, look, the sleepyheads!" the gold frog said to the turquoise frog. "This time those human beings have brought us two meals in one; what a feast we'll have!" "Yes," rejoined the turquoise frog, "if only they knew that it needs but a rod cut from the yellow willow and for us to be beaten with it, and the two of us would be done for. Anyone who then ate your body would spew out gold, while

the man who ate mine would spew out turquoises." Having exchanged the time of day, the two frogs returned to the lake.

One of the friends had not in fact been asleep at all but had heard all the frogs had said, and so, without further ado, he woke his friend and told him the gist of the frogs' conversation. They lost no time in cutting two branches from the yellow willow and waited for the man-eating frogs to return. When the gold frog and the turquoise frog resurfaced from the lake, the two friends set upon them with their rods. The frogs were killed in an instant. The friends, however, remained by the lake for three more days, where they ate the dead frogs, bones and all. Thereupon they decided not to go home but to travel the world instead.

After a few days' journey through a wilderness, they came to a hut in which a painter was stirring his paints. For a while the two friends stood and watched him. First the painter took some finely ground azurite gemstones out of a small leather pouch, added them to a pan of hot water, and began to stir the mixture furiously. After the azurite had settled, he poured off the scum and the loamy water, then added a little glue and worked the mixture between his fingers. After that he added some more hot water, stirred it as before, and, once again, poured off the scum and the loamy water. He kept repeating the process until the water was clear. He then took out a mortar and pestle, added a little water, and, with regular, measured movements, pounded the mixture which, initially dull in color, soon became dark blue. "With azurite," the painter told the astonished strangers, "it is important not to grind it too long. The longer you pound it, the brighter the color will be."

The painter now reached out his hand for a second mortar—this time white in color—and added cinnabar minerals, which he then proceeded to pound. The coarse-grained powder he mixed with *arura* water, which he left to stand until a yellowish scum had formed. He then poured away this surface liquid, transferred the cinnabar to a porcelain cup and ground the contents with a gentle circular action. "If you grind in a circle, the red becomes brighter, whereas if you pound firmly from top to bottom, the powder will then be darker in color. Alas, I still lack certain dyestuffs before I can start to paint a picture." "What is it, Master, that you still lack?" the two friends asked as though with one voice. "I still lack gold and turquoise." "Nothing could be simpler," the friends replied with a laugh. And each of them stuck a finger down his throat, and one of them began to spew gold, the other turquoises. The painter was so delighted that he promised to give them a valuable picture if ever they passed by his hut again. They promised to do so and went on their way.

They came to a plateau and met a band of squabbling children. "Why are you arguing?" "We've a magic cap which makes the person who puts it on invisible, and a pair of shoes which transport the person who wears them to any place he desires. All of us want the shoes or the cap." "That can be arranged," the friends retorted. "Look," said one of them, "I've an arrow here which I'll fire from my bow; the first one to hold it in his hands will be given the magic cap." "And I," said the other friend, "will fire this white stone from my sling; the first one to find it will get the shoes."

So they spoke, and each of them took up his weapon and fired. Some of the children chased after the arrow, while others went after the stone. The two friends, however, stood close together and held the magic cap above their heads. All at once they became invisible. Since they were thirsty, they donned their newly acquired shoes, each of them wearing one of them, and wished to be taken to a tavern. And thereupon they found themselves standing outside an alehouse, miles from nowhere, that was run by a mother and daughter. "What will it be?" "We'd like a stale beer." "We don't have that. All we have here is the very best quality, freshly brewed beer. But, of course, it isn't cheap." The two friends remembered their gift for spewing out gold and turquoises. So they paid for round after round by belching out gold and turquoises in turns, until they were hopelessly drunk. Instead

of showing them to the guest room, the practical-minded women dragged our two drunkards to the outside privy and threw them into the stinking mire. There they continued to spew up gold and turquoises. One of the friends then came to his senses enough to wake his companion, and they dragged themselves off to a bed where they spent the rest of the night, sleeping off their stupor. The following day they thanked the two women for the hospitality they had been shown, and with that they went on their way.

They came to another country where the local king was trying to find a suitable groom for his only daughter. To this end he arranged a competition. Whichever one of the numerous suitors could spew the most precious object onto a metal plate would win his daughter's hand. But all the suitors merely spewed up the food they had just consumed. When the two friends spewed gold and turquoises onto the plate, all the people cried out in a single voice, "Truly, these two must be of royal descent; they are the rightful husbands." And a double wedding was held in the palace: the two friends both became the princess's husbands and they themselves became kings.

But the princess loved neither of her two husbands. Every day she withdrew to her chamber, taking a ball of wool to spin and closing the door behind her. Not until evening did she return. One of the friends decided to use the magic cap and make himself invisible, so he could follow his wife in secret. The very next morning he slipped unnoticed into the barred and bolted chamber. When the sun's first rays cast their golden light across the chamber floor, the son of a god appeared to float in with them. At once he began to converse with the princess in intimate terms and so it soon became clear for whom the princess's heart was secretly beating. Yet the son of the gods advised her to choose her earthly husbands in preference to himself, saying that he would return the following day in the shape of a bird in order to test her two husbands. This whole conversation was overheard by the invisible gold-spewer. Without delay he informed his com-

panion, the turquoise-spewer, of all he had heard, and together they made up their minds to put their rival out of the way.

The following morning the princess went out and stood beneath a large tree by the gate on which the son of the gods had alighted in the form of a beautiful bird. Suddenly he plunged to the ground and fell into a fire, but the princess was able to rescue him, singed and broken-winged. One of the friends had climbed into the tree, wearing the magic cap and invisible to all. There he had seized the bird and hurled it to the ground. The son of a god was now crippled for life and swore that never again would he set foot on earth. That very night the princess showed her two husbands that sense of submission they had hoped for when they had married her.

Time went by until one day the two friends chanced to recall the painter whom they had so much admired and whom they had showered with gold and turquoises. And so they put on their magic shoes and flew to the painter's hut. The painter was overjoyed to see his old acquaintances. He took out a picture from a drawer and unrolled it on the ground before the kings' inquiring eyes. But before they could make out what it depicted, the painter began to roll around on top of the painted scroll. And all at once he turned himself into a whinnying donkey. Then, when the donkey in turn had wallowed around on the painting, the animal turned back into the painter, still wearing the same friendly grin on his face. This was his present to the two friends.

They thanked him from the bottom of their hearts, then disappeared in their magic shoes, which brought them straight back to the tavern. The landlady and her daughter sensed that business was picking up and set a large tankard of beer in front of them. While the friends were drinking, the daughter asked them to tell the secret behind their gift of spewing out gold and turquoises. To which they replied, "You and your mother must roll around on top of this painted scroll, then you'll be let into the secret." Fired by greed and curiosity, the two women rolled around on the painting and were

turned at once into donkeys. The two friends rolled up the painting, mounted the braying donkeys, and rode them back to the palace. Once there, they had one of the donkeys loaded with wood and provisions, and on the other they placed the princess, who was now big with child, and resolved to return to their homeland. After many days' arduous traveling they came to a mountain pass beyond which they disappeared from sight. The story does not say whether they ever saw again the country they had left so long before as potential human sacrifices. It is only said that in the sky beyond the pass where the two friends were last seen a golden band of light would always form each morning and a turquoise-colored band each evening.

Sources

Hoffmann, Helmut. *Märchen aus Tibet*. Düsseldorf, 1965.

Jackson, David, and Janice Jackson. *Tibetan Thangka Painting*. London, 1984.

Needham, Joseph. *Science and Civilisation in China*. Vol. 5, part 3. Cambridge, 1976.

Tucci, Giuseppe. *Tibetan Painted Scrolls*. Rome, 1949.

Translated from the German by Stewart Spencer. A French translation of this essay appeared in *Sigmar Polke*, exh. cat. (Paris: Amis du Musée d'Art Moderne de la Ville de Paris, 1988).

KATHARINA SCHMIDT

ARROWS INTO THE STORM: OBSERVATIONS ON THE DRAWINGS, WATERCOLORS, AND SKETCHBOOKS OF SIGMAR POLKE

The scene has a disturbing effect. It concerns three men in hat and coat (*Three Men*, 1962–63, pl. no. 71). While the left one loses his profile, turned away from us, in the irregularly ripped edge of the paper—the rigid neck betrays the utmost tension—an impudent Serves-You-Right face conceals the middle one. White-gray veils intrude into the recognizable person on the right, who is presented frontally. He is the one who matters. The black arrow over his head marks him as the culprit—or the victim? He is stuck between the barred window in the background and the balustrade with its half-destroyed sign for HAMBURG in the front. A picture from the most-wanted list or a still from a spy, gangster, or emigrant movie: the dominant gray scale is compatible with the black-white pattern of a documentary photo, its torn edges indicating the haste of its appropriation, while camouflaged traces of red increase the powerfully threatening atmosphere. The space-defining lines are essential to this scene.

Yet in another sheet from these mostly non-objective early works on paper, which Polke executed in 1962–63 on newsprint, the empty ground is covered with a network of horizontal and vertical lines in watercolor (*Lines*, 1963, pl. no. 72). The slightest trace of red-orange edges the bottom of the paper and allows the image to be read as a landscape; a lofty sky appears divided up over a softly glowing, flat horizon. The relation of surface and color, of the geometric pattern and its intersection with the format of the page, and the tension between the outlined section and the colors freely dispersed over it—such things are examined in these drawings, and the boundary between the various levels of meaning they imply.

The example of the German flag (*Black, Red, Gold*, 1962–63, pl. no. 73), analogous in subject matter to Jasper Johns's choice of the American national emblem, makes clear the slippery transition from the color-field study of black-red-gold to its literal and symbolic reading. The use of cheap, unpretentious materials such as newsprint, poster paint, pencil, and watercolor correspond at this time as much with modest student circumstances as with a programmatic turning toward the reality of the surrounding society. In 1963, together with Gerhard Richter and Konrad Lueg, Polke founded "Capitalist Realism." The tattered, withering sheets that he chose to hang in their group *Demonstrativausstellung* (Demonstration exhibition) in the Kaiserstrasse in Düsseldorf throw into bold relief the scant attention paid to the durability of materials as compared to the consciousness-raising aim of the work.

Polke's drawings from the extremely productive year of 1963 form extensive and varied constellations of images, many of which the artist continued to explore in later years. Based on the materials and dimensions used, the vertical drawings done with brush and poster paint on light gray-brown kraft paper form one such group. Thematic relationships exist between *A-Man*, *B-Man*, *C-Man*, and *V-Man*—all given titles after their completion[1]—and single ballpoint-pen drawings from 1963–65; other sheets prefigure the heads of the *Duo Series* of 1965–66.

The *A-Man* is a clown with a pointed cap, a big nose, and a round chin (*A-Man*, 1963, pl. no. 76). A red slapstick floats in front of the yellow curve of his body. Six black dots dance around his head and chest, as if they had flown off his jacket; a blue mark that goes right across his gaping face keeps everything suspended. Precisely playful, Polke uses

dots, lines, and planes, and yellow, red, and blue in such a way that the outlined figure also stands as a metonymy for his own metier and therefore can be read in the context of both the critical and iconographic traditions.

Other large drawings on the same kraft paper encompass traumatic situations, which Polke pointedly represents in large heads turned toward one another. The example of the mother-child relationship works formally through the comic effect of the distorted relative sizes of the figures and, in terms of content, through the confrontation of domineering reprimand and hopeless perplexity (*Mother and Child*, 1963, pl. no. 74). The three eyes with black pupils—glowing red—underline the psychic inferiority of the child. They dominate the sheet as signs of the alienating rage of the mother and the totality of her all-encompassing powers of observation. The fact that by her presence she comes into our line of sight takes the edge off the drama and draws her behavior into the realm of the laughable. In the example from the relationship between the sexes, marked with the man's bared teeth and his black chin thrust forward, it is clear who has the last word (*Pair*, 1963, pl. no. 75). In her embarrassing situation the woman with flushed cheeks is rendered silently defiant. In both of these drawings the few brush-drawn lines of red, red-brown, and black, or red, yellow, and black serve to outline the faces and emphasize the important features. The caricatural exaggeration of human relationships is concentrated here on basic situations and emotional states; these are expanded and differentiated in terms of both content and context in the later *Duo Series* and in the *Heads* of 1965–66.

Today the best-known and most extensive grouping in Polke's early graphic work is doubtless the ballpoint-pen drawings he made beginning around 1963 and continuing to the end of the decade. An affinity for commonly available materials corresponds to a thematic turning toward the everyday and the consumer world. In Düsseldorf during the period of reconstruction Galerie 22, founded in 1957 by Jean-

Pierre Wilhelm, provided for the art world a great deal of information garnered from its international program. The work of Cy Twombly, first shown in Germany at Galerie 22 in 1960, made a lasting impression on Polke. The way in which, in certain of his early works, Twombly took into account the graphic potential of public places, including both public bathrooms and natural settings such as lime trees seen on excursions, turned Polke's attention to the psychic content and expressive quality of obsessive inscriptions. In an apparently amateurish way Polke began to depict objects and scenes. The first drawings, made up of haphazard, thin double lines, offer a representative group that describes the rapidly growing needs of the Society of the Economic Miracle: crispy baked goods (*Buns* 1965, pl. no. 85), endless strings of spicy sausages, rich pralines (*Pralines*, 1963, pl. no. 79), swinging parades of shirts and socks (*Shirts in All Colors*, 1963, pl. no. 80), columns of hairspray cans, and *Sparkling Wine for Everyone*. The verbal clichés copied from posters and small announcements take on a shabby, fragile, immaterial appearance, due to the fine blue ballpoint-pen lines and occasional light coloring (*Richter: Starting September in a Theater near You*, 1965, pl. no. 82 and *Slimming through Richter*, 1965, pl. no. 83). They express the privations endured and the astonished contemplation of a sudden newfound abundance. Deprivation and riches occupy the opposite ends of the comic seesaw, and neither one seems willing to give up the game.

Although all these drawings function as autonomous objects, they often represent ideas or concepts for paintings, plans for projects, notes for actions. The pages of the ring binders with Polke's clippings foreshadow lengthy and painstaking preparation and the various stages of the genesis of completed works. For example, comparison of the drawing and large-format painting with the inscription WHY CAN'T I STOP SMOKING? (*Why Can't I Stop Smoking?*, 1963, pl. no. 81) reveals an interesting step between the two. The motif comes from an ad for an effective treatment for drug addicts. All the pain of the futile effort appears to flow into the multifarious lines

36

and marks of the written band. The large *I*, directly over the crown of the head, points to the heart of the matter: the strong-willed chin, closed lips, the tie—the attributes of macho virility—amount to nothing in the face of this piercing, unanswered question. In the painting the writing diminishes in importance compared to the life-sized head. The black, carefully formed hair, the melancholic slanting brows of the reformer, his burning red mouth, and the thin lines of the dangling tie all join to express the physiognomy of a failure, which would have been a credit to Zeno Cosini and his delusion of the *L.C.*, the last cigarette.[2] The uneasy question seems to be carried off into pure rhetoric!

Polke occasionally uses spare marks of watercolor to break up the cool, blue color quality of these drawings. Made with the uncommon art tool of a ballpoint pen, they work essentially with the hard contrast between fine lines and liberated space. A large field covered with energetic watercolor dots (*Dots*, 1963, pl. no. 86) makes one forget to track the distribution of colors through its vibrant interplay. The expanding format in the profusion of the watercolors and brush drawings from 1965 to 1969 corresponds to the growing variety of themes and stylistic experiments in Polke's oeuvre. Nothing hinders the free manipulation of time and space, of styles and their historic influence, of the invention of images and the use of an iconographic tradition.

Every night a surrealist poet hung on his door a sign that said, "Le poète travaille" (The poet is working). With this device he pointed to the unfettered, creative power of his dreams; René Magritte collected photographs of his artist friends with closed eyes, assembled around a central woman.[3] One of Polke's most beautiful watercolors, the large head from 1967 (*Woman's Face*, 1967, pl. no. 91) takes up the motif in this new tradition that goes back to Odilon Redon and Giorgio de Chirico. Instead of presenting a frontal view, however, he gives us the head in a three-quarter profile turned to the right. The fluid lines of ear and hair, the closed lid with the long, spread-out lashes, and the triangles, rectangles, and pencil marks loosely

arranged around the chin and neck as if a flattering ruffle, pay a debt to the large-featured heads Picasso made in the late thirties.[4] That the pink nose can snake its way up from the pale tasting pan of a mouth like a captivating aroma and the sleeping one can appear as an allegory of the senses is Polke's own variant, with which he amusingly escalates our comprehension of the mysterious experiential intensity of the entranced. The complementary ensemble of pale lilac, green, and gray tones has the power to characterize distance and the sensual presence of the dreamer in a subtle way. The picture is reminiscent of Polke's witty praise for the creative powers of the potato sprouts budding in the very same colors.[5]

Two sets of drawings are grouped on the basis of their subject matter, which corresponds to a fairly unified choice of materials. One set of watercolors is made on notebook paper, and the other has a representative size of 1000×700 mm. They deserve special consideration. The first group comprises brush drawings from 1966 to 1968 on white and pink foolscap that were first discussed by Hagen Lieberknecht;[6] the other group comprises the *Heads* and *Duo Series* from 1965–66.

Lieberknecht first of all undertook to classify the brush drawings, which he set forth in the following way:

The brush drawings on show here involve a network of relationships, as the titles of the various groups infer: their names, "Baroque Group" (ten drawings, ca. 1966); "Contemporary Pictures" (four drawings, 1966); "Capriccios" (four drawings, 1963–65) [Capriccio 2, pl. no. 84]; "Chancellory Pictures" (six drawings, before 1968); "Transitions" (thirteen drawings between 1965 and 1968); "Solutions" (seven drawings between 1966 and 1968); "Paste" (three drawings, 1967), were not coined by the artist, but result from an analysis of how they are understood.

The "Baroque Group" is so called because it displays baroque motives and tendencies. The next pictures—a series which could be continued in abundance—are called "contemporary" because they are a repository for trivial forms of the 1950's; "Capriccios," because they are the most freely drawn, the most surprising and indeed the most capricious of the drawings in this exhibition, although not independent. Six of them are called after the paper and after their relationship to the baroque group

"Chancellory Pictures-Vegetal-Baroque." The largest group, after all, is called "Transitions," partly to give an idea of the problems of terminology. Finally, the pictures covered by the grand title of "Solutions" are enchanting designs and preliminary sketches for pictures which, executed or not, indicate the independence and prevalence of what Sigmar Polke sees.

The project for Zwirner's cellar (*Potato Pyramid in Zwirner's Cellar*, 1969, pl. no. 92) serves as an example of a drawing for the works in which Polke uses the principle of peg games and an actual trellis.[7] This combination of an open garden house—and pyramid—evokes an ironic association with spontaneously regenerative creativity. The potato, that universal food, amorphous in form, plain in appearance, humble in proportion to its powers, appears as the quintessential symbol of creative energy.

The bulbous form and the Rhenish colloquialism *Kartoffelkopf* (potato head) are responsible for the fact that today various series of drawings with two life-sized and over-life-sized heads are subsumed under this term of abuse. While several works bring top politicians with round faces together in dialogue, others take up the theme of intimate male-female relationships (*Kiss, Kiss*, 1965, pl. no. 90). The aggressiveness of female power is in no way inferior to the violence with which two male rivals confront one another. The delicate brush drawings transfer the typical patterns of small black-and-white magazine cartoons to life-size and over-life-size and demonstrate in this expanded way an array of comic characters: the husband met with reproach; the fat suitor with the enticing present; the passionate lover of a prudish old maid; worn-out mommies, newly betrayed; the black sweetheart; and the high hats at the end, shaped to fit over bouffant wigs. Cliché-like reduction and comic exaggeration do not distract our attention from the fact that no one has the upper hand and that even the amused onlooker will be implicated in the goings-on.

Polke's raster paintings became a kind of trademark over the course of the years. From 1963 to the present he has used the process with variations. In its proper formulation, this style is more prevalent in Polke's paintings done on a fabric support,

although he originally executed them on paper by hand and then, since the mid-sixties, with a spray gun. The earliest example of this is the portrait of Kennedy's murderer, Lee Harvey Oswald (*Raster Drawing [Portrait of Lee Harvey Oswald]*, 1963, pl. no. 70), in which Polke is less interested in the personality than in the possibility of manipulating his physiognomy by means of different screens and their shifting registration.

In a section of his 1975 catalogue essay entitled *Polke and the Great Triviality*, Benjamin Buchloh outlines the historical predecessors and the contemporary influences on Polke's work, which, compared with Polke's screen-dot works, put to artistic use "the mechanicity of the suggestive power that translates photography into the benday dot process to convey everyday, illusionistic, pictorial information."[8] Buchloh sees parallels to the divisionist painting of Georges Seurat, among others, who took a "comparable position to his craft . . . in the attempt to eliminate completely any subjective expression [in order that] effects other than simple, hedonistic + aesthetic perception might come from art." Before anything else, Polke works "on an examination of pictorial reality and its transformation of reality in the consciousness as an act of criticism of ideology in its most basic sense." This "is seen as much through the . . . principles of his choice of photographed subjects as through the process of the construction of a pictorial reality. . . . By contrast, the question of historical priority among contemporary screen paintings is simply answered: on the one hand, since Andy Warhol's first screen painting, *Baseball*, was made in 1962, and Roy Lichtenstein's benday dot paintings such as *Black Flowers* were made in 1961–62, they both unquestionably precede Polke's first dot paintings." Buchloh continues with a further argument, that Polke's first dot paintings, which he did with a rubber stamp on evenly drawn pencil lines or stippled through soldered, perforated metal stencils, are free in their "pithy, dry, security [from] influence or technical plagiarism," and refer instead to

the various conceptions and handling of an objective painterly problem. This had . . . been developed over a long period and was

38

the inevitable outcome of the evolution of the pictorial process. The primary difference lies in the production process that characterizes Polke's unique approach. In contrast to Warhol and Lichtenstein—whose conceptions of the dot paintings are already completely different from each other—Polke's dots derive from a complicated manual process of transcription, painstakingly translating each particle of the projection to form a whole picture. Lichtenstein's sections of dots in the early paintings—for the dots were only in sections, which were bounded and varied through contour and color areas—are made exclusively with stencils, and Warhol's dot pictures, such as the Most Wanted Men *series (1964), are pure, unmanipulated serigraphs, screened on canvas and later mounted on stretchers. As Lichtenstein's dot paintings are the traditionally oriented works of a classicist of pop art, the principle of the benday dots for him functioned only as a "sign" and the formal props for pictorial "modernity," which he used as a strategy against the dominant aesthetic of abstract expressionism to emphasize a painting that was emotionally aesthetic and iconographically provocative. Warhol, however, was concerned with radically advancing Duchamp's point of departure, inherent in the principle of the ready made: out of the sphere of objects into the realm of perception. In Warhol's silkscreen paintings, the single daily act of seeing and representing is declared a ready-made experience. Warhol's act leads on the one hand to the qualitative leap into conceptual art and on the other hand explains the apparent return to the easel picture, however advanced the technical means used to produce it may be.*

Polke would accept this position completely: for him the everyday repetition of mechanical representation—the shock of technical innovation as the normal experience of perception—became one aspect of his pictorial project. The rigor with which his dot paintings simulated the illusionism of the technical reproduction escalated the obvious contradiction between photographic and painterly media to the extreme. Not that the manual transfer itself would be more virtuous than Warhol's mechanical application, if anything it could make one suspect that Polke did not fully recognize the problem. (Incidentally, he gave up this technique in the mid-sixties in favor of the more mechanical stencil.) But it is the degree of differentiation of the contradiction between manual painting and the screen-dot system that generates the specific experience of Polke's dot pictures.

Dot by dot the artist deliberates. The imaginary appearance of a figure, the seeming particularity of the individual image, is dissolved into its constituent parts, which reveal themselves as the actual particles constituting the painting. Ground becomes figure. What falsely appears as everyday, authentic representation, and generally remains unquestioned and thereby begins to exercise its suggestive domination, becomes the transparent in Polke's work.

It is characteristic that Polke reworks and retouches his paintings in a long process of distillation. Thus a thorough preparation precedes the work on the well-known, specially chosen textiles, especially when the work proceeds quickly. The process involves a collection of many different kinds of materials, which has grown and changed over the decades. From mountains of everyday printed material from the sixties, the brown, red, and yellow plastic ring binders with their squared, punched sheets are transformed into primers of colorful clippings. The look created by these advertising strategists is sharply contorted. Form and content mesh as price listings are juxtaposed with hackneyed slogans and slightly manipulated short stories.

In the early eighties Polke again took up cutting and pasting in common school exercise books, though now with a changed focus. In the period from 1965 to 1970 he filled well over thirty stenographer's notebooks and exercise books with drawings and watercolors of all kinds, which, despite the variety among the individual sheets, are seen today as a significant component of his oeuvre. Hagen Lieberknecht has numbered thirty-five of these notebooks, but these thirty-five in no way encompass Polke's total production.[9] The sketchbooks that were barely noticed in Konrad Fischer's 1970 exhibition in Düsseldorf are today highly sought-after, but in the main barely accessible. Studies done in the evening, sketches of ideas, first jottings, musings on specific plans for exhibitions, word games, and excerpts—these things fill the flimsy sheets of graph paper. Incoherent things flow page by page into an increasing pattern, only to subside again. Other, perfectly worked-through books contain in the sum of their rhythmic pages the Polke universe in a nutshell. This fund of original brainstorms is still not exhausted. Numerous themes and motifs, which are familiar in Polke's paintings, are found in their first formulation here.

Transparency is an aspect of Polke's artistic strategy that has less to do with his complex interaction with sources and prototypes than with an unremitting need to see through and illuminate relationships, connections, situations. In his *Transparencies*, Francis Picabia had superimposed overlapping, transparent,

blended pictorial layers.[10] With Polke the urge to see through things leads him to pay remarkable attention to their back and reverse sides. What gleams through? In several sketchbooks he uses the effect of strongly colored felt-tip pens soaking through the paper. The drawing on the reverse of one page reacts with the image on the following sheet. Throughout an entire notebook a lively debate ensues uninterruptedly between the figures on facing pages, which seem to turn toward and away from each other, to communicate and diverge. Their movements in fact prove to be ever more expressive, ever more comical, and end in an ecstatic dance.

Polke playfully institutes another process of combination, when in *Notebook Number 23* he cuts out the body of a model in such a way that it is put on the black page with white stars and the ground fills out the contour as if with a remarkable dress. The stars are reminiscent of a motif that, apart from various graphic variants, characterized one of Polke's most beautiful early paintings, *Aurora*. Here the gold-bronze stars on the light beige ground give a delicate shimmer to the beginning of the day. This picture demonstrates the synthesis of painting and drawing, of ornament and figurative representation, of imitation and original creation. Untouched by revolution and advertising, the goddess of dawn—beautiful as the Queen of Sheba and bordered by the black flowers of night—pilots her boat among the constellations.[11]

Perhaps Polke's most beautiful sketchbook, *Number 21*, a lined volume with sixty-eight drawn pages, has in its compact sequence of images the effect of a systematically thought-out work. With the exceptions of the first page and the closing color sequence, the images are representational. Red rectangles form the opening, on the next pages they already appear organized as a glowing window, out of which a phantom peeps. As the story continues, he ogles the white body of a beautiful woman, who shows herself in the gap of her curtains. The thread breaks; only the blue is spun out further, in which a big cube appears, on each corner of which are four smaller ones bound with laces, some trans-

parent and some opaque. Demonic portraits of men closely follow a view of an intimate dressing table with an open box of powder. One framework on top of another framework demonstrates the strength of the base. Stamps take the liberty of playing a game with ornaments while bananas, then the favorite fruit of artists in Düsseldorf, pile up to skyscrapers, swinging like a hammock for a monument—or are eaten. Sinister images, reminiscent of Nosferatu or Hitchcock's shower-curtain scene, alternate with magically swinging pendulums and spheres; a giant hand pushes forward a small toy man under a night-blue sky. Visionary landscapes and seascapes are mixed up; a huge corkscrew flies through the air between ads for haute couture, stockings, and sunshine; "Klinger's Glove" leads a jauntily accessorized pink walking stick.[12] The size relationships, orientation, and cropping are secondary to the relationship between figure and ground. Colored layers, streaked, slapped on, modulated, and smudged on the finely made grid, create the space for the objects and at the same time create their iridescent substance. The final pages with threadlike shadings, as if the colors were firmly drawn with a brush, do without any kind of figuration. The striking color tones of lilac, honey yellow, and brown would return to dominate the enamel pictures of 1982.

The colorful sketchbooks done in watercolor can be contrasted with those in which color recedes completely. *Sketchbook Number 28* presents the highly expressive stylization and deformation of the human head, which seems to correspond to various states of consciousness. Dainty, humanized flying mushrooms, poppy heads made dreamy or diabolical, thorny cacti, and deadly nightshade offer direct evidence of diverse consciousness-expanding experiences, which connect Polke to nineteenth-century writers as well as to the surrealists, and to his contemporaries from Huxley to Jünger, from Burroughs to Ginsberg. Here, however, the going gets rough. Colloquial turns of speech, according to which the head bursts, is sharpened, or somebody's eyes pop out, convey only part of the torture.

40

Registro is the name of an arithmetic exercise book from the beginning of the seventies executed predominantly in red, orange, green, and black felt-tip pen, and also in pencil and blue ballpoint; this notebook signals a changed mood. Anthropomorphic figures and objects are vigorously transformed by the barely interrupted course of the strictly drawn lines—what began as an arm can end as an angel or a torch. What counts is the capacity to transform, to exist in all forms. Many pages are occupied by swinging figures in a distorted perspective; a symmetrical central-axial orientation operates strongly on ornamentally interwoven elements. Just as mechanical concepts were once applied to the human organism, so now are electronic ones; the aura appears as a tomogram. These creatures are not spared the protrusions, the elongations, the doublings of the sense organs or their gruesome closings with stitches and zippers that we recognize from Jean Cocteau's opium drawings and Marcel Jean's object.[13] Only the pulverization, the disintegration, free them from the rigid, ornamental order. Stronger than the omnipresent eyes, which enliven even the strangest shapes, appears the power of the grasping hands. The right hand of the one kneeling alone on the red earth becomes a mirror, which reflects the opaque window of his eyes. Kneeling on the lowly ground, another one can hardly balance in his right hand the far-too-large prism of his universe. What appears here as an isolated, complex picture is later transformed by Polke into the monumental 1971 drawings *The Trip on the Neverending Eight I–IV*, characterized by a large format filled with dense superimpositions of pictorial layers. Whoever risks the tour of the *Neverending Eight* needs strong nerves: everything is at risk.

In 1972–73 Polke moved to the farm Gaspelhof at Willich, where his pictorial output was prolific. The forms and ideas developed previously, the whole repertoire of the previous years, flows into collaborative works corresponding to the collective lifestyle, in which Polke doubtless retained the dominant role. Next to the telephone lay large pieces of paper

(*Telephone Drawing*, 1975, pl. no. 96). Coffee cups and wine glasses were put on them, daily calls and errands were noted, addresses appended, conversations commented on in words as well as in drawings. Different handwritings were mixed up as were the flashy colors of the then faddish felt-tip pens and ballpoints. Scraps were torn out, collages of Romy Schneider and Princess Anne pasted in, mindless repetitions cover outlandish outbursts of fantasy. Anything and everything can happen in this restricted space. There is no protection against the wildest neighbor! Chance, caprice, and whim spin a web piece by piece, incorporating short anecdotes and references to ongoing life experiences. The *Telephone Drawings* from Willich came into being at the same time as the profusion of picture-and-text journals of individual mythologists, trailblazers, and conceptual artists. They combine several aspects of *art brut* and of *Parallele Bildwelten* (Parallel Image Worlds), which were exhibited extensively at *Documenta 5* in 1972. Automatic writing and children's drawings, image inventions and clichés, silly rhymes and creatures of intoxication, sober facts and thoughtful squiggles—all of these find a place on these pages. Whoever had any contact with Willich will find himself in some way worked into Polke's open concept, for which the sheets are evidence. Seen from a distance their graphic wit, authenticity, and vitality are pleasing.

If Polke's hard-core pornographic drawings of the seventies, which were quickly done on a saccharine ground of gouache, today seem less important, the ten large, paintinglike paper works from 1976 confirm their special significance. Their actual total area consists of six sheets 70 by 100 centimeters (27 ½ × 39 ⅜ in.), which are mounted on a stable support. Their titles are: *New Guinea, Tree Houses, Can You Always Believe Your Eyes?, Pig Slaughter, People in Line, Supermarkets, Pills, Kandingamajig, Egyptian Firmament*.

The work most prized by the artist as representative of the entire group is the one in which he reflects critically on Western civilization and con-

trasts it with manifestations of non-European cultures that are disappearing or transmitted only in photographs. In 1980 Polke fulfilled his childhood dream to travel to Kaiser-Wilhelm-Land, formerly a German protectorate in New Guinea that today is politically independent. He could still see the remnants of an old tree house of the Koiari, just like the one he had included as a brown screen drawing on a plane of gesturally painted ground in 1976. For this drawing he used a reproduction from Chalmer's *Pioneering in New Guinea* from 1887.[14] The house, ingeniously erected in the treetop and reachable only by a teetering ladder, is translated by Polke through the irregularly dense grid into a symbol of dwelling in adventurous rapture. The color fields of the background—the brown hinting at the earth in the white field of the terra incognita; the blue of the sea or the sky; the red, fresh like spilled blood—combine to form an imperialistic symbol of majesty, which prophesies its own decline like a mighty, impending storm. The two figures at the foot of the tree, at the foot of the ladder, appear as if time had forgotten them or preserved them in the drawing after the reproduction of the print, after the original capturing of the image, so that their paradisiacal existence would never end. The breadth of the light pictorial space, emanating from its solitary, vulnerable existence, creates a still melancholy that is rarely to be found in Polke's earlier works.

Gouaches from 1980–81, all around 39⅜ by 27½ inches (100×70 cm) in size, present ornamental forms executed with the brush in lilac, yellow, olive, ocher, and flesh tones, from which a droll self-portrait sometimes peeps out (*Ornament*, 1980, pl. no. 94). In some sheets the black drawing, over which a stick figure is painted with a broad brush, includes a comic melding of motifs. The quiet street becomes a place of obscure horror; here a long-legged pair of scissors pursues the fear-filled fir tree, and the large knife in the foreground on the balustrade does not bode well (*Running Scissors*, 1981, pl. no. 97). The solitary hunt of the abandoned objects appears as a sinister simile in the Chinese

puzzle of the superimposed levels of the drawings. In other works from this time the ground is covered with brushed-on colors; yellow, cyan, lilac, silvery gray, and candy-pink spread out, wriggle around a thing with a life of its own, running into and playing off of each other.

Beginning in 1978 Polke undertook major trips to Asia and Australia. In the early eighties his painting evidenced a change, which was much discussed by those who saw the exhibitions *Zeitgeist* and *Documenta 7* in 1982, and which climaxed in his contribution to the German pavillion of the 42nd Venice Biennale in 1986. Figuration recedes in favor of more strongly gestural, process-derived colors, characterized by saturated or veil-like superimpositions and blendings. The intimate acquaintance with pigment and its surprisingly quick or creepingly slow chemical reactions is anything but harmless; Polke has been compared to alchemists and prospectors for gold.[15] In preparation for this phase, he once again chose the school exercise book, the ring binder, that he treated with sumptuous colors, until the devil of standardized layout is reduced to hiding in the punched-out holes. Parallel to them, although completely different in character, are numerous notebooks with graphic, playful collages.

Short headlines or sentences cut out of major daily newspapers, their typography still identifiable, are placed on lined pages as single lines. However, their placement does not necessarily follow the printed lines; sometimes a slogan is placed crosswise, or a small printed picture slips in. The color appears sparingly, small bits of red remain on the writing. Fine lines of ballpoint-pen commentary grow around the text and bring out its sense and nonsense. The conclusion drawn from the heading of an article is only the most obvious effect. The more closely Polke looks, and in his way shortens, stretches, or puffs up the snatches of text in his way, the more sharply emerges from the rhythm of anecdote and signals of horror the dumb slogans, dear notes, bad jokes, and thoughtless acts, a picture that easily makes our flesh creep: *Dismal and Icy,*

SIGMAR POLKE

Hodgepodge en Détail. Opening to the first page, one recognizes the lines *3 mal lachte* (3× Laughed) emanating from the left-hand page.

A ring binder, also from 1981–82, is stuffed full of sheets that are soaked through with colorful liquids. Fabric dyes, especially for silk, provide a fluid course of powerful pastel tones. Totally absorbed by the paper, they create a smooth matte surface. Grotesque beings, solitary houses, quiet blossoms, and fantastic forms, quickly and haphazardly drawn in black felt-tips and highlighted in white or lilac, stand in these spaces as in wondrous rooms open on all sides. In another, blue-bound book Polke works with the process of blotches and slapped-on color. In the dissolving colored inks or washes the brush places concise signs, which, once again covered over, produce spatial effects. Others float on the surface like projections. The sequence of pages with the archers is remarkable for its thematic connection. Through it, the artist alludes to a ritual of the getae mentioned by Mircea Eliade and noted by Herodotus: "This Thracian tribe also shoots its arrows into the heavens and threatens the god when there is thunder and lightning."[16]

The meaning of the ritual is not as clear as Eliade claims; perhaps the intention was to help the god against a lower band of weather demons. This modifies the Promethean interpretation and shifts the emphasis to a more comprehensive enfolding of mankind in the processes of nature.

There is a variety of ways to approach Polke's extensive graphic output. Apart from his works expressly conceived for their effect on paper, Polke takes the classical path through sketch, plan, and study to painting. But on the one hand, through a profusion of materials, techniques, and processes, the connections between these forms are easily lost, and on the other hand, aesthetic values have shifted over time and the hierarchy of the media has broken down. While a small, scarcely indicated watercolor can be distilled into a multilayered painting, a few black palm lines drawn in charcoal extend over the large, stretched, glittering piece of carnival fabric.

With his origins in the criticism of society and civilization, Polke embraced the inflation of the reproduced image: as a follower who exposed the forms of dilution and manipulation through his own reworking; as a copyist, a transmuter of motifs, themes, and styles, through which he shrewdly differentiates the unsolvable question of authenticity with the playful insistence of his work. Objects, figuration in the broadest sense, only barely retain their identity, caught in the outlines and taken a step further. Their volume is only hinted at; the substance of their physical body, which is slight and transparent like glass, is dominated by the background. This seems to signify two things: not only the fragile construction of identity, but also the constant threat of its dissolution in the never-ending flow of appearances.

Polke never totally abandons terrain once it has been gained. But since the early eighties a new position has begun to emerge, appearing first in the intimate realm of drawings. Against the background of changed scientific insights into the condition of matter and the consequences resulting from this knowledge, new possibilities for collaborating with nature present themselves to the artist for testing. This new orientation manifests itself in his preoccupation with pigments, their chemical composition and transformation, their physical properties, and the history of their expanded implications and symbolic meaning.

Notes

1. On the occasion of his exhibition in Rotterdam in 1983, Polke made a group of the four drawings *A-Man, B-Man, C-Man,* and *V-Man.* He called them *The Four Best-Known Directors of Art Galleries and Museums in 1964.* Probably the first three drawings, if not all four of them, were made in 1963.

2. Italo Svevo, *Confessions of Zeno,* trans. Beryl de Zoete (New York: Vintage Books, 1989), chap. 3.

3. René Magritte, *I Do Not See the Person Hidden in the Forest,* 1929, photomontage for *La Révolution surréaliste,* no. 12 (15 December 1929): 73.

4. Pablo Picasso, *Portrait of Dora Maar,* 1937, oil on canvas, 92×65 cm, Musée Picasso, Paris; Pablo Picasso, *Weeping Woman,* 1937, oil on canvas, 60×49 cm, Tate Gallery, London.

5. Compare Sigmar Polke, *Potato House,* 1967, ca. 250×200×200 cm, private collection; *Palm Picture with Grid,*

1967, 200 × 190 cm, private collection; *A Piece of Potato*, 1969, reproduced in *Sigmar Polke*, exh. cat. (Tübingen: Kunsthalle, 1976), pp. 85, 88, 89. What is more, Polke portrayed the homeless person Sigi from Cologne, framed by heads, in a drawing and added a potato lattice to it: *Drawing with Potato Lattice*, 1966–69, private collection, reproduced in the catalogue for *Documenta 7*, vol. 1, p. 217.

6. Hagen Lieberknecht, "Über Pinselzeichnungen von Sigmar Polke," in *Sigmar Polke*, exh. cat. (Rotterdam: Museum Boymans-van Beuningen, 1983), pp. 44–46.

7. As a contribution to the 1969 exhibition in the basement of Zwirner's gallery Polke connected the potato tubers according to the principle of a peg system. See also Amine Haase, "Kartoffel als Genie-Symbol," *Kölner Stadtanzeiger*, 28 February 1984, p. 27.

8. Benjamin Buchloh, "Polke und das grosse Triviale," *Sigmar Polke* (Tübingen), pp. 135–50.

9. Apart from numbering these exercise books Lieberknecht made photos of them, thus providing essential information for scholarly consideration. Bice Curiger published six double pages from *Sketchbook No. 3* (pp. 9, 10, 10a, and 11) and from *Skizzenbuch Nr. 22* (pp. 4 and 6) in *Parkett*, no. 2 (1984): 44–45.

10. For Picabia's *Tranparencies*, see Schuldt Heinz and Marianne Heinz, "Einführung: Francis Picabia," in *Francis Picabia*, exh. cat. (Düsseldorf: Städtische Kunsthalle, 1983), p. xxxiv: "At the beginning of 1927 Picabia exhibited a new series of *Espagnoles* at a yacht club in Cannes; some of them signal a new style. . . . Because of the transparent superimposition of various pictures or picture fragments these works are called *Transparencies*. In 1949 Duchamp worked on a text for the catalogue of the Société Anonyme collection at Yale University. There he associated his own purposes with Picabia's work and tried to explain *transparence* as a method of spatial representation without perspective. It is also possible to look at these pictures as dealing with questions of identity, of ambiguity, of juxtaposition, and of a 'non-committal coordination' of motifs." At the 1975 exhibition *Surrealität—Bildrealität* at the Kunsthalle Düsseldorf the author documented the obvious impact that Picabia's work had on Polke by presenting both Picabia's *Transparencies* and Polke's drawing *The Trip on the Neverending Eight I*, 1971.

11. Compare Polke's rendering to Picabia, *Heads and Stars*, ca. 1930, and *Heads and Landscape*, ca. 1930, and the copy of Piero della Francesca, *The Discovery of the Holy Cross* (Presentation to the Queen of Sheba), ca. 1453–1454, San Francesco, Arrezzo. According to Polke, he drew his *Aurora* from a knickknack figure. For illustrations of these works, see *Sigmar Polke*, exh. cat. (Bonn: Kunstmuseum, 1988), pp. 118–19.

12. Max Klinger, *A Glove*, series of ten etchings, 1881. See Barbara Reise, "Wer . . . Was . . . ist Sigmar Polke," *Sigmar Polke*, exh. cat. (Zurich: Kunsthaus, 1984), p. 50: "At that time Polke presented himself as a receiver of telepathic messages from two nineteenth-century artists, William Blake and Max Klinger." For illustrations of these works, see *Sigmar Polke*, exh. cat. (Bonn: Kunstmuseum, 1988), pp. 110–13.

13. Jean Cocteau, *Opium, Tagebuch einer Entziehungskur* (Frankfurt-am-Main: Fischer, 1988) [in English, *Opium: The Diary of a Cure*, 1980], including drawings by the artist, in particular the self-portrait on the cover; Marcel Jean, *The Specter of the Gardenia*, 1936, object, The Museum of Modern Art, New York. For illustrations of these works, see *Sigmar Polke*, exh. cat. (Bonn: Kunstmuseum, 1988), pp. 124–25.

14. Polke took as his source *Melanesien: Schwarze Inseln der Südsee*, exh. cat. (Cologne: Kunsthalle, 1971–72).

15. See Jürgen Hohmeyer, "Die Alchemie der giftigen Bilder," *Sigmar Polke* (Zurich).

16. Mircea Eliade, *Zalmoxis, the Vanishing God*, trans. Willard R. Trask (Chicago: University of Chicago Press, 1972), chap. 2.

Translated from the German by Eva Marie Holler and Fronia Simpson. A slightly longer version of this essay appeared in *Sigmar Polke*, exh. cat. (Bonn: Kunstmuseum, 1988).

PLATE 1. *Polkes gesammelte Werke*
(Polke's Collected Works), 1969. Oil
on cardboard, 15 ¾ × 59 ⅛ in. (40 ×
150 cm). Jerry and Emily Spiegel
Family Collection, New York.

PLATE 2. *Socken* (Socks), 1963. Oil
on canvas, 27 9/16 × 39 3/8 in. (70 ×
100 cm). Private collection, Cologne.

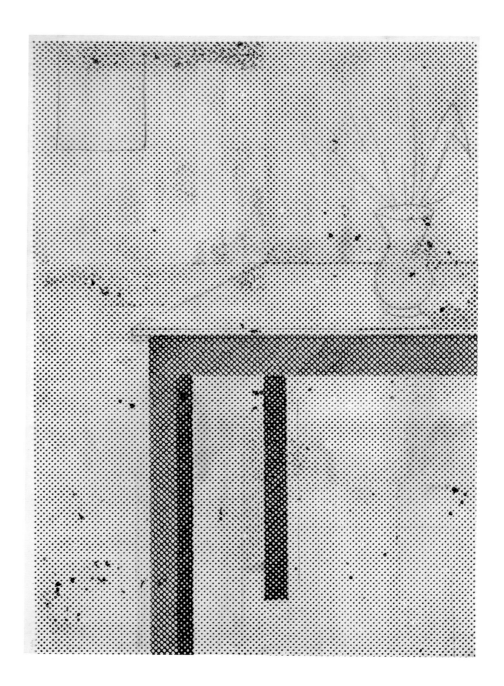

PLATE 3. *Tisch* (Table), 1963. Acrylic
on canvas, 66 ¹⁵⁄₁₆ × 46 ⅞ in. (170 ×
119 cm). Private collection, Germany.

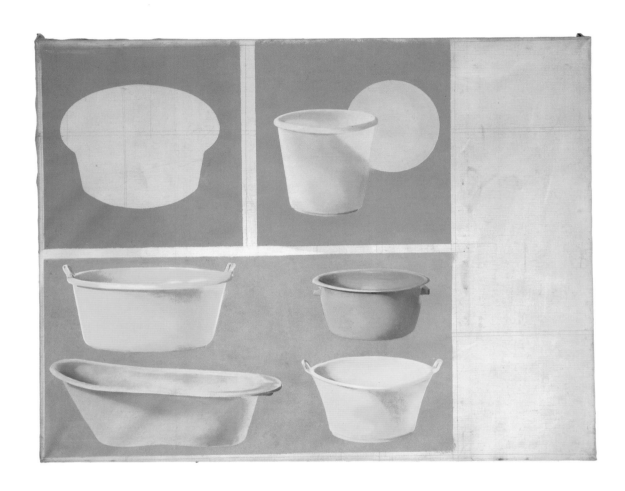

PLATE 4. *Plastik Wannen* (Plastic
Tubs), 1964. Oil on canvas, 37 ⅜ ×
47 ¼ in. (95 × 120 cm). Collection of
Linda and Harry Macklowe, New
York.

PLATE 5. *Schokoladenbild* (Chocolate
Painting), 1964. Lacquer on canvas,
35⁷⁄₁₆ × 39⅛ in. (90 × 100 cm).
Collection of Prof. Dr. Rainer
Jacobs, Cologne.

PLATE 6. *Puppe* (Doll), 1965. Acrylic
on canvas, 49 3/16 × 63 in. (125 ×
160 cm). The Stober Collection,
Berlin.

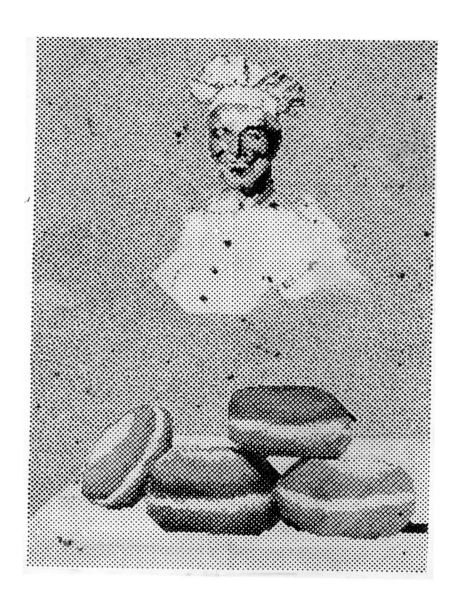

PLATE 7. *Berliner* (*Bäckerblume*)
(Doughnuts), 1965. Acrylic on
canvas, 63 × 49 ¾₆ in. (160 × 125 cm).
The Garnatz Collection, Cologne.

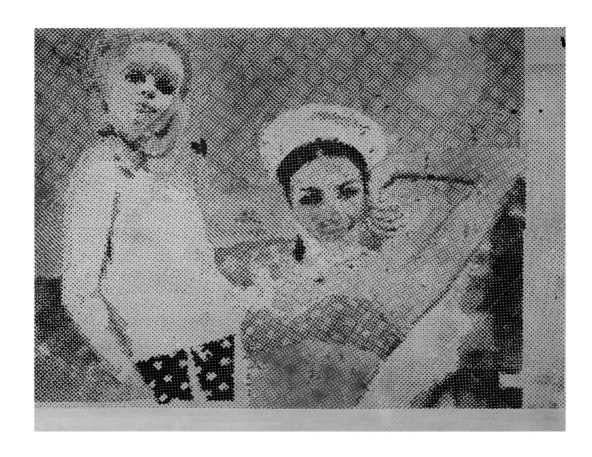

PLATE 8. *Freundinnen* (Girlfriends),
1965. Acrylic on canvas, 59¹/₁₆ ×
74¹³/₁₆ in. (150 × 190 cm). The
Froehlich Collection, Stuttgart.

PLATE 9. *Japanische Tänzerinnen*
(Japanese Dancers), 1966. Acrylic
on canvas, 78 ¾ × 66 ¹⁵⁄₁₆ in. (200 ×
170 cm). Private collection,
New York.

PLATE 10. *Schneeglöckchen* (Snow-
drops), 1965. Acrylic and poster
paint on plywood, 28⅜ × 28⅜ in.
(72 × 72 cm). The Froehlich Collec-
tion, Stuttgart.

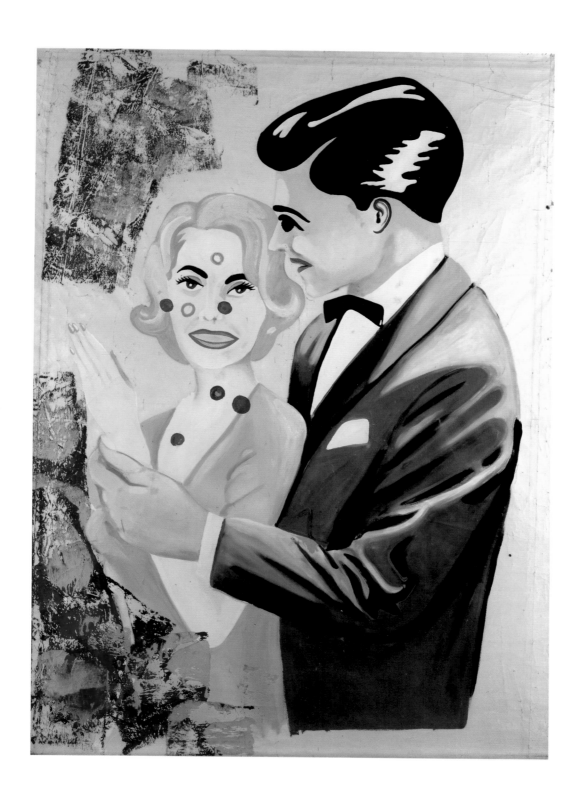

PLATE 11. *Liebespaar II* (Lovers II),
1965. Lacquer and oil on canvas,
74¹³⁄₁₆ × 55⅞ in. (190 × 142 cm).
Courtesy Thomas Ammann, Zurich.

PLATE 12. *Die 50er Jahre* (The Fifties), 1963–69. Mixed media on 12 canvases, installation dimensions variable. Karl Stroeher Foundation, Hessisches Landesmuseum, Darmstadt.

PLATE 13. *Zwei Palmen* (Two Palm
Trees), 1964. Artificial resin on
fabric, 35⁷/₁₆ × 29½ in. (90×75 cm).
Private collection, Cologne.

PLATE 14. *Lila Form* (Lilac Form),
1967. Acrylic on fabric, 59¹⁄₁₆ ×
49³⁄₁₆ in. (150 × 125 cm). Kunst-
museum, Bonn, Donation Ingrid
Oppenheim.

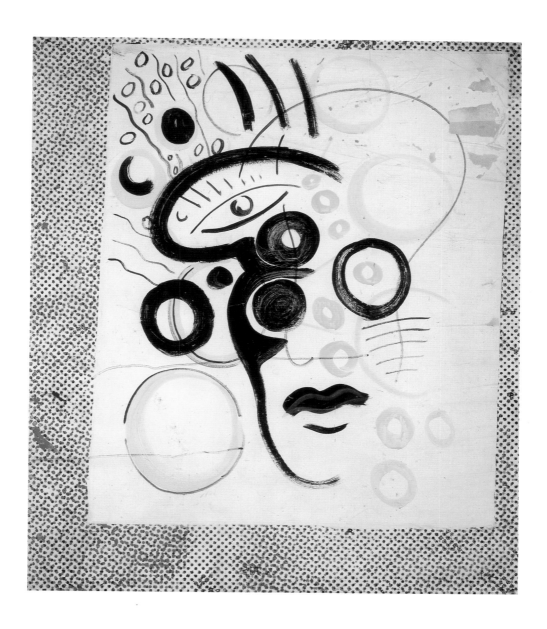

PLATE 15. *Ohne Titel* [Kopf] (Untitled: Head), 1969. Acrylic and casein on raw cotton, 44⅞ × 39 in. (114 × 99 cm). Kunstmuseum, Bonn, extended loan from private collection.

PLATE 16. *Akt mit Salamandern* (Nude
with Salamanders), 1971. Acrylic,
spray paint, and artificial resin
on fabric strips, 70⅞ × 59¹⁄₁₆ in.
(180 × 150 cm). Collection of Susan
and Lewis Manilow, Chicago.

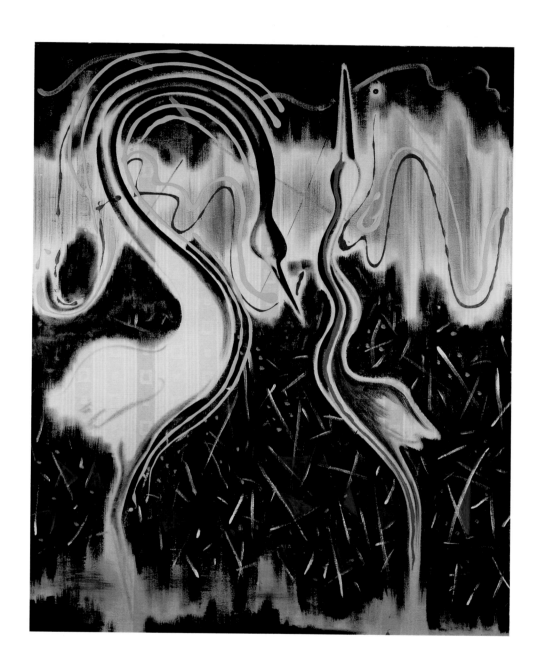

PLATE 17. *Reiherbild IV* (Heron
Painting IV), 1969. Acrylic on beaver
cloth, 74¹³⁄₁₆ × 59¹⁄₁₆ in. (190 ×
150 cm). The Garnatz Collection,
Cologne.

$$1 + 1 = 3$$

$$2 + 3 = 6$$

$$4 + 4 = 5$$

$$7 + 3 = 8$$

$$5 + 1 = 2$$

$$3 + 4 = 9$$

$$6 + 2 = 7$$

$$8 + 7 = 4$$

$$1 + 5 = 2$$

PLATE 18. *Lösungen* (Solutions), 1967.
Lacquer on burlap, 59 1/16 × 49 3/16 in.
(150 × 125 cm). The Dr. Speck
Collection, Cologne.

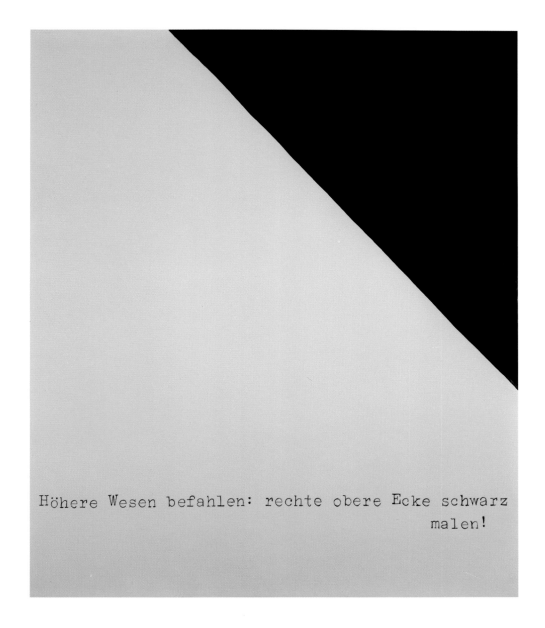

PLATE 19. *Höhere Wesen befahlen: rechte obere Ecke schwartz malen!* (Higher Powers Command: Paint the Upper Right Corner Black!), 1969. Lacquer on canvas, 59 1/16 × 49 7/16 in. (150 × 125.5 cm). The Froehlich Collection, Stuttgart.

PLATE 20. *Handlinien Links* (Lines of
the Left Palm), 1968. Acrylic on
Turkish blue Lurex, 61 × 49 3⁄16 in.
(155 × 125 cm). Kunstmuseum, Bonn.

PLATE 21. *Handlinien Rechts* (Lines of
the Right Palm), 1968. Acrylic on
old rose Lurex, 61 × 49 ¾₆ in.
(155 × 125 cm). Kunstmuseum, Bonn.

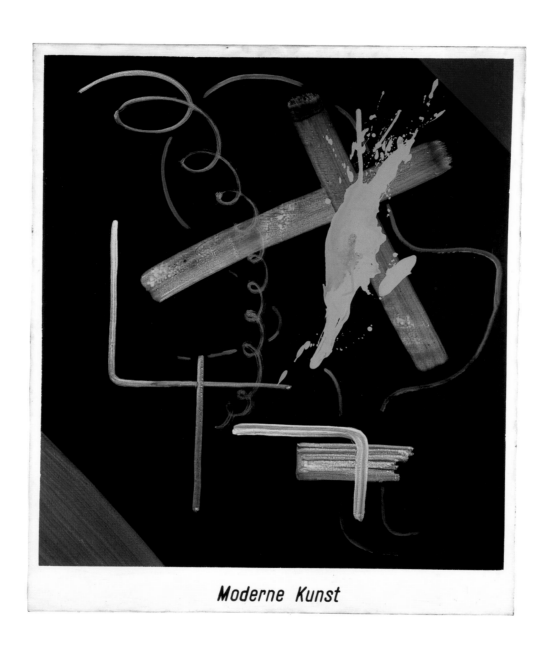

Moderne Kunst

PLATE 22. *Moderne Kunst* (Modern
Art), 1968. Acrylic on canvas,
59 1/16 × 49 1/16 in. (150 × 125 cm).
Private collection, Berlin.

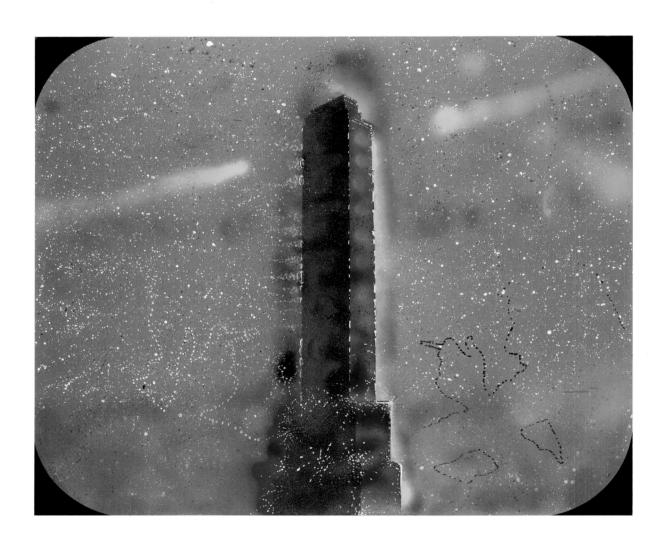

PLATE 23. *Portrait of David Lamelas*
(*Obelisk*), 1971. Acrylic and spray
paint on canvas, 51³⁄₁₆ × 59¹⁄₁₆ in.
(130 × 150 cm). Collection of Joseph
E. and Arlene McHugh, Chicago.

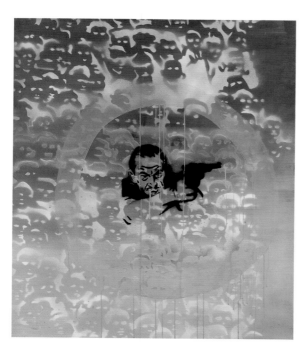 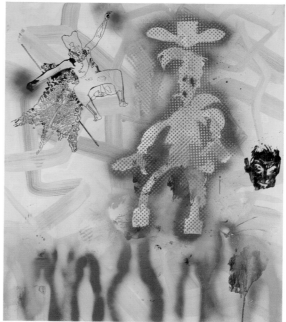

PLATE 24. *Lucky Luke and His Friend*,
1971–75. Acrylic and oil on canvas,
two panels, 51¹⁄₁₆ × 43⁵⁄₁₆ in. (130 ×
110 cm) each. The Dr. H. G. Lergon
Collection, Rheinbach, Germany.

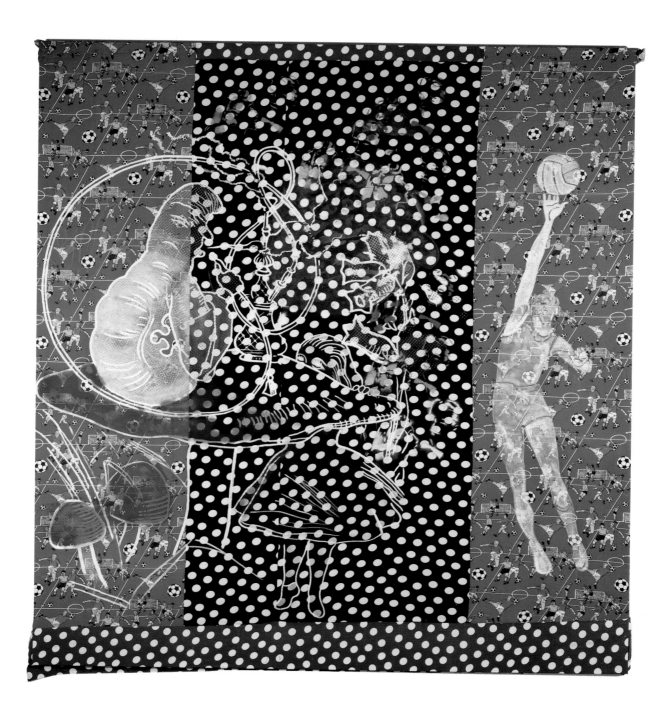

PLATE 25. *Alice im Wunderland* (Alice
in Wonderland), 1971. Mixed media
on fabric strips, 126 × 102⅛ in. (320 ×
260 cm). Private collection, Cologne.

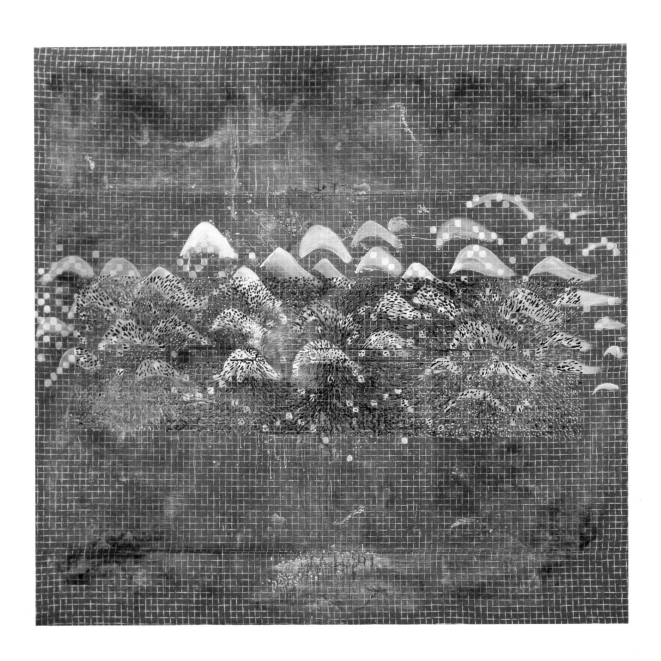

PLATE 26. *Magnetische Landschaft*
(Magnetic Landscape), 1982. Acrylic
and ferrous mica on canvas,
114 3/16 × 114 3/16 in. (290 × 290 cm).
Raschdorf Collection, Düsseldorf.

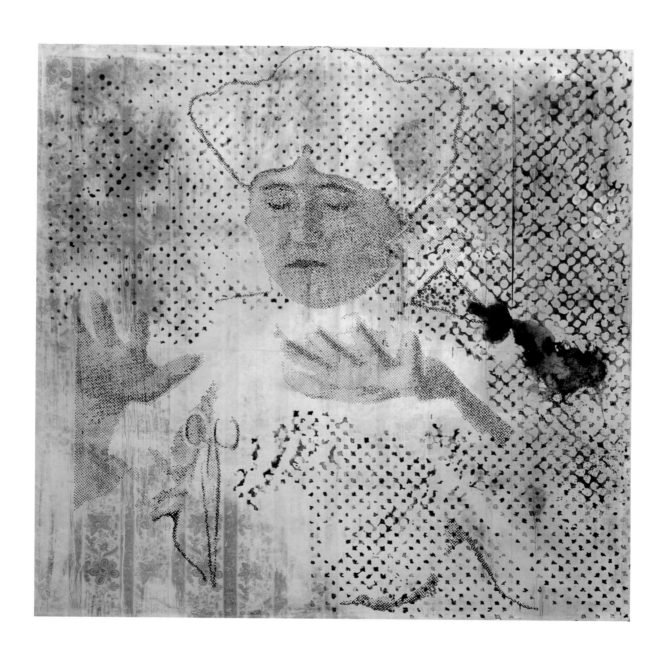

PLATE 27. *Die Schere* (Scissors), 1982.
Acrylic and ferrous mica on canvas,
114¹⁄₁₆ × 114¹⁄₁₆ in. (290 × 290 cm).
Raschdorf Collection, Düsseldorf.

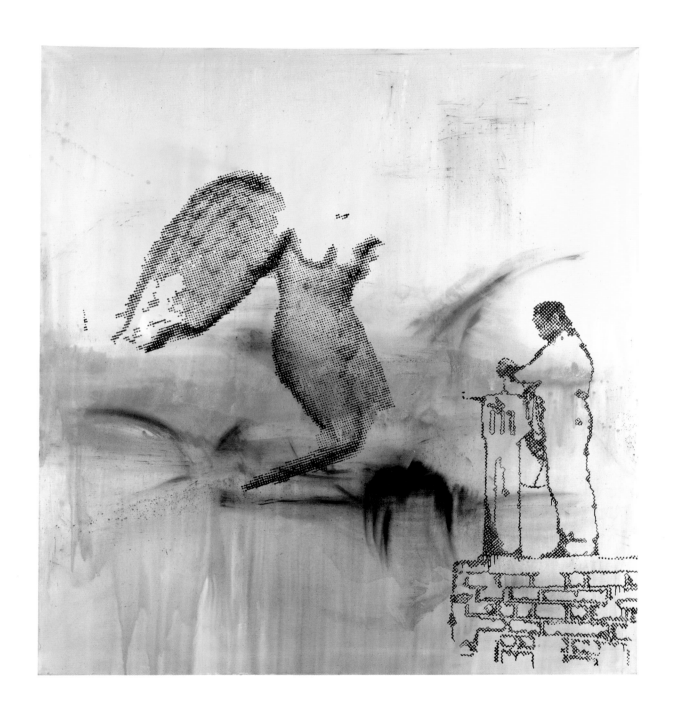

PLATE 28. *Der Traum des Menelaos*
(The Dream of Menelaus), 1982.
Acrylic on canvas, 102⅛ × 94½ in.
(260 × 240 cm). Raschdorf Collection,
Düsseldorf.

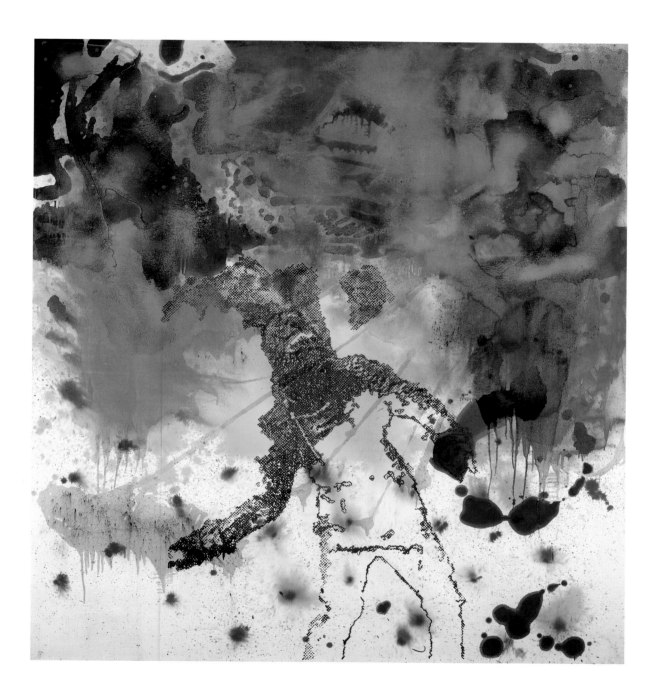

PLATE 29. *Der Traum des Menelaos II*
(*Kuh und Schaf gehen zusammen aber der
Adler steht allein*) (The Dream of
Menelaus II [Cow and Sheep Go
Together but the Eagle Stands
Alone]), 1982. Acrylic and ferrous
mica on canvas, 102⅜ × 94½ in.
(260 × 240 cm). Raschdorf Collection,
Düsseldorf.

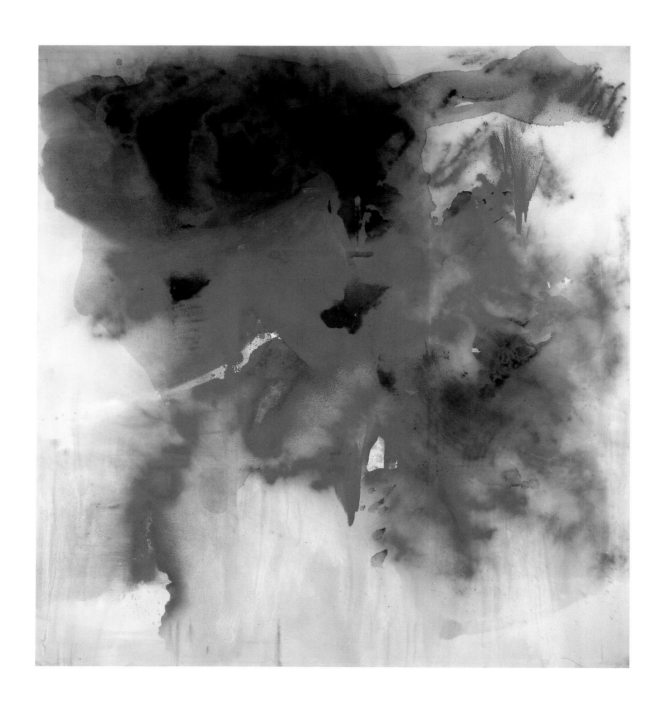

PLATE 30. *Der Traum des Menelaos III*
(*Wolke*) (The Dream of Menelaus
III [Cloud]), 1982. Acrylic on canvas,
102⅜ × 94½ in. (260 × 240 cm).
Raschdorf Collection, Düsseldorf.

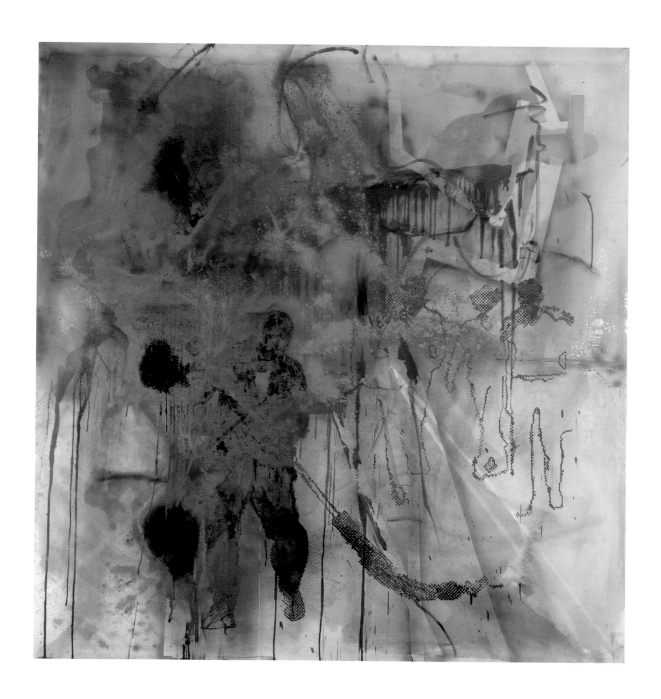

PLATE 31. *Der Traum des Menelaos IV*
(The Dream of Menelaus IV),
1982. Acrylic on canvas, 102⅛ × 94½
in. (260 × 240 cm). Raschdorf
Collection, Düsseldorf.

PLATE 32. *Hannibal mit seinen
Panzerelephanten* (Hannibal with His
Armored Elephants), 1982. Artificial
resin on canvas, 102⅜ × 78¾ in.
(260 × 200 cm). Courtesy Gagosian
Gallery, New York.

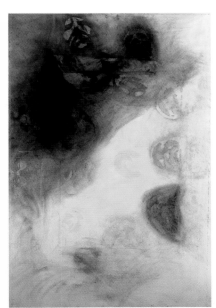

PLATE 33. *Ohne Titel* (Untitled),
1982. Artificial resin and mixed
media on canvas (triptych), 3 parts,
118 × 78¼ in. (300 × 200 cm) each.
Collection of Gerald S. Elliott,
Chicago.

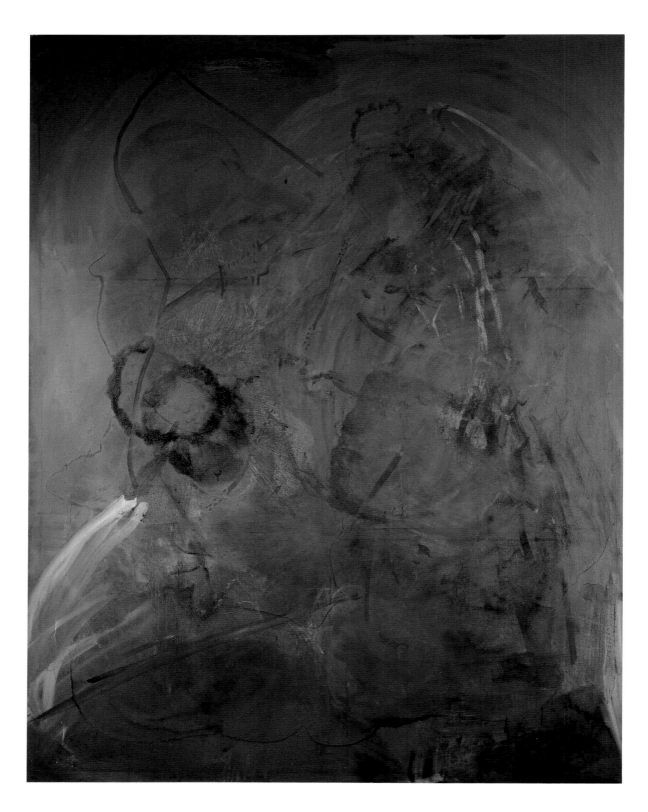

PLATE 34. *Negativwert I: Alkor*
(Negative Value I: Alkor), 1982. Oil,
pigment of violets, and red lead
underpainting on canvas, 102⅛ ×
78¼ in. (260 × 200 cm). Raschdorf
Collection, Düsseldorf.

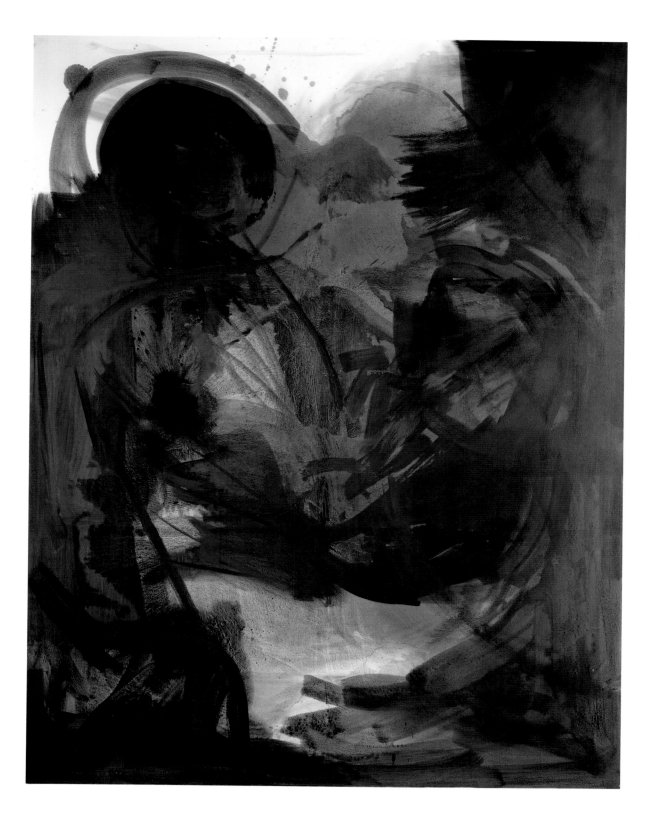

PLATE 35. *Negativwert II: Mizar*
(Negative Value II: Mizar), 1982. Oil,
pigment of violets, and red lead
underpainting on canvas, 102⅜ ×
78¼ in. (260 × 200 cm). Raschdorf
Collection, Düsseldorf.

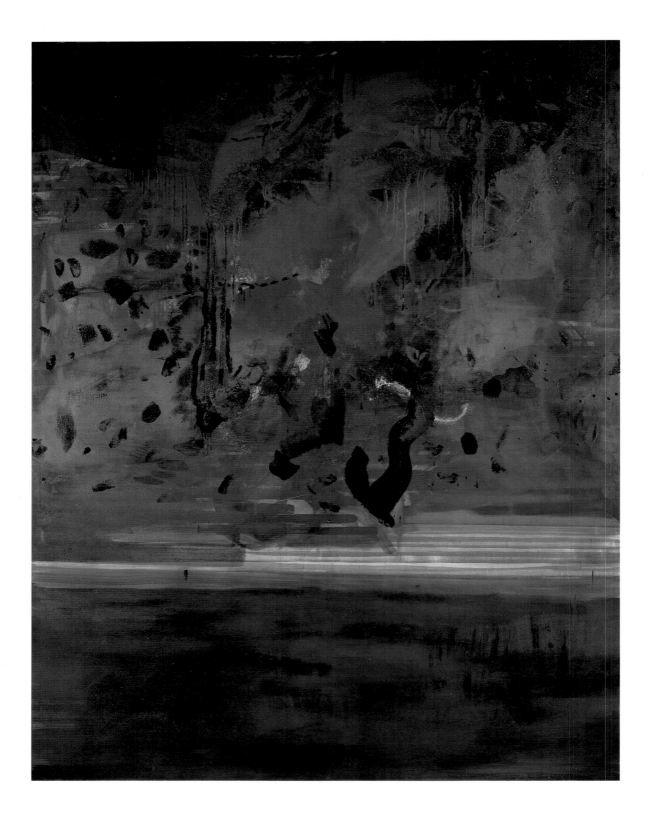

PLATE 36. *Negativwert III: Aldebaran*
(Negative Value III: Aldebaran),
1982. Oil and pigment of violets on
canvas, 102⅜×78¾ in. (260×
200 cm). Raschdorf Collection,
Düsseldorf.

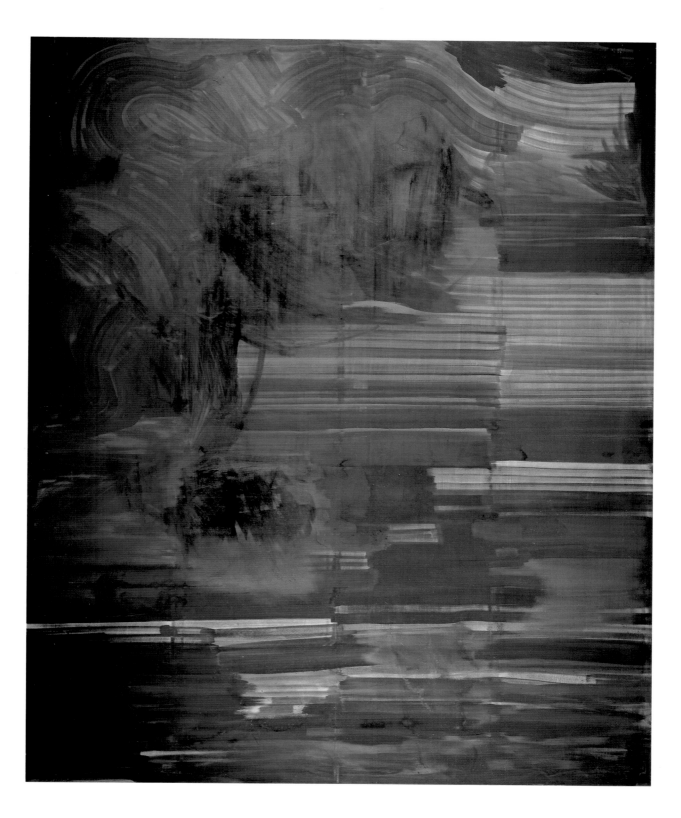

PLATE 37. *Hallucinogen* (Hallucino-
gen), 1983. Oil on canvas, 126 ×
94½ in. (320 × 240 cm). Private
collection, Cologne.

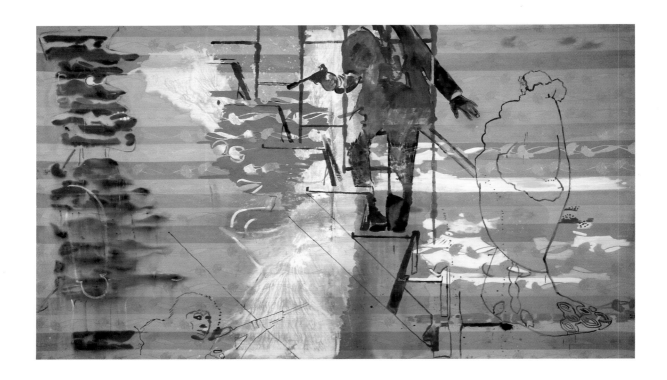

PLATE 38. *Treppenhaus* (Stairwell),
1982. Acrylic on fabric, 91⅝ ×
158½ in. (232.7 × 402.5 cm).
Hirshhorn Museum and Sculpture
Garden, Smithsonian Institution,
Washington, D.C. Museum purchase
with funds provided by the Jacob
and Charlotte Lehrman Foundation
and the Holenia Purchase Fund,
1989.

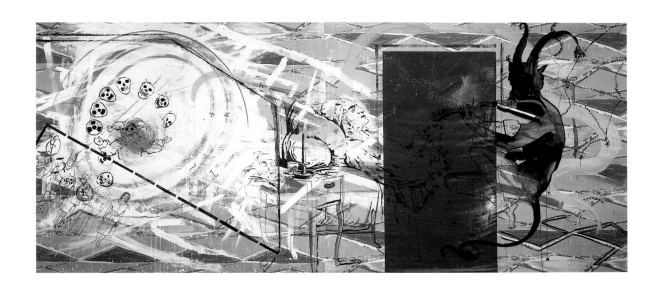

PLATE 39. *Paganini* (Paganini), 1982.
Acrylic on fabric, 78¾ × 177 ³⁄₁₆ in.
(200 × 450 cm). Courtesy Thomas
Ammann, Zurich.

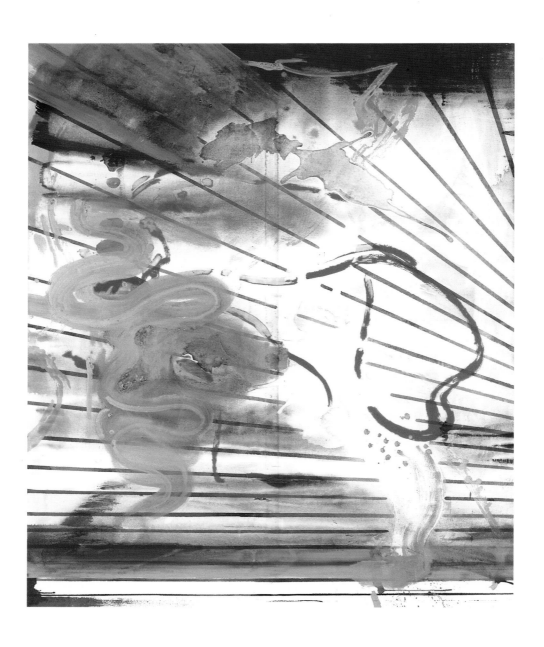

PLATE 40. *Ohne Titel* (Untitled),
1982. Artificial resin and mixed
media on canvas, 70⅞ × 59 1/16 in.
(180 × 150 cm). Raschdorf Collection,
Düsseldorf.

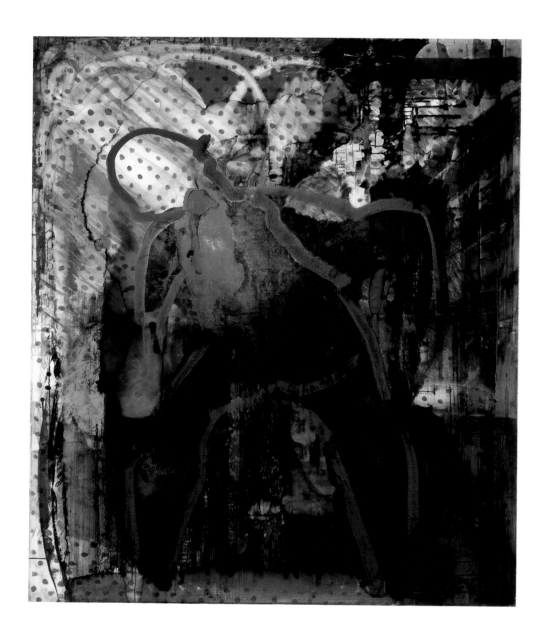

PLATE 41. *Schwarzer Mann* (Black Man), 1982. Artificial resin, alcohol-diluted pigment, and beeswax on canvas, 70⅞ × 59¹⁄₁₆ in. (180 × 150 cm). Raschdorf Collection, Düsseldorf.

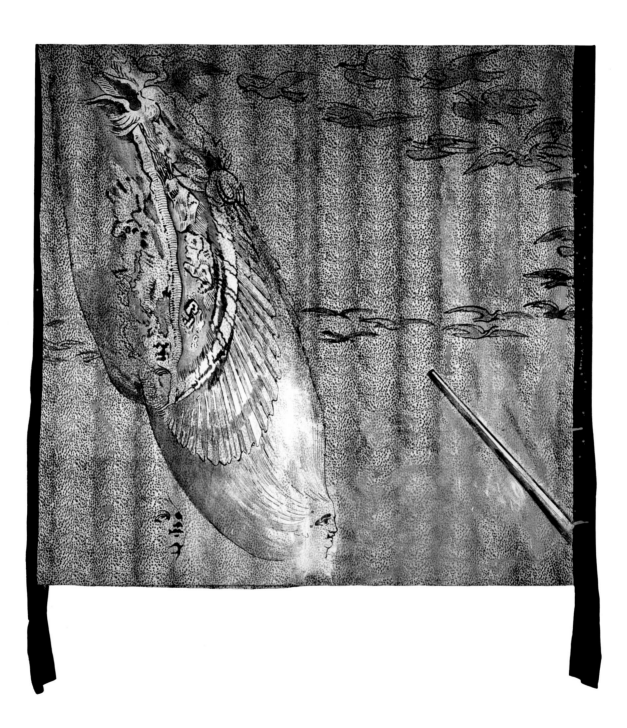

PLATE 42. *Perücke* (Wig), 1983.
Acrylic on fabric, 114³⁄₁₆ × 114³⁄₁₆ in.
(290 × 290 cm). Raschdorf Collection,
Düsseldorf.

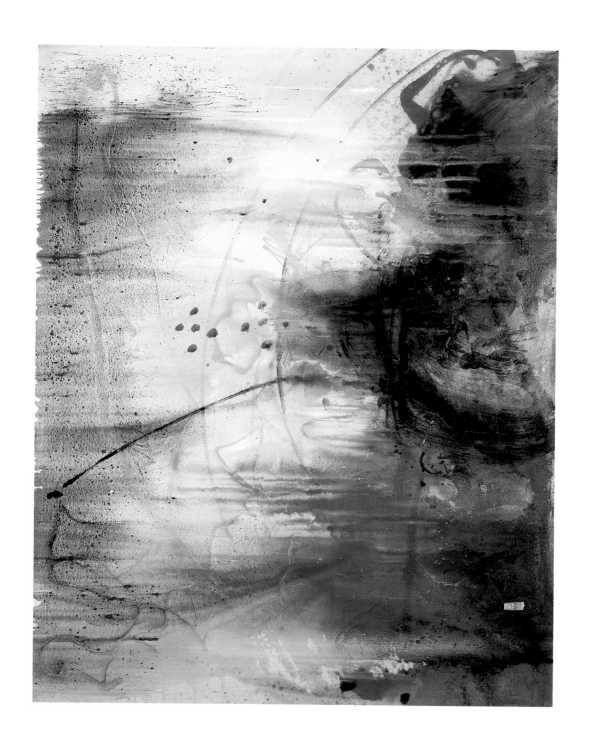

PLATE 43. *Frau Tuchers Tuch* (Mrs.
Tucher's Shawl), 1983. Artificial resin
and acrylic on canvas, 102⅛ ×
78¾ in. (260 × 200 cm). Raschdorf
Collection, Düsseldorf.

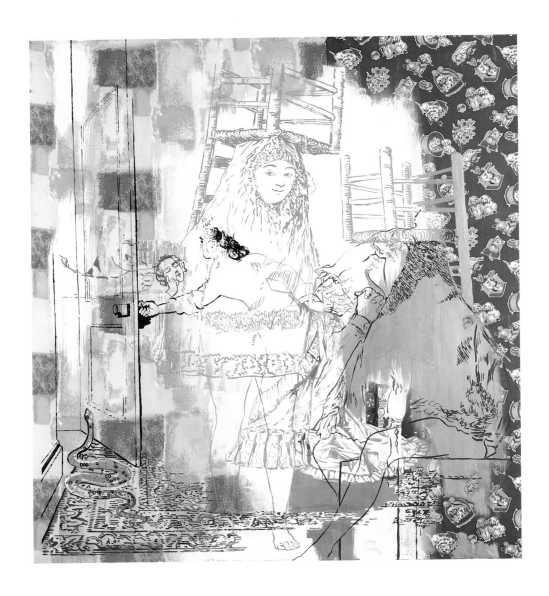

PLATE 44. *So sitzen Sie richtig (nach Goya)* (This Is How You Sit Correctly [after Goya]), 1983. Acrylic on fabric, 78¾ × 74¹³⁄₁₆ in. (200 × 190 cm). Private collection, Germany.

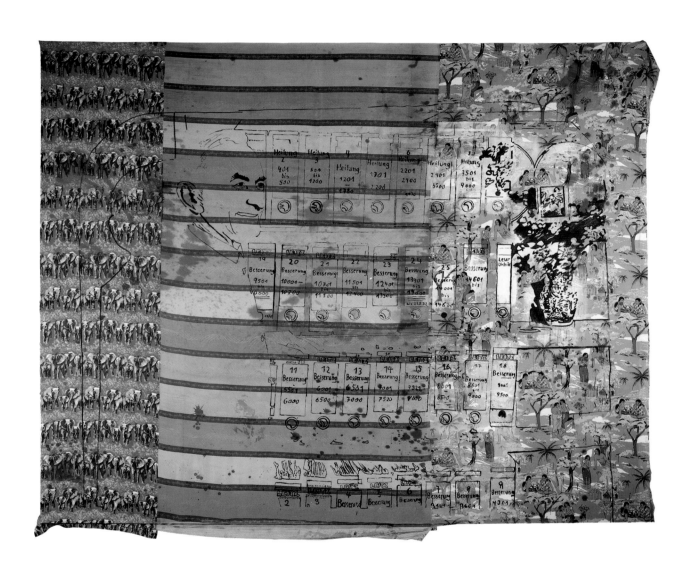

PLATE 45. *Die Lebenden stinken* (The
Living Stink), 1983. Acrylic on
fabric, 110¼ × 141¼ in. (280 ×
360 cm). Jerry and Emily Spiegel
Family Collection, New York.

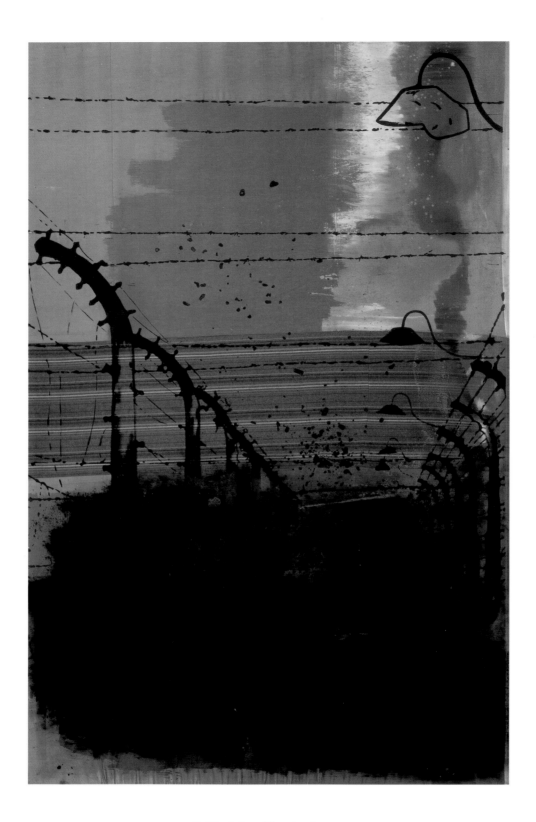

PLATE 46. *Lager* (Camp), 1982.
Acrylic and spattered pigment on
fabric and blanket, 177 ³⁄₁₆ × 98⁷⁄₁₆ in.
(450 × 250 cm). Collection of
Charlene Engelhard, Cambridge.

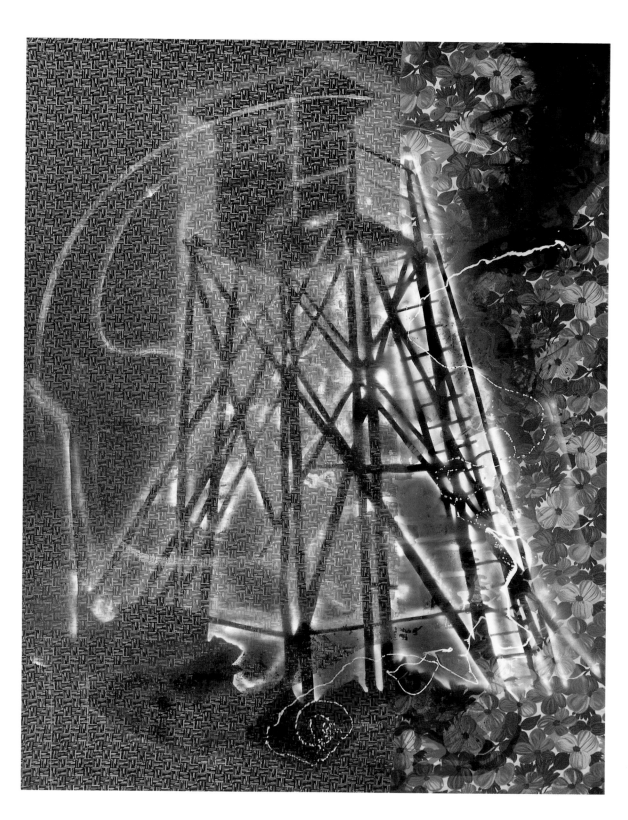

PLATE 47. *Hochsitz* (Watchtower), 1984. Artificial resin and acrylic on canvas, 118 1/8 × 87 13/16 in. (300 × 223 cm). Collection of Raymond Learsy, New York.

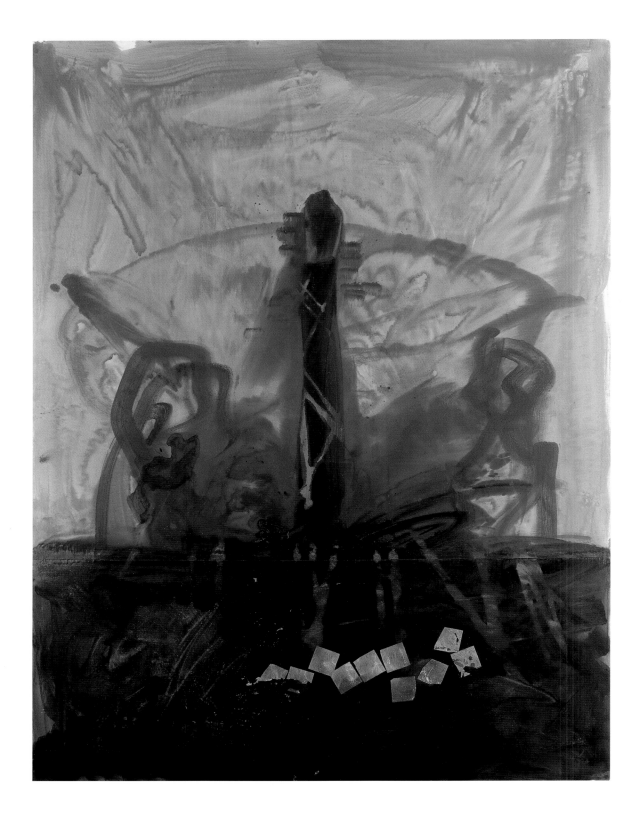

PLATE 48. *Hochsitz (Bufo Tenin)*
(Watchtower [Bufo Tenin]), 1984.
Silver, silver bromide, and natural
resins on canvas, 118⅛ × 88³⁄₁₆ in.
(300 × 224 cm). The Rivendell
Collection, New York.

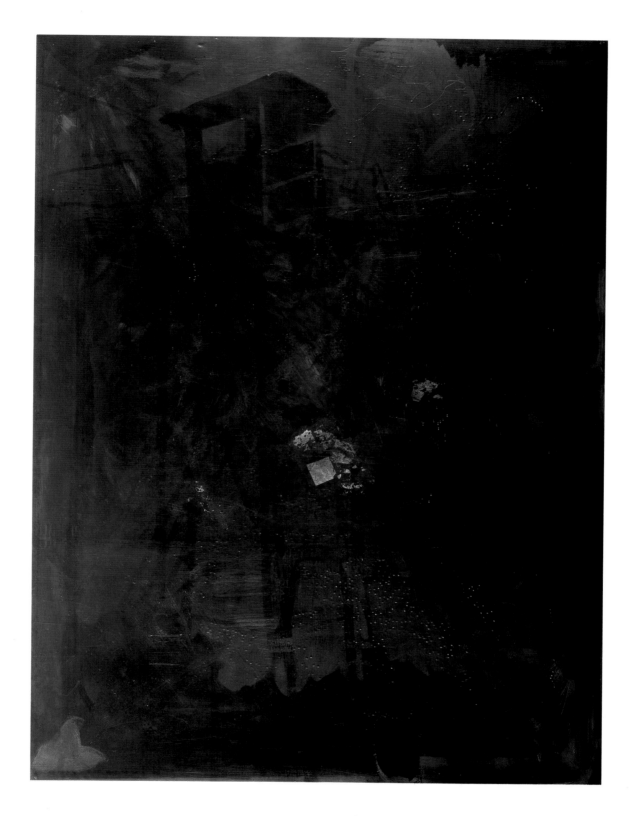

PLATE 49. *Hochsitz II* (Watchtower
II), 1984–85. Silver, silver oxide, and
artificial resin on canvas, 119 11/16 ×
88 9/16 in. (304 × 225 cm). The
Carnegie Museum of Art, Pittsburgh,
William R. Scott, Jr., Fund.

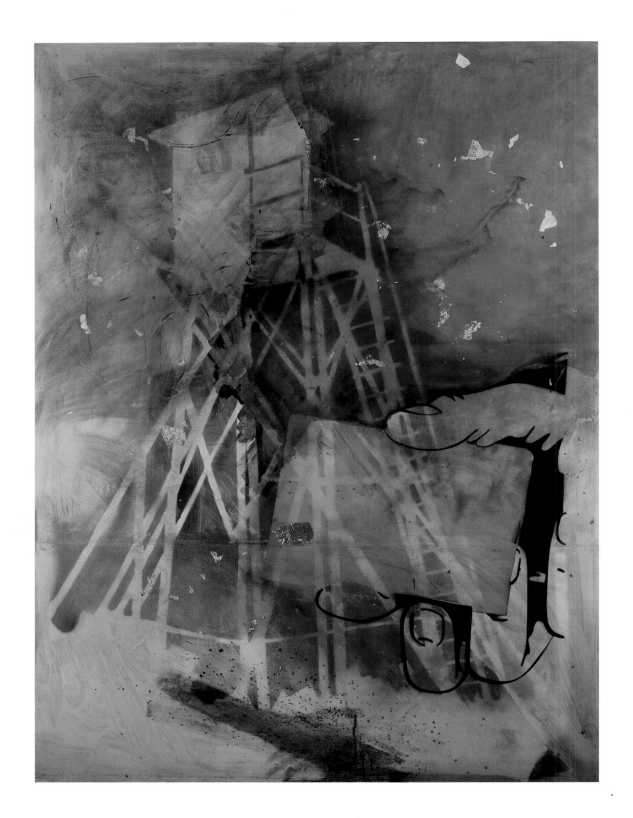

PLATE 50. *Hochsitz III* (Watchtower
III), 1985. Silver, silver nitrite,
iodine, Cobalt II, chloride, and
artificial resin on canvas, 118⅛ ×
88%₁₆ in. (300 × 225 cm). Staatsgalerie
Stuttgart, Germany.

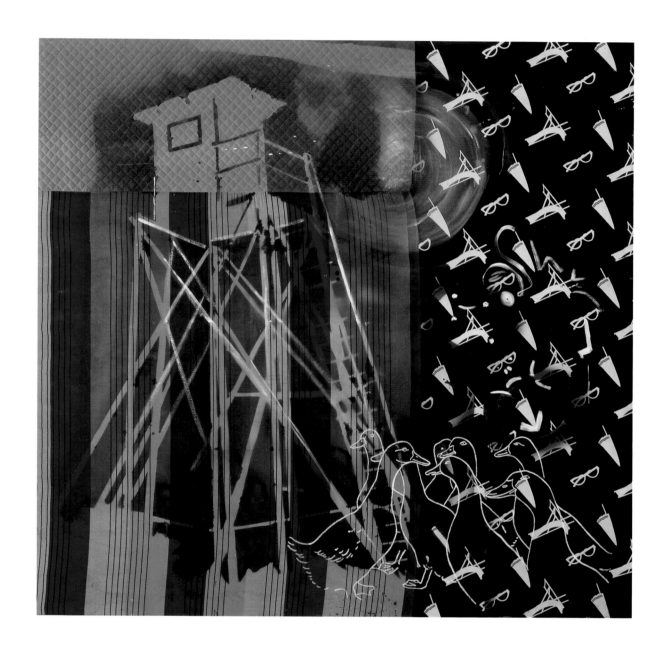

PLATE 51. *Hochsitz mit Gänse*
(Watchtower with Geese), 1987–88.
Artificial resin and acrylic on various
fabrics, 114¾₆ × 114¾₆ in. (290 ×
290 cm). The Art Institute of
Chicago, restricted gift in memory
of Marshall Frankel, Wilson L. Mead
Endowment, 1990.81.

PLATE 52. *Acrimonia*, 1986. Amber varnish, graphite dust, and silver oxide on canvas, 74¹³⁄₁₆ × 78¾ in. (190 × 200 cm). Private collection, Cologne.

PLATE 53. *Ratio*, 1986. Amber varnish, graphite dust, and silver oxide on canvas, 74¹³⁄₁₆ × 78¾ in. (190 × 200 cm). Private collection, Cologne.

PLATE 54. *Audatia*, 1986. Amber
varnish, graphite dust, and silver
oxide on canvas, 74¹³/₁₆ × 78¾ in.
(190 × 200 cm). Private collection,
Cologne.

PLATE 55. *Velocitas*, 1986. Amber
varnish, graphite dust, and silver
oxide on canvas, 74¹³/₁₆ × 78¾ in.
(190 × 200 cm). Private collection,
Cologne.

PLATE 56. *Helena's Australien*
(Helena's Australia), 1988. Artificial
resin and acrylic on fabric,
118⅛ × 88⁹⁄₁₆ in. (300 × 225 cm).
Private collection, Cologne.

PLATE 57. *Der Angler* (Fisherman),
1988. Artificial resin and acrylic on
fabric, 118⅛ × 88⅞₁₆ in. (300 ×
225 cm). Private collection, Cologne.

PLATE 58. *"Haute Couture ist viel zu tür"* ("Haute Couture Is Much Too Expensive"), 1988. Artificial resin and acrylic on fabric, 88⁹⁄₁₆ × 118⅛ in. (225 × 300 cm). Collection of Helen van der Meij, London.

PLATE 59. *Jeux d'enfants* (Children's
Games), 1988. Artificial resin
and acrylic on fabric, 86⅝ × 118⅛ in.
(220 × 300 cm). Musée National d'Art
Moderne, Centre Georges Pompi-
dou, Paris, Gift of the Society of
Friends of the MNAM (1989).

PLATE 60. *Le Jour de gloire est
arrivé . . .* (The Day of Glory Has
Come . . .), 1988. Artificial
resin and acrylic on fabric,
86 ⅝ × 118 ⅛ in. (220 × 300 cm).
Private collection, Paris.

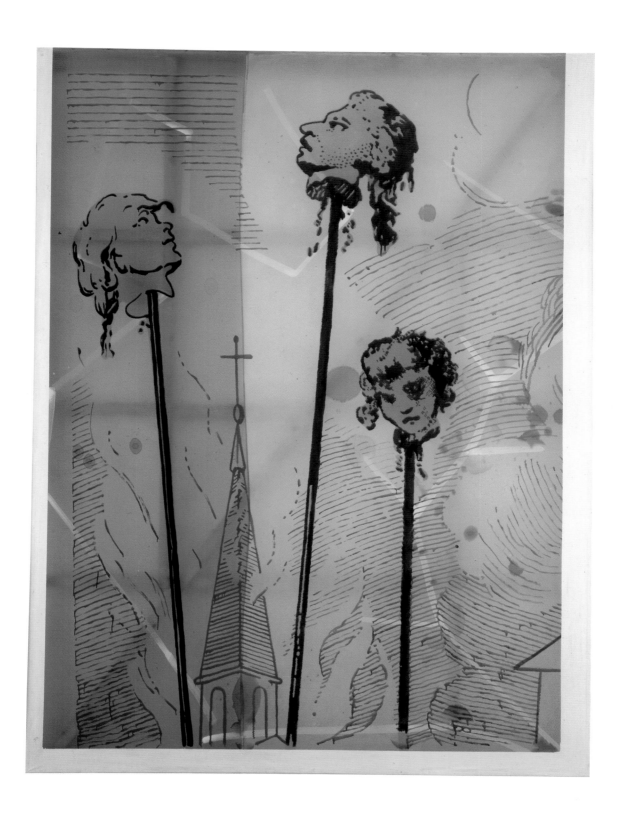

PLATE 61. *Liberté, Egalité, Fraternité*
(Liberty, Equality, Fraternity), 1988.
Artificial resin and acrylic on
fabric, 118⅛ × 78¾ in. (300 ×
200 cm). Galerie Crousel-Robelin/
Bama, Paris.

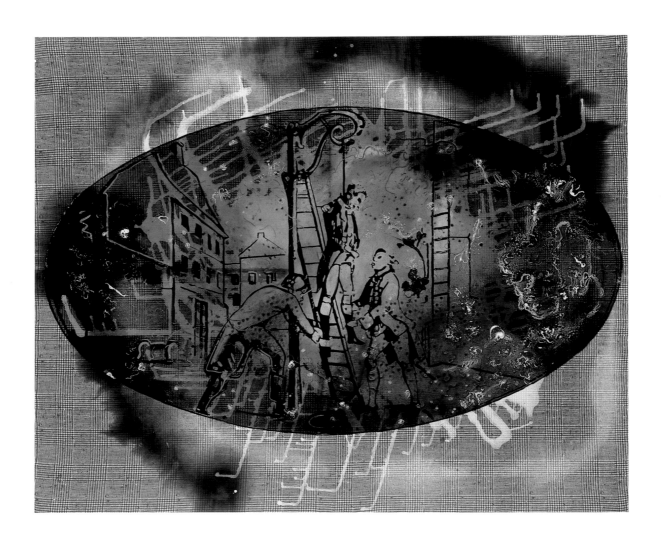

PLATE 62. *Médaillon* (Medallion),
1988. Artificial resin and acrylic on
fabric, 70⅞ × 78¾ in. (180 ×
200 cm). F. Roos Collection, Zug,
Switzerland.

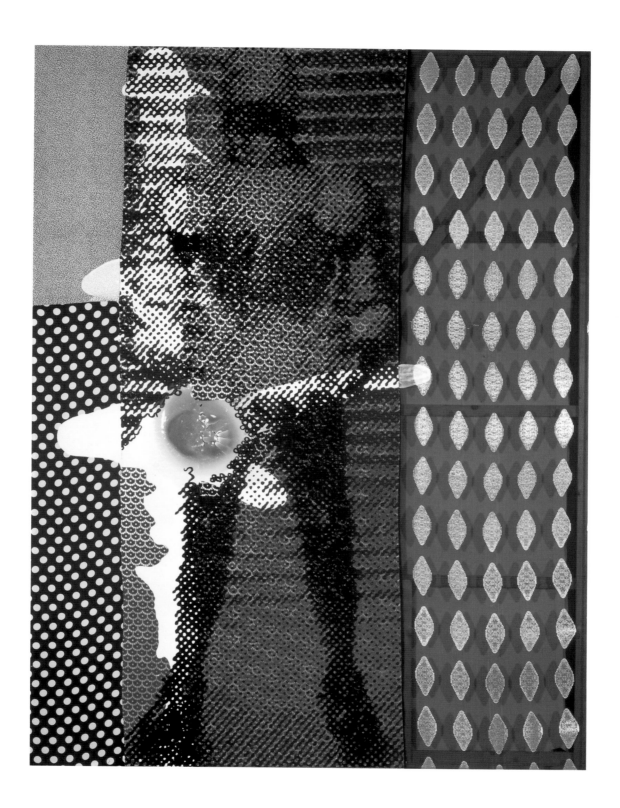

PLATE 63. *Der Ritter* (Knight), 1988.
Artificial resin and acrylic on
fabric, 118⅛ × 88⁹⁄₁₆ in. (300 ×
225 cm). ARC, Musée d'Art
Moderne de la Ville de Paris.

PLATE 64. *UFO* (UFO), 1988.
Artificial resin and acrylic on fabric,
47 ¼ × 47 ¼ in. (120 × 120 cm).
Private collection, Cologne.

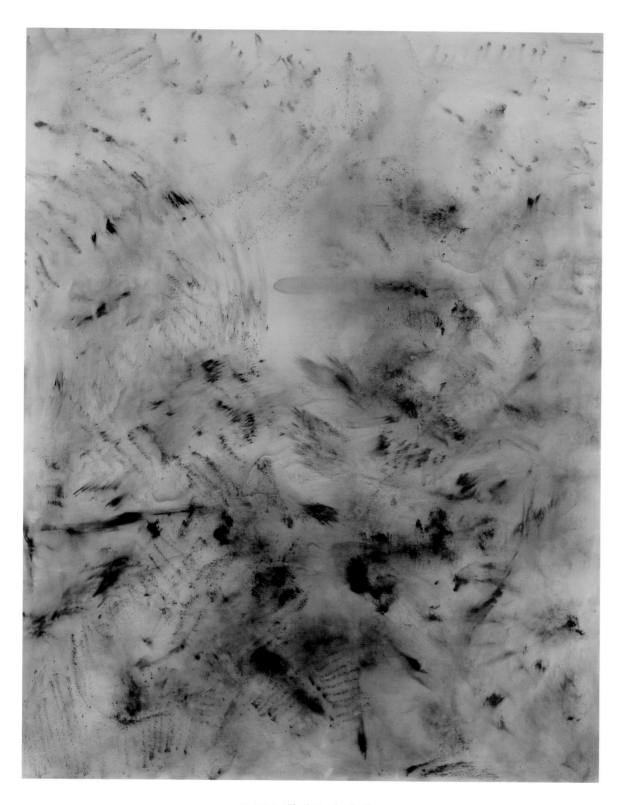

PLATE 65. *The Spirits that Lend Strength Are Invisible I* (*Tellurium Terrestrial Material*), 1988. Tellurium (pure) blown onto artificial resin on canvas, 157½ × 118⅛ in. (400 × 300 cm). Private collection, San Francisco.

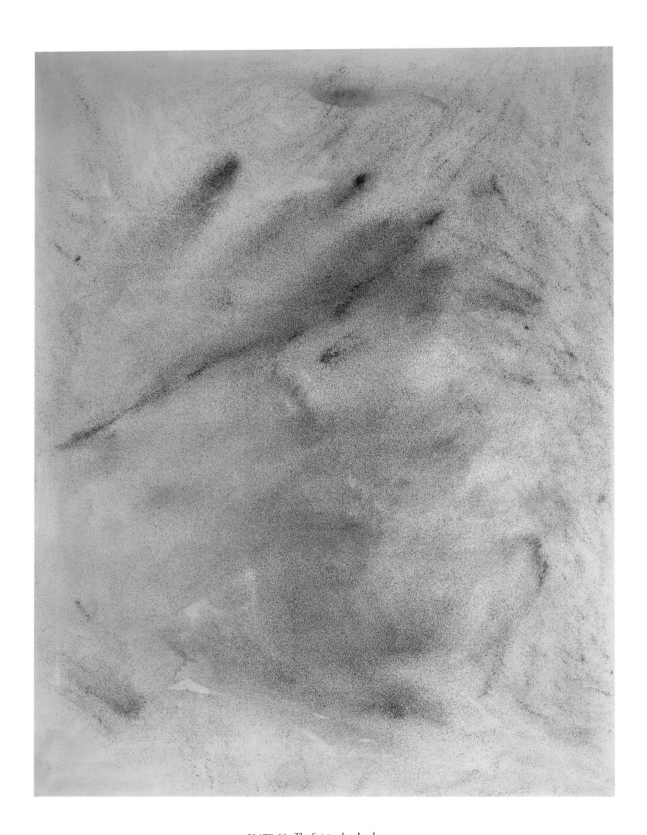

PLATE 66. *The Spirits that Lend Strength Are Invisible II (Meteor Extraterrestrial Material)*, 1988. 1 kg of meteoric granulate of a 15-kg meteor found in 1927 at 22°40′ south and 69° 59′ west of Tocopilla, thrown onto artificial resin on canvas, 157 ½ × 118 ⅛ in. (400 × 300 cm). Private collection, San Francisco.

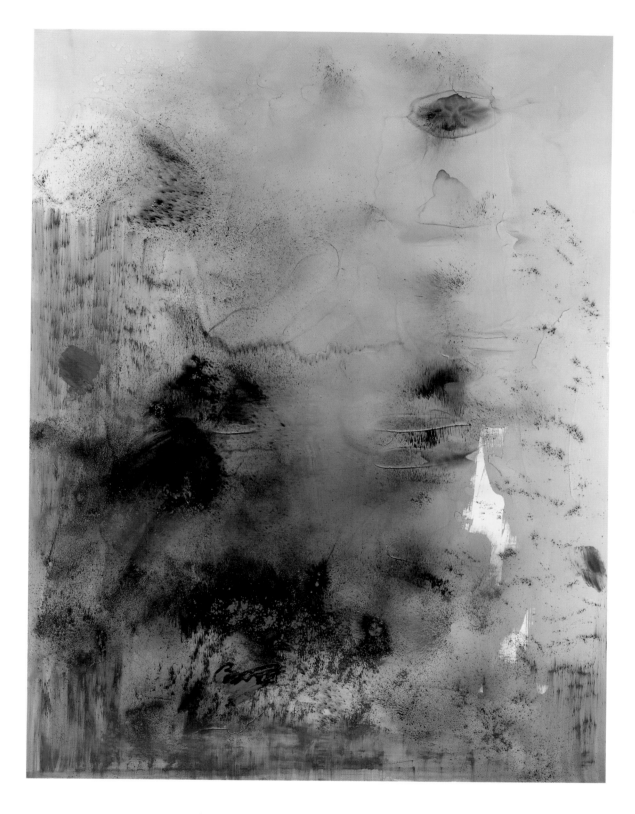

PLATE 67. *The Spirits that Lend Strength Are Invisible III (Nickel/Neusilber)*, 1988. Various layers of nickel incorporated in artificial resin on canvas, 157 ½ × 118 ⅛ in. (400 × 300 cm). San Francisco Museum of Modern Art. Gift of the friends of John Garland Bowes, William Edwards, and Donald G. Fisher and the Accessions Committee Fund: gift of Frances and John G. Bowes, Shirley and Thomas Davis, Mr. and Mrs. Donald G. Fisher, and Mimi and Peter Haas, 89.2.

PLATE 68. *The Spirits that Lend
Strength Are Invisible IV (Salt of Silver)*,
1988. Silver nitrate painted on
invisible, hermetic structure and
artificial resin on canvas,
118⅛ × 157 ½ in. (300 × 400 cm).
Collection of Mimi and Peter Haas,
San Francisco.

PLATE 69. *The Spirits that Lend
Strength Are Invisible V (Otter Creek)*,
1988. Silver leaf, neolithic tools, and
artificial resin on canvas, 118⅛ ×
157½ in. (300×400 cm). Collection
of John and Frances Bowes, San
Francisco.

PLATE 70. *Rasterzeichnung* (*Porträt Lee Harvey Oswald*) (Raster Drawing [Portrait of Lee Harvey Oswald]), 1963. Poster paint, pencil, and rubber stamp on paper, 37 5/16 × 27 3/8 in. (94.8 × 69.6 cm). Private collection, Cologne.

PLATE 71. [Drei Männer] (Three
Men), 1962–63. Poster paint on
wrapping paper, 26 ¹⁵⁄₁₆ × 20⅞ in.
(68.5 × 53 cm). Private collection,
Cologne.

PLATE 72. *Ohne Titel* [Linien]
(Untitled: Lines), 1963. Pen and ink
and poster paint on newsprint,
22⅝ × 21⅞ in. (57.5 × 55.6 cm).
Private collection, Cologne.

PLATE 73. [Schwarz, Rot, Gold]
(Black, Red, Gold), 1962–63. Poster
paint and pen and ink on newsprint,
15¹⁄₁₆ × 21⅞ in. (38.3 × 55.5 cm).
Private collection, Cologne.

PLATE 74. [Mutter und Kind] (Mother and Child), 1963. Poster paint on kraft paper, 41 5/16 × 29 7/16 in. (105 × 74.7 cm). Private collection, Cologne.

PLATE 75. [Paar] (Pair), 1963. Poster paint on kraft paper, 41 9/16 × 29 1/8 in. (105.5 × 74 cm). Private collection, Cologne.

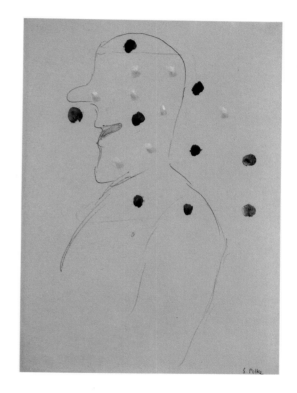

PLATE 76. *A-Mann* (A-Man), 1963.
Poster paint on kraft paper, 41⁵⁄₁₆ ×
29⁷⁄₁₆ in. (105 × 74.7 cm). Private
collection, Cologne.

PLATE 77. *Ohne Titel* (Untitled: Man
and Dots), 1963. Ballpoint pen,
watercolor, whitewash, and lacquer
on paper, 11⁵⁄₈ × 8¼ in. (29.6 ×
21 cm). Private collection.

PLATE 78. *Butter*, 1963. Ballpoint pen and watercolor on paper, 11⅝ × 8¼ in. (29.6 × 21 cm). Private collection.

PLATE 79. *Pralinen* (Pralines), 1963. Ballpoint pen and watercolor on paper, 11⅝ × 8¼ in. (29.6 × 21 cm). Private collection.

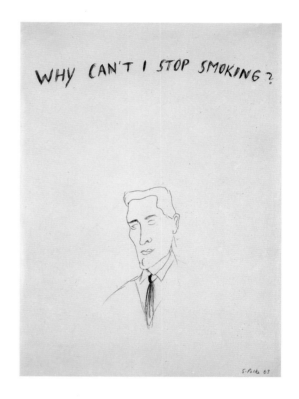

PLATE 80. *Hemden in allen Farben*
(Shirts in All Colors), 1963. Ballpoint
pen and watercolor on paper,
11 ¹¹⁄₁₆ × 8 ⅜ in. (29.7 × 21.2 cm).
Private collection.

PLATE 81. *Why Can't I Stop Smoking?*,
1963. Ballpoint pen on paper,
11 ¹¹⁄₁₆ × 8 ¼ in. (29.7 × 21 cm). Private
collection.

PLATE 82. *Richter: Ab September ständig im Kino* (Richter: Starting September in a Theater near You), 1965. Ballpoint pen and pencil on paper, 11 ¹¹⁄₁₆ × 8 ¼ in. (29.7 × 21 cm). Private collection.

PLATE 83. *Schlankheit durch Richter* (Slimming through Richter), 1965. Ballpoint pen on paper, 11 ¹¹⁄₁₆ × 8 ¼ in. (29.7 × 21 cm). Private collection.

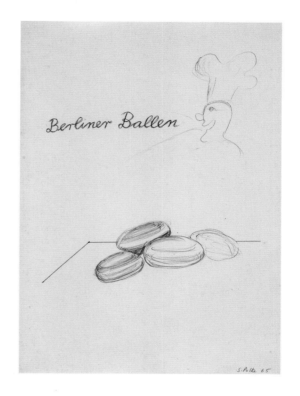

PLATE 84. *Capriccio* 2, 1963–65.
Watercolor and wash on paper,
11 11/16 × 8 ¼ in. (29.7 × 21 cm). Private
collection, Cologne.

PLATE 85. *Berliner Ballen* (Buns),
1965. Ballpoint pen on paper, 11 5/8 ×
8 ¼ in. (29.7 × 21 cm). Private
collection.

PLATE 86. [Punkte] (Dots), 1963.
Ballpoint pen and watercolor on
paper, 11¹¹⁄₁₆ × 8⁵⁄₁₆ in. (29.7 ×
21.1 cm). Private collection.

PLATE 87. [Punkte] (Dots), 1963.
Watercolor on paper, 24⅝ × 20¼ in.
(62.5 × 51.5 cm). The Froehlich
Collection, Stuttgart.

PLATE 88. *Ohne Titel* (Untitled:
Vase), 1965. Ballpoint pen on paper,
11¹¹⁄₁₆ × 8¼ in. (29.7 × 21 cm). Private
collection.

PLATE 89. *Ohne Titel* (Untitled:
Floating Triangles), 1966. Watercolor
on paper, 11¹¹⁄₁₆ × 8¼ in. (29.7 ×
21 cm). Private collection.

PLATE 90. *Ohne Titel* [Kuss, Kuss]
(Untitled: Kiss, Kiss), 1965. Gouache
and watercolor on paper, 27 9/16 ×
35 7/16 in. (70 × 90 cm). The Dr. Speck
Collection, Cologne.

PLATE 91. *Ohne Titel* (Untitled:
Woman's Face), 1967. Watercolor on
paper, 39⅛ × 27⁹⁄₁₆ in. (100 × 70 cm).
Museum of Fine Arts, Bern, Toni
Gerber Collection, Donation 1983.

PLATE 92. *Kartoffelpyramide in
Zwirners Keller* (Potato Pyramid in
Zwirner's Cellar), 1969. Ballpoint
pen, watercolor, and Rapidograph
on paper, 11 $^{11}\!/_{16}$ × 8 $^{1}\!/_{4}$ in. (29.7 ×
21 cm). Private collection.

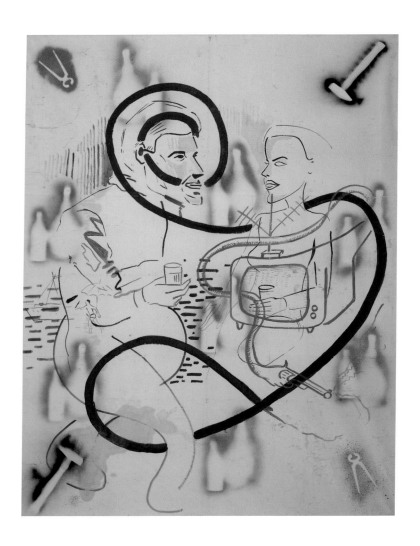

PLATE 93. *Ohne Titel* (Untitled:
Couple and Television), 1971.
Gouache and mixed media on paper
mounted on canvas, 91 × 69 in.
(231.1 × 175.3 cm). Private collection,
San Francisco.

PLATE 94. *Ohne Titel* [Ornament]
(Untitled: Ornament), 1980.
Gouache on paper, 39⅛ × 27⁹⁄₁₆ in.
(100×70 cm). Kunstmuseum, Bonn,
permanent loan from private
collection.

PLATE 95. *Ohne Titel* (Untitled: Coin
and Moose), 1981. Gouache on
paper, 39 ⅛ × 27 ⁹⁄₁₆ in. (100 ×
70 cm). Kunstmuseum, Bonn,
permanent loan from private
collection.

PLATE 96. *Telefonzeichnung* (Tele-
phone Drawing), 1975. Felt-tip pen,
ballpoint pen, and pencil on paper,
27 9/16 × 39 3/8 in. (70 × 100 cm).
Museum of Fine Arts, Bern, Toni
Gerber Collection, Donation 1983.

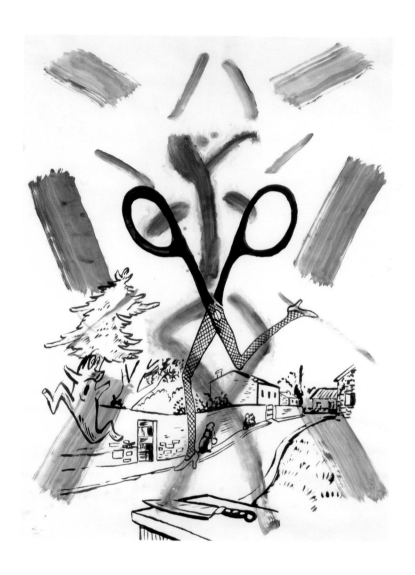

PLATE 97. *Ohne Titel* [Rennende
Schere] (Untitled: Running Scissors),
1981. Gouache on paper, 39 1/16 ×
27 3/8 in. (99.5 × 69.5 cm). Collection
of Udo and Anette Brandhorst,
Cologne.

BIOGRAPHY, EXHIBITION HISTORY
AND SELECTED REVIEWS

Biography

1941
Born 13 February in Oels, Silesia (now Olesnica, Poland)

1953
Emigrated to West Germany

1959
Studied glass painting in Düsseldorf–Kaiserwerth

1961–67
Studied at the Künstakademie (Art Academy), Düsseldorf,
 under Karl Otto Goetz and Gerhard Hoehme

1966
German Youth Art Prize (with Klaus Geldmacher and Dieter
 Krieg)
First one-person shows, Berlin and Düsseldorf

1970–71
Lecturer at Hochschule für bildende Künste (Academy of Fine
 Arts), Hamburg

1975
Painting Prize, XIII São Paulo Bienal
Professor at the Hochschule für bildende Künste (Academy of
 Fine Arts), Hamburg

1982
Will Grohmann Prize of the City of Berlin

1984
Kurt Schwitters Prize of the City of Hannover

1986
Golden Lion Prize for painting, XLII Venice Biennale

1987
Lichtwark Prize of the City of Hamburg

1990
International Prize for Painting of the State of Baden–
 Württemberg
Lives and works in Cologne

Solo Exhibitions
(listed chronologically)

1966
Galerie h, Hanover (with Gerhard Richter). Catalogue.
"Sigmar Polke." Galerie René Block, Berlin. Catalogue.
 Review by Heinz Ohff, *Der Tagesspiegel*, 15 May.
"Hommage à Schmela." Galerie Schmela, Düsseldorf.

1967
"Sigmar Polke: Neue Bilder." Galerie Heiner Friedrich,
 Munich.

1968
Galerie René Block, Berlin, and "Kunstmarkt," Cologne.

1969
Galerie René Block, Berlin.
Galerie Rudolf Zwirner, Cologne.

1970
Galerie Heiner Friedrich, Munich (with Chris Kohlhöfer).
"Sigmar Polke." Galerie Konrad Fischer, Düsseldorf.
Kabinett für aktuelle Kunst, Bremerhaven.
"Bilder und Zeichnungen." Galerie Toni Gerber, Bern.
Galerie Thomas Borgmann, Cologne.
Galerie Michael Werner, Cologne.

1971
Galerie Ernst, Hanover.
Galerie Konrad Fischer, Düsseldorf.

1972
Galerie Rochus Kowallek, Frankfurt.
Galerie Michael Werner, Cologne.
"Zeichnungen." Galerie Graphikmeyer, Karlsruhe.
Galerie im Goethe-Institut, Provisorium, Amsterdam.
"Der Dürer-Hase und Anderes: Arbeiten, 1964–1972." Galerie
 Toni Gerber, Bern.

1973
Galerie Konrad Fischer, Düsseldorf.
"Franz Liszt kommt gern zu mir zum Fernsehen" (with Achim
 Duchow). Westfälisches Kunstverein, Münster. Catalogue.
"Sigmar Polke: Bilder." Galerie Michael Werner, Cologne.
Galerie Loehr, Frankfurt. Review by Susanne Müller-Hanpft,
 Kunstwerk (September): 77–78.

1974
Galerie Loehr, Frankfurt.
"Original + Falschung" (with Achim Duchow). Städtisches
 Kunstmuseum, Bonn. Catalogue by Dierk Stemmler.
Galerie Cornels, Baden-Baden.
"Hallo Shiva." Galerie Toni Gerber/Bea Hegnauer, Zurich.
"Sigmar Polke." Galerie Klein, Bonn.
Galerie Springer, Berlin.
"Sigmar Polke: Bilder." Galerie Michael Werner and Thomas
 Borgmann in the Galerie Rudolf Zwirner, Cologne.

1975
Galerie Klein, Bonn.
"Mu Nieltman Netorruprup" (with Achim Duchow). Kunst-
 halle and Schleswig-Holsteinischer Kunstverein, Kiel.

Catalogue includes "Verzeichnis der Druckgrafik, 1966–1974" by Carl Vogel.

Galerie Michael Werner, Cologne.

"Day by Day They Take Some Brain Away" (with Georg Baselitz and Blinky Palermo). XIII Bienal, São Paulo. Catalogue.

1976

"Bilder, Tücher, Objekte: Werkauswahl, 1962–1971." Kunsthalle, Tübingen. Traveled to Städtische Kunsthalle, Düsseldorf; and Stedelijk Van Abbemuseum, Eindhoven. Catalogue by B. H. D. Buchloh. Reviews by Wolfgang Rainer, *Stuttgarter Zeitung*, 26 February, p. 30; Günther Wirth, *Kunstwerk* (June): 32, 69.

"Seriaal." Helen van der Meij, Amsterdam.

"Wir Kleinbürger: Zeitgenossinnen und Zeitgenossen." Galerie Toni Gerber, Bern.

1977

"Sigmar Polke: Fotos/Achim Duchow: Projektionen." Kunstverein, Kassel. Catalogue.

Galerie Klein, Bonn.

1978

Galerie Centro, Oldenburg.

"Sigmar Polke: Fotos." Galerie Gerhild Grolitsch, Munich.

"Sigmar Polke." InK, Halle für internationale neue Kunst, Zurich. Catalogue by Christel Saur.

"Sigmar Polke." Galerie Hetzler & Keller, Stuttgart.

1979

Galerie Bama, Paris.

Galerie Klein, Bonn.

1980

Galerie Klein, Bonn. Review by Annelie Pohlen, *Kunstforum* 38:244, ill.

Galerie Rudolf Zwirner, Cologne.

1981

"Sie fliegen wieder." Galerie Toni Gerber, Bern. Review in *Weltwoche*, 15 July, p. 24.

1982

"Sigmar Polke." Galerie Bama, Paris.

"Sigmar Polke: Works, 1972–1981." Holly Solomon Gallery, New York. Reviews by Michael Klein, *Art News* (September): 156; Thomas Lawson, *Artforum* (October): 67, ill.; Roberta Smith, *Village Voice*, 25 May, p. 88.

1983

Oldenburger Kunstverein, Oldenburg.

"Zeichnungen, 1963–1968." Galerie Michael Werner, Cologne. Catalogue by A. R. Penck. Reviews by Annelie Pohlen, *Artforum* (November): 90–91, ill.; *Kunstforum* 63–64: 349, ill.

"Skizzenbuch aus der Jahre 1968–1969." Städtisches Museum Abteiberg, Mönchengladbach. Catalogue is facsimile sketchbook. Reviews by Barbara Catoir, *Frankfurter Allgemeine Zeitung*, 18 February, p. 21, ill.; Laszlo Glozer, *Süddeutsche Zeitung*, 25 February, p. 16, ill.

"Sigmar Polke: Carte . . . Foto . . . Tele." Studio d'Arte Cannaviello, Milan.

"Sigmar Polke: Paris, Febr.–März 71, Serie 39 Fotounikate." Galerie Thomas Borgmann, Cologne.

"Sigmar Polke: Retrospektive." Galerie Toni Gerber, Bern.

"Sigmar Polke." Museum Boymans-van Beuningen, Rotterdam. Traveled to Städtisches Kunstmuseum, Bonn, 1984. Catalogue. Reviews by Saskia Bos, *Artforum* (Summer 1984): 102, ill.; Annelie Pohlen, *Du* 4 (1984): 68, ill.; Renate Puvogel, *Kunstwerk* (June): 59–60, ill.; Wolf Schön, *Rheinischer Merkur*, 24 February 1984, p. 18, ill.; Karin Thomas, *Weltkunst* 6 (1984): 728–29.

1984

Galerie Klein, Bonn. Reviews by Lucie Beyer, *Flash Art* (April–May): 41–42, ill.; Annelie Pohlen, *Du* 4:68, ill.

Galerie Nächst St. Stephan, Vienna. Review in *Die Presse*, 29 March, p. 5.

"Sigmar Polke." Kunsthaus, Zurich. Traveled to Josef-Haubrich Kunsthalle, Cologne. Catalogue by Harald Szeemann, Dietrich Helms, Siegfried Gohr, and Rainer Speck. Reviews by Laszlo Glozer, *Süddeutsche Zeitung*, 27 April, p. 37, ill.; Klaus Honnef, *Kunstforum* 71–72:132–207, ill.; Jan Marek, *Weltwoche*, 12 April, p. 51, ill.; Hans-Joachim Müller, *Die Zeit*, 4 May, p. 46; Elke Trappschuh, *Handelsblatt*, 5 October, p. B5; *Frankfurter Rundschau*, 10 October, p. 15, ill.; *Neue Zürcher Zeitung*, 5 April, p. 39.

"Sigmar Polke: Paintings." Marian Goodman Gallery, New York. Reviews by Kay Larson, *New York*, 4 June, pp. 70–71; John Russell, *New York Times*, 11 May, p. C20; Jeanne Silverthorne, *Artforum* (October): 89–90, ill.; Roberta Smith, *Village Voice*, 29 May, p. 85, ill.

1985

Mary Boone/Michael Werner Gallery, New York. Reviews by Robert Berlind, *Art in America* (April): 201–2, ill.; Michael Brenson, *New York Times*, 11 January, p. C21, ill.; Jean Fisher, *Artforum* (May): 102–3, ill.; Nancy Grimes, *Art News* (April): 136–37, ill.; Kim Levin, *Village Voice*, 29 January, pp. 81, 94; Therese Lichtenstein, *Arts* (March): 37–38, ill.; Simeón Sainz, *Figura* [Spain] 4:21–23, ill.; Mary Anne Staniszewski, *Manhattan, Inc.* (January): 101, ill.

"Sigmar Polke." Galerie Bama, Paris.

"Sigmar Polke: Recent Paintings." Anthony d'Offay Gallery, London. Review by Tony Godfrey, *Burlington Magazine* (April): 251, ill. 249.

Alfred Kren Gallery, New York. Catalogue. Review by Stephen Frailey, *Print Collector's Newsletter* (July–August): 77–80, ill.

Galerie Schmela, Düsseldorf.

"Sigmar Polke: Neue Bilder." Galerie Toni Gerber, Bern.

1986

"Sigmar Polke." Mary Boone/Michael Werner Gallery, New York. Reviews by Ronald Jones, *Artscribe* (May 1987): 76–77, ill.; Donald Kuspit, *Artforum* (February 1987): 111–12, ill.; Gerald Marzorati, *Vanity Fair* (November): 143, ill.; Joseph Masheck, *New York Times*, 14 November, p. C30, ill.; Maurice Poirier, *Art News* (February 1987): 127–28, ill.

"Sigmar Polke: Bilder." Thomas Borgmann-Kunsthandel, Cologne.

138 "Sigmar Polke: Farbproben—Material Versuche—Probier-
bilder aus den Jahren 1973–1986." Galerie Klein, Bonn.
Athanor. XLII Biennale, Venice. Catalogue. Reviews by Michael
Brenson, *New York Times,* 13 July, pp. 29, 33, ill.; Milton
Gendel, *Art in America* (October): 31, ill. 30; Paul Groot,
Artforum (September): 118–19, ill.; Jürgen Hohmeyer, *Der
Spiegel,* 23 June, pp. 160–63; Robert Hughes, *Time,* 14 July,
pp. 67–68; Gary Indiana, *Village Voice,* 5 August, p. 78, ill.;
Alfred Nemeczek, *Art: Das Kunstmagazin* (August): 78, 85, ill.;
Michael Newman, *Artscribe* (September–October): 54, ill.;
Wolfgang Rainer, *Stuttgarter Zeitung,* 30 May, p. 10; Dierk
Stemmler, *Kunstforum* 85:82–187, ill.; Max Wechsler, *Artforum*
(October): 142, ill.
"Sigmar Polke: Titel gibt's nicht." Galerie Schmela, Düssel-
dorf. Reviews by Peter Winter, *Frankfurter Allgemeine Zeitung,*
10 April, p. 27, ill.; *Kunstwerk* (June): 67–68, ill.
"Sigmar Polke: Neue Bilder." Kunsthalle, Hamburg.
"Sigmar Polke: Offsets." Galerie Gabriele von Loeper, Hamburg.
"Sigmar Polke: Biennale Venedig 1986." Städtisches Museum
Abteiberg, Mönchengladbach. Catalogue. Review by Alfred
Aedtner, *Die Welt,* 28 November, p. 19.
"Sigmar Polke: Fotografie." Galerie Gugu Ernesto, Cologne.

1987
"Sigmar Polke: Drawings from the 1960s." David Nolan
Gallery, New York. Catalogue. Reviews by Donald Kuspit,
Art in America (January 1988): 130–31, ill.; Meyer Raphael
Rubinstein, *Arts Magazine* (February 1988): 30–32, ill.; Barry
Schwabsky, *Flash ArtNews* (October 1988): 8, ill.; Roberta
Smith, *New York Times,* 6 November, p. C32, ill.
"Sigmar Polke: Arbeiten auf Papier." Galerie Ha. Jo. Müller,
Cologne.

1988
"Sigmar Polke: Zeichnungen, Aquarelle, Skizzenbücher, 1962–
1988." Städtisches Kunstmuseum, Bonn. Catalogue by
Katharina Schmidt. Reviews by Tony Godfrey, *Art in America*
(November): 41, ill.; Isabelle Graw, *Flash Art* (October):
111, ill.; Martin Hentschel, *Artforum* (December): 134, ill.;
Johannes Meinhardt, *Kunstforum* 96:311–12, ill.; Peter
Winter, *Art International* 5 (Winter): 72, ill.
"Sigmar Polke." Musée d'Art Moderne de la Ville de Paris/
ARC. Catalogue. Reviews by Nicolas Bourriaud, *Flash Art*
(March 1989): 104, ill.; B[ice] C[uriger], *Parkett* 18:160–61,
ill.; Philippe Dagen, *Le Monde,* 16 November, p. 16; Claude
Gintz, *Art Press* (December): 68, ill.; Tom Holert, *Artscribe*
(March–April 1989): 89–90, ill.; Jill Lloyd, *Burlington
Magazine* (January 1989): 56–57, ill.; Jutta Martens, *NIKE* 26
(December 1988–February 1989): 37, ill.; Clio Mitchell, *Art
International* (Spring 1989): 51, ill.; Philippe Piguet, *L'Oeil*
(December): 76, ill.; Werner Spies, *Frankfurter Allgemeine
Zeitung,* 30 November, reprinted in the author's *Rosarot vor
Miami* (Munich, 1989).
"Sigmar Polke/Andy Warhol: From the Martin and Geertjan
Visser Collections." Museum Boymans-van Beuningen,
Rotterdam.
"Sigmar Polke: Drawings, 1963–1969." Mary Boone/Michael
Werner Gallery, New York. Review by Roberta Smith, *New
York Times,* 26 February, p. C28.
"Sigmar Polke: Peintures récentes." Galerie Crousel-Robelin/
Bama, Paris. Reviews by Bernard Marcadé, *Artforum* (Summer

1989): 154–55, ill.; Nicolas Bourriaud, *Flash Art* (March
1989): 104, ill.

1989
"Sigmar Polke: Photographien, Paris 1971." Jablonka Galerie,
Cologne. Catalogue.
"Sigmar Polke." Mary Boone Gallery, New York. Catalogue.
Reviews by Kim Levin, *Village Voice,* 25 April, p. 91; Barry
Schwabsky, *Arts Magazine* (October): 81, ill.; Peter Schjeldahl,
Seven Days, 26 April, pp. 66–67, ill.; Roberta Smith, *New York
Times,* 7 April, p. C22, ill.
"Carl Andre, Sigmar Polke." Kunstforum, Munich. Catalogue.
Review by Rainer Metzger, *Flash Art* (November–December):
146, ill. 147.

1990
"Sigmar Polke: Fotografien." Staatliche Kunsthalle, Baden-
Baden. Catalogue edited by Jochen Poetter. Review by
Stephan Berg, *Kunstforum* 107:340–42, ill.
"Sigmar Polke: Arbeiten auf Papier." Galerie Marie-Louise
Werth, Hochfelden, Switzerland.
"Sigmar Polke: Peintures récentes." Galerie Crousel-Robelin/
Bama, Paris. Reviews by Liliana Albertazzi, *Contemporanea*
(May): 99, ill.; Nicholas Bourriaud, *Flash Art* (May–June):
163, ill.; Joseph Sims, *Arts Magazine* (May): 125, ill.

Group Exhibitions and Reviews

1963
"Demonstrative Ausstellung in Düsseldorf, Kaiserstrasse"
(with Manfred Kuttner, Konrad Lueg, and Gerhard Richter).

1964
"Neodada Pop Decollage Kapitalistischer Realismus." Galerie
René Block, Berlin. Reviews by Heinz Ohff, *Kunst* (June–
July): 126, ill., and *Studio International* (December): 262–63,
ill.
"Neue Realisten." Galerie Parnass, Wuppertal.

1965
"Lueg, Polke, Richter." Galerie Orez, The Hague.
Galerie Heiner Friedrich, Munich (with Joseph Beuys and
Cy Twombly).
Galerie h, Hanover.
Galerie PRO, Bad Godesburg.
"Hommage à Berlin." Galerie René Block, Berlin. Catalogue.
"Phänomene und Realitäten." Galerie René Block bei Rowohlt-
Verlag, Reinbeck bei Hamburg. Catalogue.
"Tendenzen." Städtisches Museum, Trier. Catalogue.

1966
"Deutscher Künstlerbund 14. Ausstellung." Essen. Catalogue.
"Düsseldorfer Künstler." Kunstverein, Wolfsburg.
"Extra." Städtisches Museum, Wiesbaden. Catalogue by
Clemens Weiler.
"Junge Generation: Maler und Bilder in Deutschland." Akade-
mie der Künste, Berlin. Catalogue.
"Kunstpreis der deutschen Jugend." Staatliche Kunsthalle,
Baden-Baden. Review by Hans Alexander Baier, *Kunst*
22–24:409.
"Das Nichtbarocke in der Kunst." Galerie René Block, Berlin.

1967

"Artypo." Stedelijk Van Abbemuseum, Eindhoven. Catalogue.

"Kunst Markt." Cologne. Catalogue.

"Demonstrative 1967." Galerie Heiner Friedrich, Munich.

"Hommage à Lidice." Galerie René Block, Berlin. Traveled in 1968 to Caput Galerie, Hamburg; Galerie Spala, Prague. Catalogue.

"Neuer Realismus." Haus am Waldsee, Berlin. Traveled to Kunstverein, Brunswick. Catalogue.

"Figurationen." Württembergischer Kunstverein, Stuttgart. Catalogue by Dieter Honisch.

"Wege '67." Museum am Ostwall, Dortmund. Traveled to Goethe-Institut, Brussels. Catalogue.

1969

"Accrochage II." Onnasch-Galerie, Berlin.

"Blockade '69: Räume von Beuys, Palermo, Hödicke, Panamarenko, Lohaus, Giese, Knoebel, Ruthenbeck, Polke." Galerie René Block, Berlin. Catalogue.

"Kunst Markt Köln." Cologne. Catalogue.

"Düsseldorfer Szene." Kunstmuseum, Lucerne. Catalogue by Jean-Christophe Ammann. Review by Jean-Christophe Ammann, *Art International* (October): 68, ill.

"Industrie und Technik in der deutschen Malerei." Wilhelm Lehmbruck Museum, Duisberg. Catalogue by Siegfried Salzmann.

"Konzeption-Conception: Dokumentation einer heutigen Kunstrichtung." Städtisches Museum Schloss Morsbroich, Leverkusen. Catalogue by Rolf Wedewer and Konrad Fischer.

"Neue Landschaften." Galerie von Loeper, Hamburg. Catalogue by Dorothea Neumeister.

"Sammlung Helmut Klinker." Städtisches Museum, Bochum. Catalogue.

1970

"Jetzt: Kunst in Deutschland heute." Kunsthalle, Cologne. Catalogue.

"Malerei nach Fotografie: Von der Camera Obscura bis zur Pop Art." Münchener Stadtmuseum, Munich. Catalogue.

"New Multiple Art." Whitechapel Art Gallery, London. Catalogue.

"Objects." Philadelphia Museum of Art. Catalogue.

"Pop-Sammlung Beck." Rheinisches Landesmuseum, Bonn. Catalogue. Review in *Magazin Kunst* 39:1915, ill. 1914.

"Strategy: Get Arts." Richard DeMarco Gallery, Edinburgh International Festival. Catalogue.

"Zeichnungen I." Städtisches Museum Schloss Morsbroich, Leverkusen. Catalogue by Rolf Wedewer and Fred Jahn. Traveled to Kunsthaus, Hamburg; Kunstverein, Munich.

"Zeitgenossen." Kunsthalle, Recklinghausen. Catalogue by Thomas Grochowiak.

1971

"20 Deutsche." Onnasch-Galerie, Berlin, and Cologne. Catalogue.

"Düsseldorf: Stadt der Künstler." Kulturamt der Stadt Düsseldorf. Catalogue.

"Entwürfe, Partituren, Projekte: Zeichnungen." Galerie René Block, Berlin. Catalogue.

"Kölner Kunst Markt." Cologne. Catalogue.

"Fünf Sammler, Kunst unserer Zeit." Von der Heydt-Museum, Wuppertal. Catalogue.

"Multiples: The First Decade." Philadelphia Museum of Art. Catalogue by John L. Tancock.

"Polke, Palermo, Richter." Galerie Annemarie Verna, Zurich.

"Prospect 71, Projection." Städtische Kunsthalle, Düsseldorf. Traveled to Louisiana Museum, Humlebaek, Denmark. Catalogue.

1972

"Amsterdam Paris Düsseldorf." Solomon R. Guggenheim Museum, New York. Catalogue. Reviews by Elena Canavier, *Artweek*, 17 March 1973, pp. 1, 12; Carter Ratcliff, *Artforum* (December): 90.

"Kölner Kunst Markt." Cologne. Catalogue.

"Documenta 5." Documenta, Kassel. Catalogue.

"Zeichnungen 2." Städtisches Museum Schloss Morsbroich, Leverkusen. Catalogue by Rolf Wedewer.

"Zeichnungen der deutschen Avantgarde." Galerie im Taxispalais, Innsbruck. Catalogue by Peter Weiermair.

1973

"Aspekte der gegenwärtigen Kunst in Nordrhein-Westfalen." Städtisches Kunsthalle, Recklinghausen. Catalogue.

"Between 7." Städtische Kunsthalle, Düsseldorf. Catalogue, subtitled *Yes Sir, That's My Baby*. Traveled to Gallery House, Goethe-Institut, London, under title "Some 260 Miles from Here: Art from the Rhein-Ruhr Germany, 1973."

"Bilder, Objekte, Filme, Konzepte: Sammlung Herbig." Städtische Galerie im Lenbachhaus, Munich. Catalogue.

"Deutsche Zeichnungen der Gegenwart." Kunsthalle, Bielefeld. Catalogue by Carl Vogel. Traveled to Kunstverein, Oslo; Griffelkunst, Hamburg; Kulturgeschichtliches Museum, Osnabrück.

"Kunst aus Fotografie: Was machen Künstler heute mit Fotografie?" Kunstverein, Hanover. Catalogue.

"Medium Fotografie: Fotoarbeiten bildender Künstler von 1910 bis 1973." Städtisches Museum Schloss Morsbroich, Leverkusen. Traveled in 1974 to Kunstverein, Hamburg; Haus am Waldsee, Berlin; Westfälischer Kunstverein, Münster. Catalogue.

"Prospect '73: Maler/Painters/Peintres." Städtische Kunsthalle, Düsseldorf. Catalogue. Review by Klaus Honnef, *Kunstforum* 6–7:140.

1974

"Demonstrative Fotografie." Kunstverein, Heidelberg. Catalogue.

"First Exhibition." René Block Gallery, New York.

"Internationale Kunstmesse." Basel. Catalogue.

"Kunst bleibt Kunst: Projekt '74, Aspekte internationaler Kunst am Anfang der 70er Jahre." Wallraf-Richartz Museum and Kunsthalle, Cologne. Catalogue.

"Multiples: Ein Versuch die Entwicklung des Auflagenobjektes darzustellen/An Attempt to Present the Development of the Object-Edition." Neuer Berliner Kunstverein, Berlin. Catalogue.

"Neue Editionen." Galerie Edition Staeck, Heidelberg. Catalogue.

"Surrealität-Bildrealität, 1924–1974: In den unzähligen Bildern des Lebens." Städtische Kunsthalle, Düsseldorf. Traveled to Staatliche Kunsthalle, Baden-Baden, 1975. Catalogue.

1975
Galerie Bama, Paris.
"Internationale Kunstmesse." Basel. Catalogue.
"Tenth Exhibition." René Block Gallery, New York.

1977
"Documenta 6: Handzeichnungen, Utopisches Design, Bücher."
 Documenta, Kassel. Catalogue.
"Pejling af Tysk Kunst: 21 kunstnere fra Tyskland." Louisiana
 Museum, Humlebaek, Denmark. Catalogue. Review by
 Peter Winter, *Louisiana Revy* (February): 21, ill.

1978
"Works from the Crex Collection, Zurich/Werke aus der
 Sammlung Crex, Zurich." InK, Halle für internationale neue
 Kunst, Zurich. Traveled to Louisiana Museum, Humlebaek,
 Denmark; Städtische Galerie im Lenbachhaus, Munich;
 Stedelijk Van Abbemuseum, Eindhoven. Catalogue.
"Internationale Kunstmesse." Basel. Catalogue.
"The Book of the Art of Artists' Books." Teheran Museum of
 Contemporary Art. Catalogue.

1979
"Für Jochen Hiltmann: Eine Solidaritäts." Hochschule für
 bildende Künste, Hamburg. Catalogue.
"Fünf in Köln: Buthe, Polke, Rosenbach, Rühm, Schuler."
 Kunstverein, Cologne. Catalogue. Reviews by Werner
 Krüger, *Kölner Stadt-Anzeiger*, 23 January, p. 9; Annelie
 Pohlen, *Vorwärts*, 22 February, p. 25, and *Kunstforum* 31:210–
 11, ill.
"Schlaglichter: Ein Bestandsaufnahme aktueller Kunst im
 Rheinland." Rheinisches Landesmuseum, Bonn. Catalogue.
"Zeichen setzen durch Zeichnen." Kunstverein, Hamburg.
 Catalogue by Uwe M. Schneede and Gunther Gercken.
"With a Certain Smile?" InK, Halle für internationale neue
 Kunst, Zurich. Catalogue published in *InKDocumentation 4*.
 Reviews in *Flash Art* (October–November): 50; by Annelie
 Pohlen, *Kunstforum* 34:242, ill.
"30 Jahre Kunst in der Bundesrepublik Deutschland: Die
 Sammlung des Städtischen Kunstmuseums Bonn." Städ-
 tisches Kunstmuseum, Bonn. Catalogue.

1980
"Art in the Seventies." Biennale, Venice. Catalogue in *General
 Catalogue 1980*.
"De la photographie: 17 artistes allemands." Goethe-Institut,
 Paris. Catalogue.
"Treffpunkt Parnass Wuppertal, 1945–1965." Von der Heydt-
 Museum, Wuppertal. Catalogue.
"Vorstellungen und Wirklichkeit, 7 Aspekte subjektiver
 Fotografie." Städtisches Museum Schloss Morsbroich,
 Leverkusen. Traveled to Künstlerhaus, Vienna; Palais des
 Beaux-Arts, Brussels. Catalogue.

1981
"Art allemagne aujourd'hui: Différents Aspects de l'art actuel
 en République Féderale d'Allemagne." Musée d'Art Moderne
 de la Ville de Paris/ARC. Catalogue.
"Les Genevois collectionnent aspects de l'art d'aujourd'hui."
 Musée Rath and Musée d'Art et d'Histoire, Geneva.
 Catalogue.

"Avantgarden-Retrospektiv: Kunst nach 1945." Westfälischer
 Kunstverein, Münster. Catalogue.
"Highligts: Rückblick Oppenheim Studio Köln, 1973–1979."
 Städtisches Kunstmuseum, Bonn. Catalogue.
"A New Spirit in Painting." Royal Academy of Art, London.
 Catalogue.
"Westkunst: Zeitgenössische Kunst seit 1939." Rheinhallen,
 Cologne. Catalogue by Laszlo Glozer. Review by Peter
 Winter, *Kunstwerk* 6:34–36.

1982
"Avanguardia, Transavanguardia." Mura Aurealiane, Rome.
 Catalogue by Achille Bonito Oliva.
"Choix pour aujourd'hui." Centre Georges Pompidou, Paris.
 Catalogue.
"Crossroads Parnass: International Avant-Garde at Galerie
 Parnass, Wuppertal, 1949–1965." Goethe-Institut, London.
 Traveled to Goethe-Institut, Paris; Musées de la Ville de
 Bourges. Catalogue.
"Documenta 7." Documenta, Kassel. Catalogue. Reviews by
 Noel Frackman and Ruth Kaufmann, *Arts* (October): 96;
 Donald Kuspit, *Artforum* (September): 65–67, ill.; Annelie
 Pohlen, *Artforum* (September): 60.
"German Drawings of the 60s." Yale University Art Gallery,
 New Haven. Traveled to Art Gallery of Ontario, Toronto.
 Catalogue by Dorothea Dietrich-Boorsch. Review by Brooks
 Adams, *Print Collector's Newsletter* (May–June): 51, ill.
"Kunst nu/Kunst unserer Zeit." Groninger Museum, Gronin-
 gen, Netherlands. Catalogue.
"Kunstmuseum Düsseldorf, 20. Jahrhundert: Gemälde,
 Skulpturen, Objekte." Städtische Kunsthalle, Düsseldorf.
 Catalogue.
"Medium Fotografie 8: Künstler arbeiten mit Fotos." Kunst-
 halle, Kiel. Catalogue by Ulrich Bischoff and J. C. Jensen.
"'Nieuwe' Schilderkunst." Akademie voor Beeldende Kunsten,
 Arnhem, Netherlands. Catalogue.
"Sammlung Ulbricht." Städtisches Kunstmuseum, Bonn.
 Traveled to Neue Galerie am Landesmuseum Joanneum,
 Graz; Kunstmuseum, Düsseldorf. Catalogue.
"Vergangenheit, Gegenwart, Zukunft: Zeitgenössische Kunst
 und Architektur." Württembergischer Kunstverein, Stutt-
 gart. Catalogue.
"Werke aus der Sammlung Crex/Works from the Crex
 Collection." Kunsthalle, Basel. Catalogue by Christel Saur
 and Jean-Christophe Ammann.
"Zeitgeist." Martin-Gropius-Bau, Berlin. Catalogue edited by
 Christos M. Joachimides and Norman Rosenthal. Review by
 J[ürgen] H[ohmeyer], *Der Spiegel*, 11 October, p. 241.
"Bilder und Zeichnungen." Galerie Gugu Ernesto, Cologne.

1983
"Kunst mit Photographie: Die Sammlung Dr. Rolf H. Krauss."
 Nationalgalerie, Berlin. Traveled to Kunstverein, Cologne;
 in 1984 to Stadtmuseum, Munich; Kunsthalle, Kiel;
 Schleswig-Holsteinischer Kunstverein, Stuttgart. Catalogue
 by Rolf H. Krauss, Manfred Schmalriede, and Michael
 Schwartz.
"Kunst nach 45 aus Frankfurter Privatbesitz." Kunstverein,
 Steinernes Haus am Römerburg, Frankfurt. Catalogue.

[Anselm Kiefer, Georg Baselitz, Marcus Lupertz, A. R. Penck, Sigmar Polke, Gerhard Richter, Blinky Palermo]. Marian Goodman Gallery, New York. Review by Roberta Smith, *Village Voice*, 20 June, p. 97.

"New Art at the Tate Gallery, 1983." Tate Gallery, London. Catalogue by Michael Compton.

"To the Happy Few: Bücher, Bilder, Objekte aus der Sammlung Reiner Speck." Kunstmuseen, Krefeld. Catalogue.

"Works on Paper." Anthony d'Offay Gallery, London.

"Michael Buthe: Briefe/Sigmar Polke: Zeichnungen." Galerie Toni Gerber, Bern.

"Zeichnung, Gouache, Collage." Galerie Gugu Ernesto, Cologne.

"Zeichnungen, Arbeiten auf Papier." Kunstverein, Oldenburg. Catalogue.

"Paintings, Installations." Stedelijk Van Abbemuseum, Eindhoven.

"Photo, Reihen." Galerie Elke Dröscher, Frankfurt.

"Kosmische Bilder in der Kunst des 20. Jahrhunderts." Staatliche Kunsthalle, Baden-Baden. Catalogue.

1984

"Aspekte der Schönheit in der zeitgenössischen Kunst." Städtische Kunsthalle, Düsseldorf. Catalogue.

"Aufbrüche: Manifeste, Manifestationen." Städtische Kunsthalle, Düsseldorf. Catalogue edited by Klaus Schrenk.

"Drawings." Mary Boone/Michael Werner Gallery, New York.

"La Grande Parade: Hoogtepunten van de schilderkunst na 1940/Highlights in Painting after 1940." Stedelijk Museum, Amsterdam. Catalogue.

"An International Survey of Recent Painting and Sculpture." The Museum of Modern Art, New York. Catalogue by Kynaston McShine.

"Little Arena: Drawings and Sculptures from the Collection of Adri, Martin, and Geertjan Visser." Rijksmuseum Kröller-Müller, Otterlo. Catalogue.

"ROSC '84: The Poetry of Vision." Dublin, Ireland. Review by Klaus Honnef, *Kunstforum* 75:172.

"Medium Fotografie." Galerie Gugu Ernesto, Cologne.

"Treppen: 30 Künstler zu einem Thema." Galerie Gugu Ernesto, Cologne.

"Umgang mit der Aura: Lichtbild, Abbild, Sinnbild." Städtische Galerie, Regensberg. Catalogue by Veit Loers.

"Von hier aus: 2 Monate neue deutsche Kunst in Düsseldorf." Messegelände Halle, Düsseldorf. Catalogue by Kaspar König. Review by Annelie Pohlen, *Kunstforum* 75:39, 43, ill. 86–87.

"Contemporary Perspectives 1984." Center Gallery, Bucknell University, Lewisburg, Pennsylvania. Traveled to Sordoni Art Gallery, Wilkes College, Wilkes-Barre, Pennsylvania. Catalogue.

1985

"Alles und noch viel mehr: Das poetische ABC, die Katalog Anthologie der 80er Jahre." Kunsthalle and Kunstmuseum, Bern. Catalogue.

"Arbeiten auf Papier." Galerie Loehrl, Mönchengladbach.

"Carnegie International." Museum of Art, Carnegie Institute, Pittsburgh. Catalogue, introduction by John R. Lane and John Caldwell. Review by Jan van der Marck, *Art in America* (May 1986): 51.

"Deutsche Kunst seit 1960: Aus der Sammlung Prinz Franz von Bayern." Staatsgalerie moderner Kunst, Munich. Catalogue.

"The European Iceberg: Creativity in Germany and Italy Today." Art Gallery of Ontario, Toronto. Catalogue by Germano Celant.

"Nouvelle Biennale de Paris, 1985." Grande Halle de la Villette, Paris. Catalogue. Reviews by Jaako Lintinen, *Taide* [Finland] 25:3, pp. 40–45, 61, ill.; Peter Weibel, *Wolkenkratzer Art Journal* (April–June): 62, 63, ill.

"Genommen Kurven: 20 Jahre Edition Staeck." Kunstmuseum, Düsseldorf. Catalogue.

"German Art in the Twentieth Century: Painting and Sculpture, 1905–1985." Royal Academy of Art, London. Traveled to Staatsgalerie, Stuttgart, in 1986. German edition of catalogue titled *Deutsche Kunst im 20. Jahrhundert: Malerei und Plastik, 1905–1985*. Reviews by Nena Dimitrijevic, *Flash Art* (February–March 1986): 56; David Elliot, *Burlington Magazine* (December): 852, 855, ill. 857; Robert Hughes, *Time*, 23 December, p. 75; Heinrich Klotz, *Wolkenkratzer Art Journal* (April–June 1986): 88.

"Måleriska Resor." Galerie Leger, Malmö, Sweden.

"Rheingold: 40 Künstler aus Köln und Düsseldorf/40 Artisti da Colonia e Düsseldorf." Palazzo della Società Promotrice delle Belle Arti, Turin. Catalogue by Wolf Herzogengrath and Stephan von Wiese.

"100 Jahre Kunst in Deutschland, 1885–1985." Weiterbildungszentrum, Ingelheim am Rhein. Catalogue.

"1945–1985: Kunst in der Bundesrepublik Deutschland." Nationalgalerie, Berlin. Catalogue by Lucius Grisebach, Jürgen Schweinebraden, and Freiherr von Wichmann-Eichhorn.

"Vom Zeichnung, Aspekte der Zeichnung, 1960–1985." Kunstverein, Frankfurt. Catalogue.

"Zeichner in Düsseldorf, 1955–1985." Kunstmuseum, Düsseldorf. Catalogue.

"Medium Photographie." Kunstverein, Oldenburg.

"Zeichnungen aus Köln." Edition Hundertmark, Cologne.

"Zoographie: Tiere in der zeitgenössischen Kunst." Galerie Gmyrek, Düsseldorf. Catalogue.

1986

"Accrochage: Baselitz, Beuys, Höckelmann, Penck, Polke, Richter." Thomas Borgmann-Kunsthandel, Cologne.

"Das Automobil in der Kunst, 1886–1986." Haus der Kunst, Munich. Catalogue by Reimar Zellar.

"Tableaux abstraits." Centre national d'art contemporaine, Villa Arson, Nice. Catalogue.

"Europa/Amerika: Die Geschichte einer künstlerischen Faszination seit 1940." Museum Ludwig, Cologne. Catalogue.

"Falls the Shadow, Recent British and European Art: 1986 Hayward Annual." Hayward Gallery, London. Catalogue.

"Beuys zu ehren." Städtische Galerie im Lenbachhaus, Munich. Catalogue by Armin Zweite.

"Kunst als Kultur = Art as Culture: Recent Art from Germany." Wesleyan University, Middletown, Connecticut. Catalogue.

"Ooghoogte/Eye Level: Stedelijk Van Abbemuseum, 1936–1986." Stedelijk Van Abbemuseum, Eindhoven. Catalogue.

"Origins, Originality, and Beyond: The Sixth Biennale of Sydney." The Biennale, Sydney, Australia. Catalogue.

"Positionen: Malerei aus der Bundesrepublik Deutschland." Neue Berliner Galerie, Berlin. Traveled to Albertinum, Dresden. Catalogue.

142

"Prospect '86: Eine internationale Ausstellung aktueller Kunst." Kunstverein and Schirn Kunsthalle, Frankfurt. Catalogue. Review by Stuart Morgan, *Artscribe* (January–February 1987): 79.

"Die Sammlung Toni Gerber im Kunstmuseum Bern." Kunstmuseum, Bern. Catalogue.

"Die 60er Jahre: Köln, Weg zur Kunstmetropole, vom Happening zum Kunstmarkt." Kunstverein, Cologne. Catalogue.

"The Spiritual in Art: Abstract Painting, 1890–1985." Los Angeles County Museum of Art. Traveled in 1987 to Museum of Contemporary Art, Chicago; Haags Gemeentemuseum, The Hague. Catalogue. Review by Raimund Stecker, *Kunstforum* 91 (1987): 305–6.

"Wild, Visionary, Spiritual: New German Art." Art Gallery of South Australia, Adelaide. Traveled to Art Gallery of Western Australia, Perth; National Art Gallery, Wellington, New Zealand. Catalogue by Ron Radford, Karl Ruhrberg, and Wolfgang Max Faust.

Anthony d'Offay Gallery, London.

Dietmar Werle, Cologne.

Galerie Gabriele von Loeper, Hamburg.

"Focus on the Image: Selections from the Rivendell Collection." Phoenix Art Museum. Traveled in 1987–1990 to Museum of Art, University of Oklahoma, Norman; Munson-Williams-Proctor Institute Museum of Art, Utica, New York; University of South Florida Art Galleries, Tampa; Lakeview Museum of Arts and Sciences, Lakeview, Illinois; University Art Museum, California State University, Long Beach; Laguna Gloria Art Museum, Austin, Texas. Catalogue published by The Art Museum Association of America.

1987

"Accrochage." Galerie Michael Werner, Cologne.

"Avant-Garde in the Eighties." Los Angeles County Museum of Art. Catalogue by Howard N. Fox.

"Brennpunkt Düsseldorf, 1962–1987." Kunstmuseum, Düsseldorf. Catalogue.

"L'Époque, la mode, la morale, la passion: Aspects de l'art d'aujourd'hui, 1977–1987." Centre Georges Pompidou, Paris. Catalogue.

"Exotische Welten, Europäische Phantasien." Württembergischer Kunstverein, Stuttgart. Catalogue.

Galerie Neuendorf, Frankfurt. Catalogue.

"Implosion: Eet Postmodernt Perpektiv/A Postmodern Perspective." Moderna Museet, Stockholm. Catalogue.

"Künstlichkeit und Wirklichkeit." Volkshochschule, Wuppertal. Catalogue.

"Multiples." Galerie Daniel Buchholz, Cologne.

"Warhol/Beuys/Polke." Milwaukee Art Museum. Traveled to Contemporary Arts Museum, Houston. Catalogue. Reviews by Dean Jensen, *Art News* (September): 154, ill.; Morgan T. Paine, *New Art Examiner* (November): 53–54.

"Menschenbild aus der Maschine." Galerie Sonne, Berlin.

"Tableaux abstraits." Centre nationale d'art contemporain, Villa Arson, Nice. Catalogue.

"Perspectives cavalières." Ecole régionale supérieure d'expression plastique, Tourcoing, France. Catalogue.

"Waldungen: Die Deutschen und ihr Wald." Akademie der Künste, Berlin. Catalogue by Bernd Weyergraf.

"Watercolors by Joseph Beuys, Blinky Palermo, Sigmar Polke, Gerhard Richter." Goethe-Institut, London. Catalogue. Review by Michael Phillipson, *Artscribe* (Summer): 71.

"Works on Paper." Anthony d'Offay Gallery, London.

"Zauber der Medusa: Europäische Manierismen." Wiener Künstlerhaus, Vienna. Catalogue by Werner Hofmann.

1988

"Arbeit in Geschichte, Geschichte in Arbeit." Kunsthaus and Kunstverein, Hamburg. Catalogue by Georg Bussmann.

"Carnegie International." Carnegie Museum of Art, Pittsburgh. Catalogue. Reviews by Alan G. Artner, *Chicago Tribune*, 13 November, sec. 13, p. 15; Michael Brenson, *New York Times*, 15 January 1989, p. 38; Nancy Spector, *Contemporanea* (January–February 1989): 105.

"Punt de confluència: Joseph Beuys, Düsseldorf, 1962–1987." Centre National de la Fundació Caixa de Pensions, Barcelona. Catalogue.

"Joseph Beuys, Sigmar Polke, Cy Twombly." Hirschl & Adler Modern, New York. Catalogue.

"Köln sammelt: Zeitgenössische Kunst aus Kölner Privatbesitz." Museum Ludwig, Cologne. Catalogue.

" 'Das Licht von der anderen Seite': Teil II Fotografie." Monika Sprüth Galerie, Cologne.

"Made in Cologne." DuMont Kunsthalle, Cologne. Catalogue.

"Mythos Europa: Europa und der Stier im Zeitalter der industriellen Zivilisation." Kunsthalle, Bremen. Traveled to Wissenschaftszentrum, Bonn. Catalogue.

"The Saatchi Collection." Saatchi Collection, London. Reviews by William Feaver, *Vogue* [U.K.], May, p. 21, ill.; *The Observer*, 8 May, ill.

"Refigured Painting: The German Image, 1960–1988." Opened at Toledo Museum of Art; traveled in 1989 to Solomon R. Guggenheim Museum, New York; Williams College Museum of Art, Williamstown, Mass.; Kunstmuseum, Düsseldorf; Schirn Kunsthalle, Frankfurt. Catalogue edited by Thomas Krens, Michael Govan, and Joseph Thompson and published by the Solomon R. Guggenheim Museum; German edition titled *Neue Figuration: Deutsche Malerei, 1960–1988* and published by Prestel Verlag, Munich. Reviews by Michael Brenson, *New York Times*, 10 February 1989, p. C30, ill.; Nancy Grimes, *Art News* (May 1989): 162; Karen Wilkin, *New Criterion* (June 1989): 54.

"Zeichenkunst der Gegenwart: Sammlung Prinz Franz von Bayern." Staatliche Graphische Sammlung, Neue Pinakothek, Munich. Catalogue.

"Zeichnungen und Gouachen." Ernesto & Krips Galerie, Cologne.

"Graphik & Arbeiten auf Papier." Galerie Duden, Neckartailfingen, Germany.

"Ansichten." Westfälischer Kunstverein, Münster. Catalogue.

"Collage-Decollage." Galerie Silvia Menzel, Berlin.

1989

"The Alien View." Galerie Kammer, Hamburg.

"Art from Köln." Tate Gallery, Liverpool. Catalogue. Review by Merlin Carpenter, *Artscribe* (September–October): 77, 78.

"Bilderstreit: Widerspruch, Einheit, und Fragment in der Kunst seit 1960." Museum Ludwig, Cologne. Catalogue by Siegfried Gohr and Johannes Gachnang. Review by Max Wechsler, *Artforum* (September): 162.

"Blickpunkte I." Musée d'art contemporaine, Montreal. Catalogue by Manon Blanchette and Wolfgang Max Faust.

"Cragg, Gerz, Messager, Nordman, Polke." Galerie Crousel-Robelin/Bama, Paris.

"D & S Ausstellung." Kunstverein, Hamburg. Catalogue.

"Departures: Photography, 1924–1989." Hirschl & Adler Modern, New York. Catalogue.

"150 Jahre Kölnischer Kunstverein: Kölner Künstler, Kölner Galerien." Kunstverein, Cologne. Catalogue.

"Das Foto als autonomes Bild: Experimentelle Gestaltung, 1839–1989." Kunsthalle, Bielefeld. Catalogue.

"Über Unterwanderung/On Subversion." Galerie Sophia Ungers, Cologne.

"Magiciens de la terre." Centre Georges Pompidou, Paris. Catalogue. Review by Jean Fisher, *Artforum* (September): 158.

" 'Das Medium der Fotografie ist berechtigt, Denkanstösse zu geben': Sammlung F. C. Gundlach." Kunstverein, Hamburg. Catalogue.

"Modern Masters." Konsthall, Helsinki.

"Journeys, 1970–1989." Galerie Crousel-Robelin/Bama, Paris.

"Open Mind (Gesloten Circuits, Circuiti Chiusi)." Museum van Hedendaagse Kunst, Ghent. Catalogue.

"Peinture—Cinéma—Peinture." Centre de la Vieille Charité, Marseilles. Catalogue.

"Photo-Kunst: Arbeiten aus 150 Jahren." Staatsgalerie, Stuttgart. Catalogue by Ulrike Gauss.

"Photographs by Painters and Sculptors: Another Focus." Karsten Schubert, London.

"Repetition." Hirschl & Adler Modern, New York. Catalogue.

"Von Dürer bis Baselitz: Deutsche Zeichnungen aus dem Kupferstichkabinett der Hamburger Kunsthalle." Kunsthalle, Hamburg. Catalogue.

"Yves Klein, Brice Marden, Sigmar Polke." Hirschl & Adler Modern, New York. Catalogue.

1990

"The Fifth Essence." Gracie Mansion Gallery, New York.

"Affinities and Intuitions: The Gerald S. Elliott Collection of Contemporary Art." The Art Institute of Chicago. Catalogue by Neal Benezra.

"Die Graphik des kapitalistischen Realismus." Daniel Buchholz, Cologne.

"Kombination: Klaus Gaida, Sigmar Polke, Lothar Römer, Stephan Runge." Galerie Ha. Jo. Müller, Cologne.

"Energieen/Energies." Stedelijk Museum, Amsterdam. Review by Annie Jourdan, *Art Press* 148 (June): 88.

"Pharmakon '90." Makuhari Messe, Nippon Convention Center, Chiba.

BIBLIOGRAPHY

Exhibition catalogues and reviews of exhibitions are not included in this section and may be found under Exhibition History and Selected Reviews.
Eugenie Candau, Librarian
Louise Sloss Ackerman Fine Arts Library
San Francisco Museum of Modern Art

By Polke

1966
"Textcollage," with Gerhard Richter, in catalogue for joint exhibition at Galerie h, Hanover. Reprinted in *Bilder, Tücher, Objekte* (Tübingen: Kunsthalle, 1976) and *Sigmar Polke* (Zurich: Kunsthaus, 1984). Also translated and reprinted in *Gerhard Richter: 36. Biennale di Venezia* (1972); excerpts translated into Italian and English, with photographs, in *Flash Art* (1972): 14–15.

1968
". Höhere Wesen befehlen." Berlin: Edition 10, Galerie René Block. 4 drawings by Polke and 14 prints from photographs by Polke and Chris Kohlhöfer, published in an edition of 50 copies.

1969
Der ganze Körper fühlt sich leicht und möchte fliegen. In collaboration with Chris Kohlhöfer. 16mm, sound/color film.

1971
P.C.A.: Projecte, Concepte, & Actionen. Compiled by Walter Aue. Cologne: DuMont.

1972
Bizarre. Heidelberg: Edition Staeck.
"Sigmar Polke." *Interfunktionen* 8:2–13, ill.
"Eine Bildgeschichte." Text by Achim Duchow. *Interfunktionen* 9:1, folded leaf inserted.

1973
"Registro." *Interfunktionen* 10:15–24, ill. Text in *Bilder, Objekte, Filme, Konzepte: Sammlung Herbig.* Munich: Städtische Galerie im Lenbachhaus.

1979
Contribution to *With a Certain Smile?* Zurich: InK. Book published on the occasion of the exhibition, in addition to catalogue.

1983
"A Project." *Artforum* (December): 51–55.

1984
"Desastres and Other Full Wonders." *Parkett* 2, insert.
"Lernen Sie unsere kleinsten Mitarbeiter kennen." In *Sigmar Polke.* Rotterdam: Museum Boymans-van Beuningen.

1985
"La Peinture est une ignominie, interview par Bice Curiger." *Art Press* 91 (April): 4–10, ill.

1987
"Insert Sigmar Polke." *Parkett* 13:105–17.
Zeichnungen, 1963–1969. Edited by Johannes Gachnang. Bern: Gachnang & Springer. Review by Wolfgang Max Faust, *Wolkenkratzer Art Journal* (May–June 1988): 32–35, ill.

1988
"What Interests Me Is the Unforeseeable: Sigmar Polke Talks about His Work." *Flash Art* (May–June): 68–70, ill.

Books

Art of Our Time: The Saatchi Collection. Vol. 3, essay by Rudi Fuchs. London: Lund Humphries, 1984. Review by Sanford Schwartz, *New Criterion* (March 1986): 22, 23, 25, 26, 30–31, 34, 36.
Atkins, Robert. *ArtSpeak: A Guide to Contemporary Ideas, Movements, and Buzzwords.* New York: Abbeville Press, 1990.
Block, René. *Grafik des Kapitalistischen Realismus.* Berlin: Edition René Block, 1971.
————. *K. P. Brehmer, K. H. Hödicke, Sigmar Polke, Gerhard Richter, Wolf Vostell: Werkverzeichnisse der Druckgrafik, Sept. 1971 bis Mai 1976.* Berlin: Edition René Block, 1976. Vol. 2 of *Graphik den Kapitalistischen Realismus.*
Bonito Oliva, Achille. *Trans-Avant-Garde International.* Milan: Giancarlo Politi, 1982.
Celant, Germano. *Precronistoria, 1966–1969.* Florence: Centro Di, 1976.
La Collection du Musée National d'Art Moderne. Paris: Centre Georges Pompidou, 1986.
Deutschland Report: Inhaltsverzeichnis 4. Edited by Rochus Kowallek. Berlin: edition et, 1967.
Dienst, Rolf-Gunter. *Deutsche Kunst: Eine neue Generation.* Cologne: DuMont, 1970.
Distel, Herbert. *Das Schubladenmuseum/Le Musée en tiroirs/The Museum of Drawers.* Zurich: Kunsthaus, 1978.
Dorfles, Gillo. *Ultime tendenze nell'arte d'oggi: Dall'informale al concettuale.* Milan: Feltrinelli, 1978.
Faust, Wolfgang Max, and Gerd de Vries. *Hunger nach Bildern: Deutsche Malerie der Gegenwart.* Cologne: DuMont, 1982.
Godfrey, Tony. *The New Image: Painting in the 1980s.* New York: Abbeville Press, 1986.
Grasskamp, Walter. *Der vergessliche Engel: Künstlerportraits für Fortgeschrittene.* Munich: Silke Schreiber, 1986.
Hoffmann, Klaus. *Kunst-im-Kopf: Aspekte der Realkunst.* Cologne: DuMont, 1972.
Honnef, Klaus. *Contemporary Art.* Cologne: Taschen, 1988.
Jappe, Georg, ed. *Ressource Kunst: Die Elemente neu gesehen.* Cologne: DuMont, 1989.
Künstler Ateliers in Köln, 1985. Cologne: Wienand, 1985.
Kunst der Gegenwart: 1960 bis Ende der 80er Jahre. Mönchengladbach: Städtisches Museum Abteiberg, 1988.
Kunst in Berlin von 1870 bis Heute: Sammlung Berlinische Galerie. Berlin: Argonverlag, 1986.

KunstLandschaft BundesRepublik: Geschichte Regionen Materialen. Stuttgart: Klett-Cotta, 1984.

Lippard, Lucy R. *Pop Art.* New York: Praeger, 1966.

————. *Six Years: The Dematerialization of the Art Object from 1966 to 1972.* New York: Praeger, 1973.

Meister, Helga. *Die Kunstszene Düsseldorf.* Recklinghausen: Aurel Bongers, 1979.

Murken-Altrogge, Christa, and Axel Hinrich Murken. *Vom Expressionismus bis zur Soul and Body Art, "Prozesse der Freiheit": Moderne Malerei für Einsteiger.* Cologne: DuMont, 1985.

Neusüss, Floris M. *Das Fotogramm in der Kunst des 20. Jahrhunderts.* Cologne: DuMont, 1990.

New Art. New York: Abrams, 1984.

Ohff, Heinz. *Pop und die Folgen; oder, Die Kunst, Kunst auf der Strasse zu finden.* Düsseldorf: Droste, 1968.

Pradel, Jean-Louis, ed. *World Art Trends, 1983–1984.* New York: Abrams, 1984.

Prince, Richard, comp. *Inside World.* New York: Kent Fine Art and Thea Westreich, 1989. Also signed, limited edition of 250 copies and 8 artist's proofs, with original artwork.

Ruhrberg, Karl. *Twentieth-Century Art: Painting and Sculpture in the Ludwig Museum.* New York: Rizzoli, 1986.

Sager, Peter. *Neue Formen des Realismus: Kunst zwischen Illusion und Wirklichkeit.* Cologne: DuMont, 1973.

Schmidt-Wulfen, Stephan. *Spielregeln: Tendenzen der Gegenwartskunst.* Cologne: DuMont, 1987.

Schmied, Wieland. *Malerei nach 1945: In Deutschland, Österreich, und der Schweiz.* Frankfurt: Propyläen, 1974.

Schnackenburg, Bernhard, and Wilhelm Bojescul. *Kunst der sechziger Jahre in der Neuen Galerie Kassel.* Kassel: Staatliche Kunstsammlungen, 1982.

Selbstportraits/Weekend. Berlin: Galerie René Block, 1971. Catalogue of published editions.

Sigmar Polke. Kyoto: ArT RANDOM, Kyoto Shoin, forthcoming.

Spies, Werner. *Rosarot vor Miami: Ausflüge zu Kunst und Künstlern unseres Jahrhunderts.* Munich: Prestel, 1989.

Staeck, Klaus, ed. *Ohne die Rose tun wir's nicht: Für Joseph Beuys.* Heidelberg: Edition Staeck, 1986.

Städtisches Kunstmuseum Bonn: Sammlung deutscher Kunst seit 1945. Bonn: Städtisches Kunstmuseum, 1983.

A Survey of the Collection: Stedelijk Museum Amsterdam. Amsterdam: Stedelijk Museum, 1989.

Szeeman, Harald. *Individuelle Mythologien.* Berlin: Merve, 1985.

Tausend Blumen: Kulturlandschaft Nordrhein-Westfalen. Lothar Romain and Hartwig Suhrbier, eds. Wuppertal: Hammer, 1984.

Thomas, Karin. *Bis Heute.* Cologne: DuMont, 1971.

————. *Zweimal deutsche Kunst nach 1945: 40 Jahre Nähe und Ferne.* Cologne: DuMont, 1985.

Tiefe Blick: Kunst der achtziger Jahre aus der Bundesrepublik Deutschland, der DDR, Österreich, und der Schweiz. Cologne: DuMont, 1985.

Zeitgenössische Kunst in der Deutschen Bank Frankfurt. Frankfurt: Deutsche Bank, 1987.

Articles

1966

Motte, Manfred de la. "Junge deutsche Maler nach Pop." *Art International* (February): 21.

1967

Motte, Manfred de la. "L'Actualité artistique en Allemagne." *Aujourd'hui* (October): 164, ill.

Restany, Pierre. "Mechanische Malerei." *Kunstwerk* (February–March): 19, ill. 16

1970

Ammann, Jean-Christophe. "Zeit, Raum, Wachstum, Prozesse." *Du* (August): 547, ill. 548.

Jappe, Georg. "Wird Kunst ein Glaubensakt?: Sigmar Polke in Köln." *Frankfurter Allgemeine Zeitung,* 24 December, p. 11, ill.

1972

Jappe, Georg. "Young Artists in Germany." *Studio International* (February): 69–71, ill.

1973

Bongard, Willy. "Willy Bongard Sammlerporträt: Dr. Wolfgang Hock." *Kunstforum* 4–5:49–51, ill.

"Grafikmeyer." *Heute Kunst* (July–August): 28, ill.

N[abakowski], G[islind]. "Wer hat Angst vor Rot, Gelb, und Blau?" *Heute Kunst* (April): 9.

Ohff, Heinz. "Das neue Porträt; oder, Was ist neu daran?" *Kunstforum* 6–7:122, ill. 103.

Winkler, Gerd. "Kunst in Düsseldorf." *Kunstforum* 4–5:60, 61.

1976

Honnef, Klaus. "Allemagne: Une Pénétration critique de la réalité." *Art Actuel: Skira Annuel* 2:131.

Reise, Barbara M. "Who, What is 'Sigmar Polke'?: Parts I and II." *Studio International* (July–August): 83–86, ill.

————. "Who, What is 'Sigmar Polke'?: Part III." *Studio International* (September–October): 207–10, ill.

1977

"Dokumentation: Künstler fotografieren, 2. Teil." *Kunstforum* 20:[130–34], ill.

Reise, Barbara M. "Who, What is 'Sigmar Polke'?: Part IV." *Studio International* (January–February): 38–40, ill.

Wörsel, Troels. "Noter on tysk Kunst." *Louisiana Revy* (February): 32, ill.

1978

Flynn, Barbara. [Review of Gerhard Richter exhibition, discussing his association with Polke], *Artforum* (April): 62.31

1980

Bongard, Willy. "Hoffnungswerte: Die 100 kommanden Künstler." *Art Aktuel* (September): 973.

Kertess, Klaus. "Figuring It Out." *Artforum* (November): 35, ill. 36.

Pohlen, Annelie. "Irony, Rejection, and Concealed Dreams: Some Aspects of 'Painting' in Germany." *Flash Art* (January–February): 17–18, ill. Reprinted in *Flash Art, Two Decades of History: XXI Years.* Cambridge: MIT Press, 1990: 67–68, ill.

Sauerbier, S. D. "Zwischen Kunst und Literatur." *Kunstforum* 37:75, ill. 77.

1981

Mai, Ekkehard. "Ein 'neuer Historismus'?" *Kunstwerk* 34/3:33, ill.

Pohlen, Annelie. "Eros: Dauerbrenner in der Kunst." *Kunstforum* 46:33, ill. 58.

146 *1982*

Buchloh, Benjamin. "Parody and Appropriation in Francis
 Picabia and Sigmar Polke." *Artforum* (March): 28–34, ill.

Hohmeyer, Jürgen. "Die Alchemie der giftigen Bilder." *Der
 Spiegel*, 6 December, p. 220. Reprinted in *Sigmar Polke*.
 Zurich: Kunsthaus, 1984, pp. 89–90.

Grasskamp, Walter. "Handschrift ist verräterisch." *Kunstforum*
 50:47.

Kuspit, Donald B. "Acts of Aggression: German Painting Today,
 Part I." *Art in America* (September): 145–46, 147, ill. 143.

Passel, Bernhard, and Wolfgang Max Faust. "Worüber zu
 sprechen ist." *Kunstforum* 47:176–77, ill. 150.

1983

Groot, Paul, and Pieter Heynen. "Wat bezielt Sigmar Polke?
 Een paging tot analyse van een geliefd kunstenar." *Muse-
 umjournaal* 5:276–85, ill.

Kuspit, Donald B. "Acts of Aggression: German Painting Today,
 Part II." *Art in America* (January): 131–32, ill. 101.

1984

Curiger, Bice. "Sigmar Polke." *Parkett* 2:36–55, ill.

Frey, Patrick. "Sigmar Polke." *Flash Art* (Summer): 44–47, ill.

Grasskamp, Walter. "Kleinbürgerlicher Realismus: Sigmar
 Polkes Frühwerk." *Wolkenkratzer Art Journal* (April–May):
 40–42, ill. Reprinted in the author's *Der vergessliche Engel*.
 Munich: Silke Schreiber, 1986.

Honnef, Klaus. "Malerie als Abenteuer; oder, Kunst und
 Leben." *Kunstforum* 71–72:132–207, ill.

Pohlen, Annelie. "The Beautiful and Ugly Pictures: Some
 Aspects of German Art." *Art & Text* 12–13:60, 61, 63–64,
 65–66, ill.

1985

Fleischer, Alain. "Polke, peintre de la surimpression." *Art Press*
 (April): 10–12, ill.

Fuchs, Rudi. "Il repertorio ampliato. Sigmar Polke." *Tema
 Celeste* (November): 24–27, ill.

Gintz, Claude. "Polke's Slow Dissolve." *Art in America* (Decem-
 ber): 102–9, ill.

1986

Dimitrijevic, Nena. "Alice in Culturescapes." *Flash Art* (Sum-
 mer): 51–53, ill.

Faust, Wolfgang Max. "Cologne's Greatness." *Artscribe*
 (November–December): 32, ill. 33.

Grasskamp, Walter. "Erleuchtung in der Dunkelkammer
 Sigmar Polke." *Wolkenkratzer Art Journal* (September–
 October): 36–39, ill. Reprinted from the author's *Der
 vergessliche Engel*. Munich: Silke Schreiber, 1986, pp. 75–85.

Hegewisch, Katharina. "Polke: 'Die Ausbeutung der Ursachen
 durch die Wirkungen muss abgeschafft werden.' " *Art: Das
 Kunstmagazin* (May): 54–57, ill.

Herter, Joachim. "Zu Walter Grasskamp: 'Erleuchtung in der
 Dunkelkammer'—Ein Leserbrief." *Wolkenkratzer Art Journal*
 (November–December): 14.

Herzogenrath, Wolf. "Fotografie und Malerie bei Sigmar
 Polke." *Fotokritik* (November): 23–25, ill.

Marcadé, Bernard. "Sigmar Polke: La Droguerie de Polke."
 Artstudio 2 (Autumn): 118–31, ill.

Schnabel, Julian. "Julian Schnabel Interviewed by Matthew
 Collings." *Artscribe* 59 (September–October): 26–28.
 Reprinted in *Julian Schnabel: Paintings, 1975–1986*. London:
 Whitechapel Art Gallery, 1986.

"Sigmar Polke: Das Banale mit Liebe aufladen." *Art: Das
 Kunstmagazin* (May): 42–52, ill.

Stachelhaus, Heiner. "The Quick-Change Artist: Sigmar Polke
 at the Venice Biennale." *Kultur Chronik* 5:4–5, ill.

Taylor, Paul. "Café Deutschland." *Art News* (April): 70, 72–73,
 ill. 68, 71.

"Die Welt als Imagination—Die Imagination als Welt."
 Kunstforum 84:150, 152–53, ill.

1987

Ellis, Stephan. "Something Different." *Bomb* (Spring): 90–91,
 ill.

Koether, Jutta. "Under the Influence." *Flash Art* (April): 47, 49,
 50, ill.

Schnabel, Julian. "Julian Schnabel l'impatient: Interview par
 Catherine Millet." *Art Press* (January): 6, 9.

1988

Beyer, Lucie, and Karen Marta. "Why Cologne?" *Art in America*
 (December): 65, 66.

Groot, Paul. "Sigmar Polke: Impervious to Facile Interpreta-
 tions, Polke Wants to Reinstate the Mystery of the Painting."
 Flash Art (May–June): 66–70, ill. Includes artist's statements.
 Reprinted in *Bijutsu Techo* (January 1990): 86–96, ill.

Kuspit, Donald. "At the Tomb of the Unknown Picture."
 Artscribe (March): 38–45, ill.

Roustayi, Mina. "Crossover Tendencies: An Interview with
 Wolfgang Max Faust." *Arts Magazine* (February): 64, 65,
 ill. 63.

Schmidt-Wulffen, Stephen. "Fit for the Postmodern." *Flash Art*
 (January–February): 97–98, ill.

Storr, Robert. "Beuys's Boys." *Art in America* (March): 97–98,
 ill.

Tosatto, Guy. "Sigmar Polke: Le Malin Génie de la peinture."
 Beaux Arts Magazine (November): 66–71, ill.

1989

Fuchs, Rudi. "Chicago Lecture." *Tema Celeste* (January–March):
 50, 52, 53, ill. Revised, English version of a text originally
 published in Italian in *Tema Celeste* (March 1985).

Govan, Michael. "Romantic Strategies of Representation:
 Beuys, Penck, Polke." *Art & Design* 9–10:69–71.

Grasskamp, Walter. "Sigmar Polke: Illumination in the Dark-
 room." *Art & Design* 9–10:51–53, ill.

Hermes, Manfred. "Repetition, Disguises, Documents: How
 Photography Has Pervaded Two Decades of Contemporary
 German Art." *Flash Art* (October): 97–103, ill.

Klotz, Heinrich. "New German Painting." *Art & Design* 9–10:
 7, 8, 11, ill.

Zutter, Jörg. "Aufspüren unterdrückter Wahrheiten." *Berliner
 Kunstblatt* 62:31, 33, ill. 32.

1990

Drateln, Doris von. "Sigmar Polke." *Contemporanea* (January):
 38–45, ill.

Giuliano, Charles. "Damaged Goods." *Art News* (February):
 72, ill.

Hirai, Tadashi. [What Lies Behind German Contemporary
 Art?] *Bijutsu Techo* (January): 48–57, ill.

"Kritiker-Umfrage." *Kunst Intern* 4:98–99.

Nakamura, Keiji. [Anti-Painting. The Case of Polke and
 Richter.] *Bijutsu Techo* (January): 100–106, ill.

S[chmid], K[arlheinz]. "Hang zur Prominenz." *Kunst Intern*
 4:55, ill.

CHECKLIST OF THE EXHIBITION

Paintings

1. *Socken* (Socks), 1963. Oil on canvas, 27⁹/₁₆ × 39³/₈ in. (70 × 100 cm). Private collection, Cologne. Plate no. 2

2. *Tisch* (Table), 1963. Acrylic on canvas, 66¹⁵/₁₆ × 46⁷/₈ in. (170 × 119 cm). Private collection, Germany. Plate no. 3

3. *Plastik Wannen* (Plastic Tubs), 1964. Oil on canvas, 37³/₈ × 47¼ in. (95 × 120 cm). Collection of Linda and Harry Macklowe, New York. Plate no. 4

4. *Schokoladenbild* (Chocolate Painting), 1964. Lacquer on canvas, 35⁷/₁₆ × 39³/₈ in. (90 × 100 cm). Collection of Prof. Dr. Rainer Jacobs, Cologne. Plate no. 5

5. *Zwei Palmen* (Two Palm Trees), 1964. Artificial resin on fabric, 35⁷/₁₆ × 29½ in. (90 × 75 cm). Private collection, Cologne. Plate no. 13

6. *Berliner* (*Bäckerblume*) (Doughnuts), 1965. Acrylic on canvas, 63 × 49³/₁₆ in. (160 × 125 cm). The Garnatz Collection, Cologne. Plate no. 7

7. *Freundinnen* (Girlfriends), 1965. Acrylic on canvas, 59¹/₁₆ × 74¹³/₁₆ in. (150 × 190 cm). The Froehlich Collection, Stuttgart. Plate no. 8

8. *Liebespaar II* (Lovers II), 1965. Lacquer and oil on canvas, 74¹³/₁₆ × 55⁷/₈ in. (190 × 142 cm). Courtesy Thomas Ammann, Zurich. Plate no. 11

9. *Puppe* (Doll), 1965. Acrylic on canvas, 49³/₁₆ × 63 in. (125 × 160 cm). The Stober Collection, Berlin. Plate no. 6

10. *Schneeglöckchen* (Snowdrops), 1965. Acrylic and poster paint on plywood, 28³/₈ × 28³/₈ in. (72 × 72 cm). The Froehlich Collection, Stuttgart. Plate no. 10

11. *Bunnies*, 1966. Acrylic on canvas, 35⁷/₁₆ × 23⁵/₈ in. (90 × 60 cm). Private collection, New York. Frontispiece

12. *Japanische Tänzerinnen* (Japanese Dancers), 1966. Acrylic on canvas, 78¾ × 66¹⁵/₁₆ in. (200 × 170 cm). Private collection, New York. Plate no. 9

13. *Lila Form* (Lilac Form), 1967. Acrylic on fabric, 59¹/₁₆ × 49³/₁₆ in. (150 × 125 cm). Kunstmuseum, Bonn, Donation Ingrid Oppenheim. Plate no. 14

14. *Lösungen* (Solutions), 1967. Lacquer on burlap, 59¹/₁₆ × 49³/₁₆ in. (150 × 125 cm). The Dr. Speck Collection, Cologne. Plate no. 18

15. *Handlinien Links* (Lines of the Left Palm), 1968. Acrylic on Turkish blue Lurex, 61 × 49³/₁₆ in. (155 × 125 cm). Kunstmuseum, Bonn. Plate no. 20

16. *Handlinien Rechts* (Lines of the Right Palm), 1968. Acrylic on old rose Lurex, 61 × 49³/₁₆ in. (155 × 125 cm). Kunstmuseum, Bonn. Plate no. 21

17. *Moderne Kunst* (Modern Art), 1968. Acrylic on canvas, 59¹/₁₆ × 49³/₁₆ in. (150 × 125 cm). Private collection, Berlin. Plate no. 22

18. *Die 50er Jahre* (The Fifties), 1963–69. Mixed media on 12 canvases, installation dimensions variable. Karl Stroeher Foundation, Hessisches Landesmuseum, Darmstadt. Plate no. 12

19. *Höhere Wesen befahlen: rechte obere Ecke schwartz malen!* (Higher Powers Command: Paint the Upper Right Corner Black!), 1969. Lacquer on canvas, 59¹/₁₆ × 49⁷/₁₆ in. (150 × 125.5 cm). The Froehlich Collection, Stuttgart. Plate no. 19

20. *Ohne Titel* [*Kopf*] (Untitled: Head), 1969. Acrylic and casein on raw cotton, 44⁷/₈ × 39 in. (114 × 99 cm). Kunstmuseum, Bonn, extended loan from private collection. Plate no. 15

21. *Polkes gesammelte Werke* (Polke's Collected Works), 1969. Oil on cardboard, 15¾ × 59¹/₁₆ in. (40 × 150 cm). Jerry and Emily Spiegel Family Collection, New York. Plate no. 1

22. *Reiherbild IV* (Heron Painting IV), 1969. Acrylic on beaver cloth, 74¹³/₁₆ × 59¹/₁₆ in. (190 × 150 cm). The Garnatz Collection, Cologne. Plate no. 17

23. *Akt mit Salamandern* (Nude with Salamanders), 1971. Acrylic, spray paint, and artificial resin on fabric strips, 70⁷/₈ × 59¹/₁₆ in. (180 × 150 cm). Collection of Susan and Lewis Manilow, Chicago. Plate no. 16

24. *Alice im Wunderland* (Alice in Wonderland), 1971. Mixed media on fabric strips, 126 × 102³/₈ in. (320 × 260 cm). Private collection, Cologne. Plate no. 25

25. *Portrait of David Lamelas* (*Obelisk*), 1971. Acrylic and spray paint on canvas, 51³/₁₆ × 59¹/₁₆ in. (130 × 150 cm). Collection of Joseph E. and Arlene McHugh, Chicago. Plate no. 23

26. *Lucky Luke and His Friend*, 1971–75. Acrylic and oil on canvas, two panels, 51³/₁₆ × 43⁵/₁₆ in. (130 × 110 cm) each. The Dr. H. G. Lergon Collection, Rheinbach, Germany. Plate no. 24

27. *Hannibal mit seinen Panzerelephanten* (Hannibal with His Armored Elephants), 1982. Artificial resin on canvas, 102³/₈ × 78¾ in. (260 × 200 cm). Courtesy Gagosian Gallery, New York. Plate no. 32

28. *Lager* (Camp), 1982. Acrylic and spattered pigment on fabric and blanket, 177³/₁₆ × 98⁷/₁₆ in. (450 × 250 cm). Collection of Charlene Engelhard, Cambridge. Plate no. 46

148

29. *Magnetische Landschaft* (Magnetic Landscape), 1982. Acrylic and ferrous mica on canvas, 114³/₁₆ × 114³/₁₆ in. (290 × 290 cm). Raschdorf Collection, Düsseldorf. Plate no. 26

30. *Negativwert I: Alkor* (Negative Value I: Alkor), 1982. Oil, pigment of violets, and red lead underpainting on canvas, 102³/₈ × 78¾ in. (260 × 200 cm). Raschdorf Collection, Düsseldorf. Plate no. 34

31. *Negativwert II: Mizar* (Negative Value II: Mizar), 1982. Oil, pigment of violets, and red lead underpainting on canvas, 102³/₈ × 78¾ in. (260 × 200 cm). Raschdorf Collection, Düsseldorf. Plate no. 35

32. *Negativwert III: Aldebaran* (Negative Value III: Aldebaran), 1982. Oil and pigment of violets on canvas, 102³/₈ × 78¾ in. (260 × 200 cm). Raschdorf Collection, Düsseldorf. Plate no. 36

33. *Ohne Titel* (Untitled), 1982. Artificial resin and mixed media on canvas, 70⅞ × 59¹/₁₆ in. (180 × 150 cm). Raschdorf Collection, Düsseldorf. Plate no. 40

34. *Ohne Titel* (Untitled), 1982. Artificial resin and mixed media on canvas (triptych), 3 parts, 118 × 78¾ in. (300 × 200 cm) each. Collection of Gerald S. Elliott, Chicago. Plate no. 33

35. *Paganini* (Paganini), 1982. Acrylic on fabric, 78¾ × 177³/₁₆ in. (200 × 450 cm). Courtesy Thomas Ammann, Zurich. Plate no. 39

36. *Die Schere* (Scissors), 1982. Acrylic and ferrous mica on canvas, 114³/₁₆ × 114³/₁₆ in. (290 × 290 cm). Raschdorf Collection, Düsseldorf. Plate no. 27

37. *Schwarzer Mann* (Black Man), 1982. Artificial resin, alcohol-diluted pigment, and beeswax on canvas, 70⅞ × 59¹/₁₆ in. (180 × 150 cm). Raschdorf Collection, Düsseldorf. Plate no. 41

38. *Der Traum des Menelaos* (The Dream of Menelaus), 1982. Acrylic on canvas, 102³/₈ × 94½ in. (260 × 240 cm). Raschdorf Collection, Düsseldorf. Plate no. 28

39. *Der Traum des Menelaos II (Kuh und Schaf gehen zusammen aber der Adler steht allein)* (The Dream of Menelaus II [Cow and Sheep Go Together but the Eagle Stands Alone]), 1982. Acrylic and ferrous mica on canvas, 102³/₈ × 94½ in. (260 × 240 cm). Raschdorf Collection, Düsseldorf. Plate no. 29

40. *Der Traum des Menelaos III (Wolke)* (The Dream of Menelaus III [Cloud]), 1982. Acrylic on canvas, 102³/₈ × 94½ in. (260 × 240 cm). Raschdorf Collection, Düsseldorf. Plate no. 30

41. *Der Traum des Menelaos IV* (The Dream of Menelaus IV), 1982. Acrylic on canvas, 102³/₈ × 94½ in. (260 × 240 cm). Raschdorf Collection, Düsseldorf. Plate no. 31

42. *Treppenhaus* (Stairwell), 1982. Acrylic on fabric, 91⅝ × 158½ in. (232.7 × 402.5 cm). Hirshhorn Museum and Sculpture Garden, Smithsonian Institution, Washington, D.C. Museum purchase with funds provided by the Jacob and Charlotte Lehrman Foundation and the Holenia Purchase Fund, 1989. Plate no. 38

43. *Frau Tuchers Tuch* (Mrs. Tucher's Shawl), 1983. Artificial resin and acrylic on canvas, 102³/₈ × 78¾ in. (260 × 200 cm). Raschdorf Collection, Düsseldorf. Plate no. 43

44. *Hallucinogen* (Hallucinogen), 1983. Oil on canvas, 126 × 94½ in. (320 × 240 cm). Private collection, Cologne. Plate no. 37

45. *Die Lebenden stinken* (The Living Stink), 1983. Acrylic on fabric, 110¼ × 141¾ in. (280 × 360 cm). Jerry and Emily Spiegel Family Collection, New York. Plate no. 45

46. *Perücke* (Wig), 1983. Acrylic on fabric, 114³/₁₆ × 114³/₁₆ in. (290 × 290 cm). Raschdorf Collection, Düsseldorf. Plate no. 42

47. *So sitzen Sie richtig (nach Goya)* (This Is How You Sit Correctly [after Goya]), 1983. Acrylic on fabric, 78¾ × 74¹³/₁₆ in. (200 × 190 cm). Private collection, Germany. Plate no. 44

48. *Hochsitz* (Watchtower), 1984. Artificial resin and acrylic on canvas, 118⅛ × 87¹³/₁₆ in. (300 × 223 cm). Collection of Raymond Learsy, New York. Plate no. 47

49. *Hochsitz (Bufo Tenin)* (Watchtower [Bufo Tenin]), 1984. Silver, silver bromide, and natural resins on canvas, 118⅛ × 88³/₁₆ in. (300 × 224 cm). The Rivendell Collection, New York. Plate no. 48

50. *Hochsitz II* (Watchtower II), 1984–85. Silver, silver oxide, and artificial resin on canvas, 119¹¹/₁₆ × 88⁹/₁₆ in. (304 × 225 cm). The Carnegie Museum of Art, Pittsburgh, William R. Scott, Jr., Fund. Plate no. 49

51. *Hochsitz III* (Watchtower III), 1985. Silver, silver nitrite, iodine, Cobalt II, chloride, and artificial resin on canvas, 118⅛ × 88⁹/₁₆ in. (300 × 225 cm). Staatsgalerie Stuttgart, Germany. Plate no. 50

52. *Acrimonia*, 1986. Amber varnish, graphite dust, and silver oxide on canvas, 74¹³/₁₆ × 78¾ in. (190 × 200 cm). Private collection, Cologne. Plate no. 52

53. *Alacritas*, 1986. Amber varnish, graphite dust, and silver oxide on canvas, 74¹³/₁₆ × 78¾ in. (190 × 200 cm). Private collection, Cologne.

54. *Audatia*, 1986. Amber varnish, graphite dust, and silver oxide on canvas, 74¹³/₁₆ × 78¾ in. (190 × 200 cm). Private collection, Cologne. Plate no. 54

55. *Experientia*, 1986. Amber varnish, graphite dust, and silver oxide

on canvas, 74¹³/₁₆ × 78¾ in.
(190 × 200 cm). Private collection,
Cologne.

56. *Providentia*, 1986. Amber varnish,
graphite dust, and silver oxide
on canvas, 74¹³/₁₆ × 78¾ in.
(190 × 200 cm). Private collection,
Cologne.

57. *Ratio*, 1986. Amber varnish,
graphite dust, and silver oxide
on canvas, 74¹³/₁₆ × 78¾ in.
(190 × 200 cm). Private collection,
Cologne. Plate no. 53

58. *Velocitas*, 1986. Amber varnish,
graphite dust, and silver oxide
on canvas, 74¹³/₁₆ × 78¾ in.
(190 × 200 cm). Private collection,
Cologne. Plate no. 55

59. *Virilitas*, 1986. Amber varnish,
graphite dust, and silver oxide
on canvas, 74¹³/₁₆ × 78¾ in.
(190 × 200 cm). Private collection,
Cologne.

60. *Hochsitz mit Gänse* (Watchtower
with Geese), 1987–88. Artificial
resin and acrylic on various
fabrics, 114³/₁₆ × 114³/₁₆ in. (290 ×
290 cm). The Art Institute of
Chicago, restricted gift in
memory of Marshall Frankel,
Wilson L. Mead Endowment,
1990.81. Plate no. 51

61. *Der Angler* (Fisherman), 1988.
Artificial resin and acrylic
on fabric, 118⅛ × 88⁹/₁₆ in.
(300 × 225 cm). Private collection,
Cologne. Plate no. 57

62. *"Haute Couture ist viel zu tür"*
("Haute Couture Is Much Too
Expensive"), 1988. Artificial resin
and acrylic on fabric, 88⁹/₁₆ ×
118⅛ in. (225 × 300 cm). Collec-
tion of Helen van der Meij,
London. Plate no. 58

63. *Helena's Australien* (Helena's
Australia), 1988. Artificial resin
and acrylic on fabric, 118⅛ ×
88⁹/₁₆ in. (300 × 225 cm). Private
collection, Cologne. Plate no. 56

64. *Jeux d'enfants* (Children's Games),
1988. Artificial resin and acrylic
on fabric, 86⅝ × 118⅛ in. (220 ×
300 cm). Musée National d'Art

Moderne, Centre Georges
Pompidou, Paris, Gift of the
Society of Friends of the MNAM
(1989). Plate no. 59

65. *Le Jour de gloire est arrivé . . .* (The
Day of Glory Has Come . . .),
1988. Artificial resin and acrylic
on fabric, 86⅝ × 118⅛ in.
(220 × 300 cm). Private collection,
Paris. Plate no. 60

66. *Liberté, Egalité, Fraternité* (Liberty,
Equality, Fraternity), 1988.
Artificial resin and acrylic on
fabric, 118⅛ × 78¾ in. (300 ×
200 cm). Galerie Crousel-
Robelin/Bama, Paris. Plate
no. 61

67. *Médaillon* (Medallion), 1988.
Artificial resin and acrylic on
fabric, 70⅞ × 78¾ in. (180 ×
200 cm). F. Roos Collection, Zug,
Switzerland. Plate no. 62

68. *Der Ritter* (Knight), 1988. Artifi-
cial resin and acrylic on fabric,
118⅛ × 88⁹/₁₆ in. (300 × 225 cm).
ARC, Musée d'Art Moderne
de la Ville de Paris. Plate no. 63

69. *The Spirits that Lend Strength Are
Invisible I* (Tellurium Terrestrial
Material), 1988. Tellurium (pure)
blown onto artificial resin on
canvas, 157½ × 118⅛ in. (400 ×
300 cm). Private collection, San
Francisco. Plate no. 65

70. *The Spirits that Lend Strength Are
Invisible II* (Meteor Extraterrestrial
Material), 1988. 1 kg of meteoric
granulate of a 15-kg meteor
found in 1927 at 22°40' south
and 69° 59' west of Tocopilla,
thrown onto artificial resin on
canvas, 157½ × 118⅛ in.
(400 × 300 cm). Private collection,
San Francisco. Plate no. 66

71. *The Spirits that Lend Strength Are
Invisible III* (Nickel/Neusilber),
1988. Various layers of nickel
incorporated in artificial resin
on canvas, 157½ × 118⅛ in.
(400 × 300 cm). San Francisco
Museum of Modern Art. Gift of
the friends of John Garland
Bowes, William Edwards, and
Donald G. Fisher and the
Accessions Committee Fund: gift

of Frances and John G. Bowes,
Shirley and Thomas Davis,
Mr. and Mrs. Donald G. Fisher,
and Mimi and Peter Haas,
89.2. Plate no. 67

72. *The Spirits that Lend Strength Are
Invisible IV* (Salt of Silver), 1988.
Silver nitrate painted on invisible,
hermetic structure and artificial
resin on canvas, 118⅛ × 157½ in.
(300 × 400 cm). Collection of
Mimi and Peter Haas, San
Francisco. Plate no. 68

73. *The Spirits that Lend Strength Are
Invisible V* (Otter Creek), 1988.
Silver leaf, neolithic tools, and
artificial resin on canvas,
118⅛ × 157½ in. (300 × 400 cm).
Collection of John and Frances
Bowes, San Francisco. Plate
no. 69

74. *UFO* (UFO), 1988. Artificial resin
and acrylic on fabric, 47¼ ×
47¼ in. (120 × 120 cm). Private
collection, Cologne. Plate no. 64

Drawings

The artist's titles or inscriptions are
italicized. For works bearing the name
"Ohne Titel (Untitled)," or works
without any name, German descriptive
titles are placed in brackets; English
descriptive titles are placed in
parentheses.

75. [Drei Männer] (Three Men),
1962–63. Poster paint on wrap-
ping paper, 26¹⁵/₁₆ × 20⅞ in.
(68.5 × 53 cm). Private collection,
Cologne. Plate no. 71

76. [Schwarz, Rot, Gold] (Black,
Red, Gold), 1962–63. Poster
paint and pen and ink on
newsprint, 15¹/₁₆ × 21⅞ in.
(38.3 × 55.5 cm). Private collec-
tion, Cologne. Plate no. 73

77. *A-Mann* (A-Man), 1963. Poster
paint on kraft paper, 41⁵/₁₆ ×
29⁷/₁₆ in. (105 × 74.7 cm). Private
collection, Cologne. Plate no. 76

78. *B-Mann* (B-Man), 1963. Poster
paint on kraft paper, 39 ×
29⁵/₁₆ in. (99 × 74.4 cm). Private
collection, Cologne.

150

79. *C-Mann* (C-Man), 1963. Poster paint on kraft paper, 39 × 29 5/16 in. (99 × 74.4 cm). Private collection, Cologne.

80. *V-Mann* (V-Man), 1963. Poster paint on kraft paper, 39 × 29 1/2 in. (99 × 75 cm). Private collection, Cologne.

81. *Butter*, 1963. Ballpoint pen and watercolor on paper, 11 5/8 × 8 1/4 in. (29.6 × 21 cm). Private collection. Plate no. 78

82. *Hemden in allen Farben* (Shirts in All Colors), 1963. Ballpoint pen and watercolor on paper, 11 11/16 × 8 3/8 in. (29.7 × 21.2 cm). Private collection. Plate no. 80

83. [Mutter und Kind] (Mother and Child), 1963. Poster paint on kraft paper, 41 5/16 × 29 7/16 in. (105 × 74.7 cm). Private collection, Cologne. Plate no. 74

84. [Punkte] (Dots), 1963. Ballpoint pen and watercolor on paper, 11 11/16 × 8 5/16 in. (29.7 × 21.1 cm). Private collection. Plate no. 86

85. *Ohne Titel* (Untitled: Man and Dots), 1963. Ballpoint pen, watercolor, whitewash, and lacquer on paper, 11 5/8 × 8 1/4 in. (29.6 × 21 cm). Private collection. Plate no. 77

86. *Ohne Titel* (Untitled: Rectangles), 1963. Ballpoint pen on paper, 11 11/16 × 8 3/8 in. (29.7 × 21.2 cm). Courtesy David Nolan Gallery, New York.

87. *Ohne Titel* [Linien] (Untitled: Lines), 1963. Pen and ink and poster paint on newsprint, 22 5/8 × 21 7/8 in. (57.5 × 55.6 cm). Private collection, Cologne. Plate no. 72

88. [Paar] (Pair), 1963. Poster paint on kraft paper, 41 9/16 × 29 1/8 in. (105.5 × 74 cm). Private collection, Cologne. Plate no. 75

89. *Pralinen* (Pralines), 1963. Ballpoint pen and watercolor on paper, 11 5/8 × 8 1/4 in. (29.6 × 21 cm). Private collection. Plate no. 79

90. [Punkte] (Dots), 1963. Watercolor on paper, 24 5/8 × 20 1/4 in. (62.5 × 51.5 cm). The Froehlich Collection, Stuttgart. Plate no. 87

91. *Rasterzeichnung* (*Empedokles ist in dem Berg*) (Raster Drawing [Empedokles Is in the Mountain]), 1963. Poster paint, rubber stamp, spray gun, and brush on paper, 25 3/16 × 30 9/16 in. (64 × 77.7 cm). Private collection, Cologne.

92. *Rasterzeichnung* (*Porträt Lee Harvey Oswald*) (Raster Drawing [Portrait of Lee Harvey Oswald]), 1963. Poster paint, pencil, and rubber stamp on paper, 37 5/16 × 27 3/8 in. (94.8 × 69.6 cm). Private collection, Cologne. Plate no. 70

93. *Why Can't I Stop Smoking?*, 1963. Ballpoint pen on paper, 11 11/16 × 8 1/4 in. (29.7 × 21 cm). Private collection. Plate no. 81

94. *Capriccio 2*, 1963–65. Watercolor and wash on paper, 11 11/16 × 8 1/4 in. (29.7 × 21 cm). Private collection, Cologne. Plate no. 84

95. *Berliner Ballen* (Buns), 1965. Ballpoint pen on paper, 11 5/8 × 8 1/4 in. (29.7 × 21 cm). Private collection. Plate no. 85

96. *Ohne Titel* (Untitled: Vase), 1965. Ballpoint pen on paper, 11 11/16 × 8 1/4 in. (29.7 × 21 cm). Private collection. Plate no. 88

97. *Ohne Titel* [Kuss, Kuss] (Untitled: Kiss, Kiss), 1965. Gouache and watercolor on paper, 27 9/16 × 35 7/16 in. (70 × 90 cm). The Dr. Speck Collection, Cologne. Plate no. 90

98. *Richter: Ab September ständig im Kino* (Richter: Starting September in a Theater near You), 1965. Ballpoint pen and pencil on paper, 11 11/16 × 8 1/4 in. (29.7 × 21 cm). Private collection. Plate no. 82

99. *Schlankheit durch Richter* (Slimming through Richter), 1965. Ballpoint pen on paper, 11 11/16 × 8 1/4 in. (29.7 × 21 cm). Private collection. Plate no. 83

100. *Ohne Titel* (Untitled: Floating Triangles), 1966. Watercolor on paper, 11 11/16 × 8 1/4 in. (29.7 × 21 cm). Private collection. Plate no. 89

101. *Ohne Titel* (Untitled: Woman's Face), 1967. Watercolor on paper, 39 3/8 × 27 9/16 in. (100 × 70 cm). Museum of Fine Arts, Bern, Toni Gerber Collection, Donation 1983. Plate no. 91

102. *Kartoffelpyramide in Zwirners Keller* (Potato Pyramid in Zwirner's Cellar), 1969. Ballpoint pen, watercolor, and Rapidograph on paper, 11 11/16 × 8 1/4 in. (29.7 × 21 cm). Private collection. Plate no. 92

103. *Ohne Titel* (Untitled: Couple and Television), 1971. Gouache and mixed media on paper mounted on canvas, 91 × 69 in. (231.1 × 175.3 cm). Private collection, San Francisco. Plate no. 93

104. *Telefonzeichnung* (Telephone Drawing), 1975. Felt-tip pen, ballpoint pen, and pencil on paper, 27 9/16 × 39 3/8 in. (70 × 100 cm). Museum of Fine Arts, Bern, Toni Gerber Collection, Donation 1983. Plate no. 96

105. *Ohne Titel* [Ornament] (Untitled: Ornament), 1980. Gouache on paper, 39 3/8 × 27 9/16 in. (100 × 70 cm). Kunstmuseum, Bonn, permanent loan from private collection. Plate no. 94

106. *Ohne Titel* (Untitled: Coin and Moose), 1981. Gouache on paper, 39 3/8 × 27 9/16 in. (100 × 70 cm). Kunstmuseum Bonn, permanent loan from private collection. Plate no. 95

107. *Ohne Titel* [Rennende Schere] (Untitled: Running Scissors), 1981. Gouache on paper, 39 3/16 × 27 3/8 in. (99.5 × 69.5 cm). Collection of Udo and Anette Brandhorst, Cologne. Plate no. 97

Because of the artist's desire to create an installation specific to each city and museum, not all works included in this catalogue are on view at each site.

DESIGNER: *Catherine Mills*

PROJECT COORDINATOR: *Kara Kirk*

EDITOR: *Fronia Simpson*

CALLIGRAPHER: *John Prestianni*

TEXT COMPOSITION: *Wilsted & Taylor*

TRANSLATORS: *Fronia Simpson*
Stewart Spencer

PHOTOGRAPH CREDITS: *Photographs have been supplied by the artist or by the owners named in the captions. Those for which an extra credit is due are listed here:* Ben Blackwell, photographer, pl. nos. 65–69; Gagosian Gallery, New York, pl. nos. 11, 23; Arno Garrels, photographer, pl. no. 24; Kunstmuseum, Bonn, pl. nos. 70–76, 81, 84, 87, 90, 94–95, 97; Jochen Littkemann, photographer, pl. nos. 41, 56–58, 63; Wolfgang Morell, photographer, pl. nos. 20–21; Mary Boone Gallery, New York, pl. no. 46; David Nolan Gallery, New York, pl. no. 93; Anthony d'Offay Gallery, London, pl. no. 33; Frank Oleski, photographer, pl. nos. 77, 88–89; Steven Sloman, photographer, pl. no. 9; Lee Stalsworth, photographer, pl. no. 38; Galerie Michael Werner, Cologne, pl. nos. 47, 78–80, 82–83, 85–86; Uli Zeller, photographer, pl. no. 19.

Printed and bound in Hong Kong through Overseas Printing Corporation.

Ein Deutscher und ein Italiener starben zur selben Zeit und begegneten sich im Fegefeuer. Da fragte man sie welche Hölle sie bevorzugten, die deutsche oder die italienenische. Der Deutsche wählte die deutsche Hölle und der Italiener die italienische. Damit man sich nicht zu sehr an der Hölle gewöhnt und weniger leidet, gibt es alle fünf Jahre eine kurze Unterbrechung im Fegefeuer. Da begegnen sich die Männer also wieder. "Na," fragte der Italiener, "wie ist es denn bei euch?" "Ach," sagte der Deutsche "könnte besser. Wir stehen alle in einem Riesentopf voller Scheisse und wenn man aufspringt um an die Luft zu kommen, schlägt ein Teufel einem mit einem Hammer auf dem Kopf, damit man wieder untertaucht. Aber wie ist es denn bei euch?" "Ungefähr das Gleiche," antwortet der Italiener, "nur gibt es 'mal nicht genügend Scheisse, 'mal fehlt der Hammer und dann wieder streiken die Teufel . . .